SURREALISM

Author: Michael Robinson Foreword: Donna Roberts

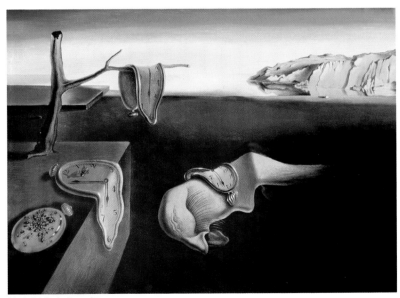

Salvador Dali, *The Persistence of Memory*

**FLAME TREE
PUBLISHING**

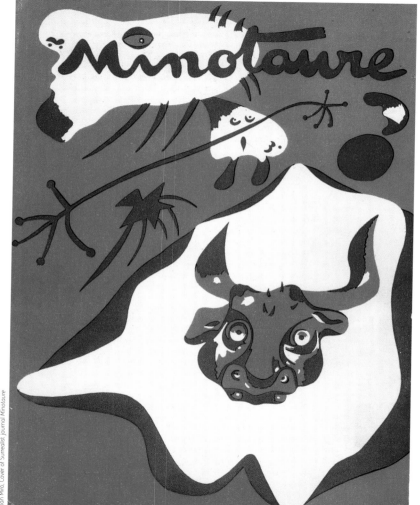

SURREALISM

Publisher and Creative Director: Nick Wells
Development: Melinda Revesz
Picture Research: Melinda Revesz, Sara Robson
Project Editor: Polly Willis
Editor: Sarah Goulding
Designer: Mike Spender
Production: Chris Herbert, Claire Walker

Special thanks to: Geoffrey Meadon, Helen Tovey

FLAME TREE PUBLISHING
Crabtree Hall, Crabtree Lane
Fulham, London, SW6 6TY
United Kingdom

www.flametreepublishing.com

First published 2005

05 07 09 08 06

1 3 5 7 9 10 8 6 4 2

Flame Tree is part of the Foundry Creative Media Company Limited

The CIP record for this book is available from the British Library.

ISBN 1 84451 267 3

Every effort has been made to contact copyright holders. We apologize in advance for any omissions
and would be pleased to insert the appropriate acknowledgements in subsequent editions of this publication.

While every endeavour has been made to ensure the accuracy of the reproduction of the images in this book,
we would be grateful to receive any comments or suggestions for inclusion in future reprints.

Printed in China

Contents

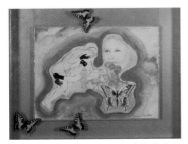

Victor Brauner, *Composition*; Hans Arp, *Head*; Hans Bellmer, *Portrait of Max Ernst at Les Milles*

Francis Picabia, *Machaon*; Raoul Hausmann, *The Spirit of Our Time*; Giorgio de Chirico, *Piazza D'Italia*

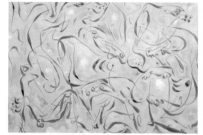 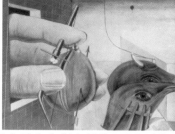 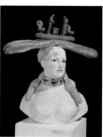

André Masson, *La Chasse a l'élan*; Max Ernst, *Oedipus Rex*; Salvador Dali, *Retrospective Bust of a Woman*

 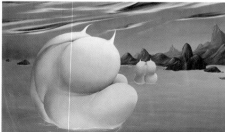 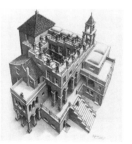

Eileen Agar, *Angel of Anarchy*; Félix Labisse, *Libidoscaphes dans la Baie de Rio*; M. C. Escher, *Ascending and Descending*

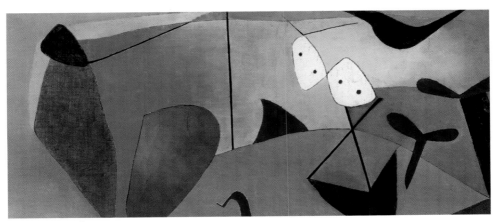

Wolfgang Paalen, *Composition*

How To Use This Book

The reader is encouraged to use this book in a variety of ways, each of which caters for a range of interests, knowledge and uses.

- The book is organized into four sections: **Movement Overview**, **Influences**, **Styles & Techniques** and **Places**.
- **Movement Overview** takes a look over the whole movement, beginning with some of Surrealism's earliest works in the 1920s up to the late 1950s to give readers a perspective on the development of the art and artists within the movement.
- **Influences** shows how Surrealism was influenced by its predecessor, Dada, and also by emerging studies of psychoanalysis and the subconscious. It also shows how Surrealist artists influenced other artists, and continue to do so to this day in popular culture.
- **Styles & Techniques** looks at the myriad techniques employed by Surrealist artists, including creating incongruous images conjured by the unconscious that transcend reality as perceived by the conscious mind.
- **Places** Although Surrealism was a largely European movement, some artists came from Mexico and the US, and many ended up living in Paris. This section looks at some of those artists.

2. Name of artist, by surname then forename

1. Title of work

3. Date of work (if known)

10. Picture credit

4. Information about the work and the context within which it was created

9. Location in which the work was created (if known)

8. Medium in which the work was created (if known)

7. Period or movement to which the work belongs (if not Surrealist)

6. Similar works, either from the same or other artists, with similar styles, techniques or subject matter

5. Biographical information about the featured artist: name, date and place of birth and date of death

Foreword

In a lecture delivered in Belgium in 1934, the leader of the Surrealist movement, André Breton, posed the question, 'What is Surrealism?'. Although this question is now seven decades old, it still requires considerable thought, and does not lend itself to simple answers. The word 'surreal' has filtered into everyday language to describe the strange or bizarre, and yet its origins are rooted in a movement that erupted in 1920s Paris, championing the indisputable force of dreams and desires, and confidently demanding 'a new declaration of the rights of man'.

Surrealism followed a number of avant-garde movements of the early twentieth century, such as Expressionism, Fauvism, Cubism, Futurism, and its immediate precursor, Dada. Dada was the explosive, nihilistic bad parent of Surrealism, and was born raging from the carnage of the First World War. Unlike previous movements, the Dadaists had no fixed artistic programme. Although they created and constructed, their works were an explicit attack on the aesthetic disengagement of art from the traumatic realities of life: their art in fact an anti-art. Consumed by the flames of its own negation, Dada was snuffed out, and yet its scorched earth yielded the new, more subtle and stranger fruit of Surrealism. Dada's legacy to Surrealism was its brilliance for controversy and its relentless spirit of provocation. It also provided Surrealism with the basis for international development, and drew members from France, Switzerland, Germany and the USA, where centres of collective Dada activity had taken root. Thus, it was in the after-shock of war that Surrealism developed in Paris into what would become one of the most important intellectual movements of the twentieth century.

The first principles of Surrealism were published in 1924 in the *Manifesto of Surrealism*, written by the group's charismatic figurehead, André Breton. Breton, a poet, was to be the most important theorist of Surrealism until, and even after, his death in 1966. Like its precursor, Dada, Surrealism developed as an angry movement, and set itself up as a challenge to all those who represented the old order that had so recently thrown Europe into turmoil. Surrealism was, however, based on more positive principles than Dada, truly believing that it could bring about real changes to everyday life. It might sound odd to see Surrealism referred to as a *practical* idea, and yet it professed

an aim to solve 'all the principal problems of life'. How could such a movement, so well known for its fascination with dreams and the imagination, make such a claim? For the Surrealists, the greatest problems that beset mankind were created by the enormous neglect of areas of thought and experience that did not conform to the rules laid down by reason, positivist science and repressive forms of morality. Man, who Breton called, 'that inveterate dreamer', suffers acutely from the restrictions of a society that denies him half of himself; the half that is not ruled by logic and conscious thought, but which finds freedom in the imagination and the unexpected in the depths of his unconscious. The Surrealists sought to redress this balance, and to reconcile the apparent opposites of dream and reality, conscious and unconscious, the internal and the external worlds.

Although the most well-known representatives of Surrealism are visual artists, the Surrealists were not originally concerned with developing their ideas through the visual arts, but rather focused their attention on writing and poetry. However, Breton soon took up the challenge of developing Surrealist ideas in the area of the visual arts. As reflected in this book, Surrealism is not a style of art. Its practitioners made use of any media: drawing, painting, collage, photography, film and objects. There was, however, one rule that governed Surrealist art, which was that it must be able to visualise what Breton called 'a purely internal model', meaning that the image or form must have its source in the mind or in the artist's inner vision. Works may be figurative, but the forms taken from the external world are always vessels for the artist's inner world, dreams and desires. They are what Breton called 'communicating vessels': conduits between the mind and the world at large. Although the art collected in here does not conform to any general stylistic or formal programme, it is united around an idea: of giving free reign to the unconscious and the imagination. While variously pleasing, provocative, disturbing and confusing, Surrealist art bears witness to the fact that, in the words of Breton, 'the eye exists in its savage state'.

Donna Roberts, *2005*

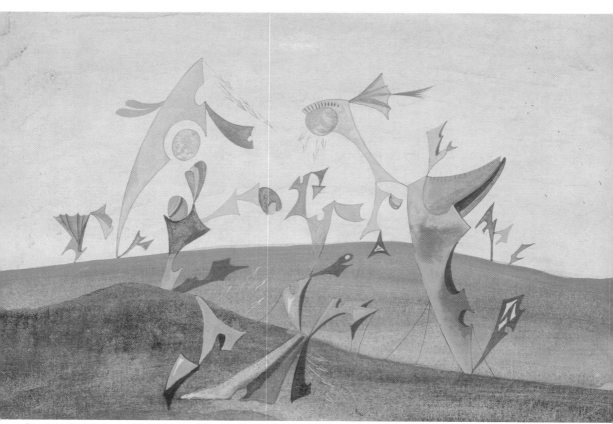

Introduction

If one is asked to define Surrealism, it is usually through an associative process that involves the strange and enigmatic images of either Salvador Dalí or René Magritte. Ironically it was Magritte who challenged the associative processes of words and pictures with the objects that they represented. In perhaps his most famous work, *The Treachery of Images*, which depicts a smoker's pipe, the viewer is asked to consider the assumptions made about the image when it is underscored with the caption, *'Ceci n'est pas une pipe'*. Surrealism was, however, more than a playful association of words and pictures. Like most art movements it came at a particular time in which the social, political and artistic circumstances facilitated an aesthetic that was influenced by those conditions. So what were those circumstances?

The arrival of the twentieth century marked the beginning of an artistic epoch, when artists sought a new language for a new era that eschewed the repetitive character of 'painting from nature'. The development of Cubism in the first decade of the new century, by Pablo Picasso and Georges Braque in their so-called 'laboratory of art', freed subsequent artists from the tyranny of nature's mimesis. They were also influenced by Friedrich Nietzsche's artistic ideals, his writings having gained currency at this time through their dissemination in the café societies of most European cities including Paris. Using the mythological characters of Apollo and Dionysus as allegory, Nietzsche advocated an art that was founded on the tensions present in life between 'civilized' man and man as the primordial being. For him, an art that encapsulated that tension, between order as personified by Apollo, and chaos as epitomized by Dionysus, was an art relevant to the 'modern' period, acting as a salvation to a nihilistic world.

This positive artistic approach to modernity reached a hiatus in its development with the outbreak of the First World War. Whether serving in their respective armies or not, most artists were affected by the conflict and its aftermath. Until this time, with one or two exceptions, artists tended to be apolitical, or at the very least to hide the lamps of their political allegiances under a bushel. The First World War facilitated a radical shift by artists in their aesthetic emphasis, as a response to the terrible carnage of the conflict, which was blamed on the machinations of the bourgeoisie. Dada had arrived.

As a phenomenon Dada has a historical place in the development of modern art and can be seen as pivotal in some aspects of contemporary art, which seek to define and redefine exactly what art is and what it is for.

Dada's original manifestation was intended as a classless 'anti-art' that did not pander to bourgeois sensibilities. Adopting a stance of irrationality, in contrast to formalized painting and sculpture, Dada permeated a number of European cities such as Paris, Berlin and Zurich, before émigré European artists disseminated its ideas into American culture. These irrational ideas found form in collage and montage, motifs borrowed from Cubism, whose aesthetic was seen, particularly by Marcel Duchamp, as no longer avant-garde, but bourgeois. These collages were often words or pictures cut from popular magazines and pasted in absurd juxtapositions with other disparate images. There was also a high degree of chance and immediacy in these images that were intended to shock and disrupt the normality of bourgeois sensibilities and etiquette. Dada artists also made 'objects' with the same lack of logicality, such as Duchamp's 'ready-mades', and were often involved in absurd events designed to disrupt the complacency of the status quo.

Although essentially a political vehicle that questioned the validity of the self-righteous status of the bourgeoisie, and an art that was complicit in its sensibilities, Dada was short-lived. This was due to its lack of infrastructure, exemplified by the lack of cohesion among its various factions. One of its protagonists was André Breton, a Paris-based French poet and contributing editor to the avant-garde review *Littérature*, who took part in Dadaist soirées and events in the early part of 1920. Breton was a veteran soldier of the First World War and, like many of his compatriots, blamed the ruling class for their exploitation of him by means of patriotic coercion. Initially a Dadaist, Breton soon realized that its ethos was too nihilistic and he sought a more positive approach to the control of man's destiny. Following a great writing tradition in France, which had given voice to political causes in the past, Breton sought to inject his own work with a more positive attitude than the recent cynicism of Alfred Jarry, or the nihilism of his near contemporary Jacques Vaché. For Breton, Dada in its present form offered little in the way of potential: he needed to reinvent its *raison d'être*.

Contemporary to this development were Breton's early experiments in 'automatic' writing. An avid reader of Sigmund Freud's theories, Breton could see the potential in the untapped creative energies retained within the unconscious, just waiting to be harvested. The need to codify the idealism of Dada within a structure led Breton to write his First Manifesto of Surrealism in 1924. Although Guillaume Apollinaire, as an impromptu remark, had coined the term, it was Breton who defined Surrealism as follows:

SURREALISM, noun. Pure psychic automatism by which it is intended to express, either verbally or in writing, or otherwise, the true function of thought. Thought dictated in the absence of all control exerted by reason, and outside all aesthetic or moral preoccupations.

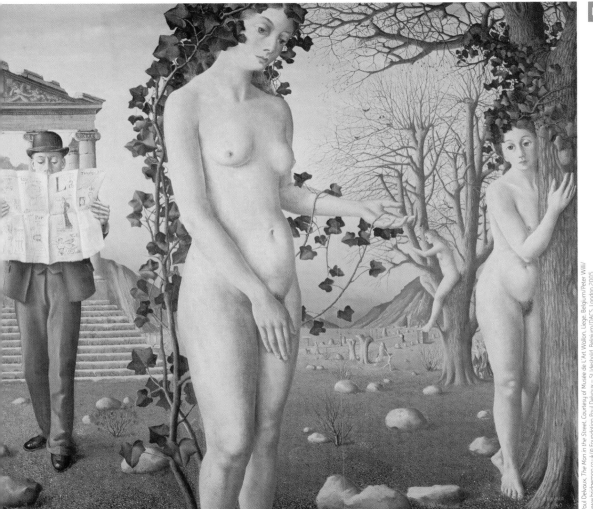

There are two points to be made about the pluralistic development of Surrealism from its Dadaist roots. Firstly that Dada was predominantly a visual manifestation, whereas Surrealism was, at least in the beginning, a literary form. The virtual omission of artists from the manifesto created an initial problem for Breton who from 1925 subsequently laid down some basic tenets of Surrealist painting in the journal *La Révolution surréaliste*. Secondly that not all Dadaists became Surrealists and not all Surrealists had their roots in Dada. A number of the Dadaists, such as Francis Picabi and Marcel Duchamp, did not want to become Surrealists, preferring to create works as 'anti-art'. The artists who did come to Surrealism through Dada fell, broadly speaking, into two groups.

The first are those who used collage, Max Ernst for one, and subsequently developed a particular style to which it was indebted. The second group, who used various forms of Automatism, included artists as diverse as Joan Miró and André Masson.

Another group of artists came to Surrealism not through Dada, but through the metaphysical paintings of Giorgio de Chirico, whose melancholic townscapes were imbued with a dream-like consciousness. This particular strand of influence was more evident in the second wave of Surrealist activity after Breton's post-1925 amendments, influencing artists such as Paul Delvaux and René Magritte.

In the early years of Surrealism it was the group of artists influenced by the 'automatic' techniques used in Dada that Breton continued to champion, until the publication of his second manifesto in 1929. Although it was published because of Breton's need to further codify the Surrealist group and make it coherent, avoiding the mistakes that the Dadaists had made, it facilitated a shift in emphasis for the painters within the group away from Automatism to the pictorial visualization of the unconscious. The

marginalization of key 'automatic' painters such as Masson, who subsequently left the group, made way for other Surrealists such as Salvador Dali, whose interests lay in the dream quality of the unconscious and irrational phenomena, particularly irrational perception. Breton advocated an investigation of the more spiritual aspects of the unconscious and its links with the Hermetic tradition. Using his so-called 'paranoid-critical method' in which he cultivated paranoid delusions, Salvador Dali's depictions of sexual obsession confront the viewer with their own anxieties and neuroses. His paintings and later his

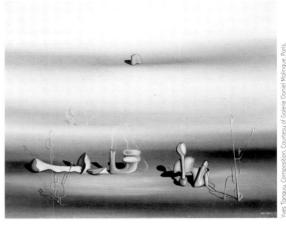

Yves Tanguy, Composition, Courtesy of Galerie Daniel Malingue, Paris, France/www.bridgeman.co.uk/© ARS, NY and DACS, London 2005

'objects' created a more revolutionary approach to Surrealism. This took it from the relative passivity of recording the messages of the unconscious, to a more dynamic interpretation of perception itself.

By the mid 1930s Surrealist ideas had begun to be disseminated through a number of international exhibitions, in London, Copenhagen, Amsterdam and Tenerife, as well as the more far-flung shores of New York and Tokyo. These laid the foundations for a number of Surrealist groups, particularly in England, due to its close proximity to Paris and the history of a cross-fertilization of artistic ideas. The Czech Surrealist group, established in 1934, was also crucial to the spread of the movement, in time becoming the strongest and most long-standing of them all. With the advent of Nazi oppression in Europe, many of the Surrealists moved to New York and its environs, which became the home of Surrealism until 1946, itself spawning the next revolution in painting, Abstract Expressionism.

It would, however, be a mistake to see Surrealism only as a revolutionary art form. From its Dada roots it was always intended as a political vehicle as well. Despite various minor disagreements within the groups in London and Paris, there was a political as well as an artistic consensus that supported a Marxist ideology, but not the totalitarianism of the Soviet Union. Some members of the group were more politically active than others, but all declared an active support for Republicanism in Spain and deplored the advance of Fascism in Europe. After all, Breton had in 1924 intended Surrealism to be a 'new declaration of the rights of man'.

Surrealism

Movement
Overview

Ernst, Max
Celebes, 1921

Courtesy of Tate, London/© ADAGP, Paris and DACS, London 2005

Like many European artists Max Ernst was disillusioned with bourgeois values following the futility of the First World War. After his service in the German Army he became the leader of the circle of Dada artists, which included Hans Arp, in Cologne. In 1920 he organized one of the most famous Dada exhibitions, in a restaurant in which visitors entered through the lavatories and were invited to break the exhibits with axes if they wanted. Then from 1922 he joined the Parisian group under the leadership of André Breton (1896–1966). Prior to his involvement in the Surrealist movement after 1924, Ernst painted a number of works that anticipate Surrealism while still reflecting the irony of Dadaism – for example, *Celebes*, and his depiction of a nonsense German poem whose opening line is 'The elephant from Celebes has sticky yellow bottom grease...'. In this painting Ernst has used his earlier university studies in psychology and philosophy, in which he became familiar with the writings of Friedrich Nietzsche (1844–1900) and Sigmund Freud (1856–1939), to provide the basis for a pictorial exploration of the irrational subconscious.

CREATED

Cologne

MEDIUM

Oil on canvas

PERIOD/MOVEMENT

Dada/proto-Surrealism

SIMILAR WORKS

Francis Picabia, *Amorous Procession*, 1917

Max Ernst *Born* 1891 Brühl, Germany

Died 1976

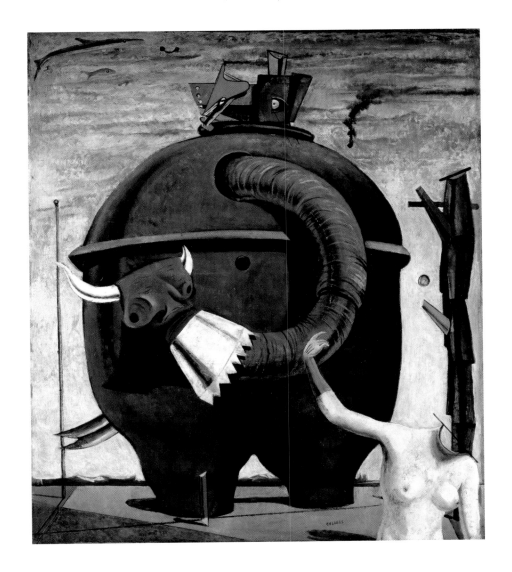

Tanguy, Yves; Breton, André; Duhamel, Marcel & Morise, Max
Cadavre exquis, 1920–40

This collaboration emanates from an old parlour game adapted for use by the Surrealist poets and known as *Cadavre exquis* ('Exquisite Corpse'). Essentially it is based on the notion of chance in which the first player writes a phrase on a piece of paper, covers part of it with a fold before passing it on to the next player for their contribution. The name comes from an initial game in which the phrase *Le cadavre exquis boira le vin nouveau* ('The exquisite corpse will drink the young wine') was written. The Surrealist artists adapted this idea to drawings, a process that came to be identified by Max Ernst as 'mental contagion', with many of them being used in Surrealist journals such as *La Révolution surréaliste*. Many artists within the Surrealist movement played this game of *Cadavre exquis* and often the 'finished' drawing would not be completed in one sitting.

The example shown here, completed over a 20-year period, demonstrates the artists' fascination with the relatively taboo subject of sexuality, depicting both male and female genitalia in a highly erotic state.

CREATED

Paris

MEDIUM

Coloured pencil on paper

PERIOD/MOVEMENT

Dada

SIMILAR WORKS

Man Ray, Yves Tanguy, Max Morise and Joan Miró, *Cadavre Exquis*, 1928

Arp, Hans
Head, 1929

Having spent his formative artistic years within conventional academic schooling in Weimar and Paris and then within the *Blaue Reiter* ('Blue Rider') group of Expressionists, Hans Arp became a founder member of the Dadaist group in Zurich from 1916. Now free from academic convention, Arp explored 'biomorphism', a concept of organic forms inspired by nature, which had already found a creative outlet in the Parisian and Belgian Art Nouveau styles at the turn of the century. However, Arp's motivation for his biomorphic work was very different to the stylizations of Art Nouveau's practitioners. Like most artists of this period he was deeply affected by the First World War. For him the biomorphic 'reliefs' that he produced from 1915 were a comment on the unity and salvation of nature, to overcome the mechanized and dysfunctional modern world that he was experiencing.

Arp remained committed to these biomorphic forms throughout his artistic career, as an early Dadaist, Surrealist and later as a Constructivist. His amoeba-like creations of fragmented parts of the human body reflected an equally fragmented world.

CREATED

Paris

MEDIUM

Relief

SIMILAR WORKS

Henry Moore, *Mask*, 1929

Hans Arp *Born* 1887 Strasbourg, France

Died 1966

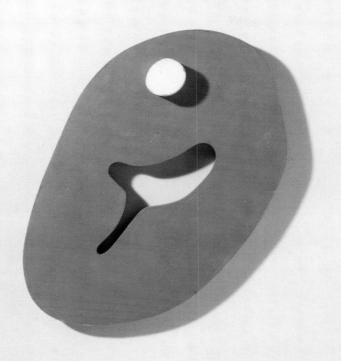

Man Ray

Je ne vois pas la (femme) cachée dans la forêt, 1929

This series of photographs by Man Ray, surrounding a photograph of a painting by René Magritte (1898–1967), appears in most books on Surrealism, because of its depictions of the movement's main protagonists. The title translates as 'I Do Not See the (Woman) Hidden in the Forest', with the figure of the woman replacing the text. The male protagonists all have their eyes closed, alluding to the commonly held dream fantasy by men of the nude woman and the desire for her, albeit only as a photograph. Given the Surrealists' proclivity for sexuality and wit the photograph has an ambiguity concerning what exactly is 'hidden' in the 'forest'. Magritte often played with language in his paintings, juxtaposing text and images. In essence he was trying to demonstrate the incongruities and shortcomings of language when relating it to reality and experience. During the 1930s, and in line with Surrealist thought, Magritte explored metaphysical theories concerning reality and the seemingly arbitrary structure of language that leads to misunderstandings.

This image was on the back cover of the last issue of *La Révolution surréaliste*, a journal that frequently explored Sigmund Freud's ideas on psychoanalysis, particularly those aspects of sexuality and desire.

CREATED

Paris

MEDIUM

Photograph

SIMILAR WORKS

Salvador Dali, *Le Phénomène de l'extase*, 1933

Man Ray (born Emmanuel Radnitsky) *Born* 1890 Philadelphia, USA

Died 1976

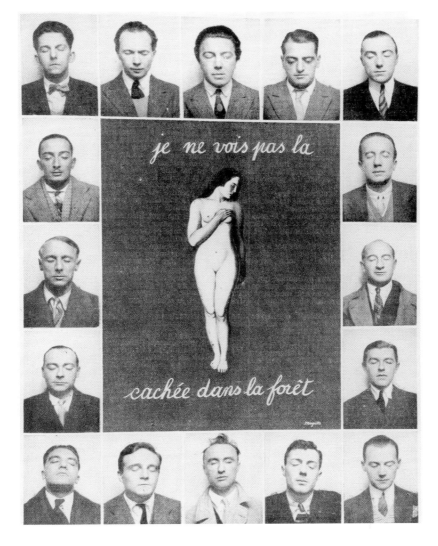

Desnos, Robert

The Spider with a Moustache, 1932

Robert Desnos was, like André Breton, a Surrealist poet and singled out by him in the publication of the *First Manifesto of Surrealism* for his particular talents of 'automatic' writing. Automatism, as it came to be known, consisted of writing while the subconscious interacts with the conscious mind of the writer, often in a trance-like state. Automatism had been known as a phenomenon in the late nineteenth century. For the Surrealists this represented a higher form of creativity that had hitherto been untapped, providing a potentially new mode of representation, namely the unconscious that was devoid of moral or aesthetic considerations.

Although essentially a writer, Desnos illustrated a number of his own collections of poems such as *La Menagerie de Tristan* a hand-written collection published in 1932 in which the illustration *The Spider with a Moustache* was included. At this time Desnos had distanced himself from Breton's circle, preferring the company of some of the more low-profile Surrealists, such as Max Morise (1903–73), Jacques Prévert (1900–77), André Masson (1896–1987) and the photographer Jacques-André Boiffard (1902–61), who gravitated towards the periodical *Documents*. This journal represented a form of anti-idealist Surrealism that exposed the sordidness of man's baser instincts.

CREATED

Paris

MEDIUM

Watercolour

SIMILAR WORKS

Marcel Duchamp, *L.H.O.O.Q.*, 1920

Robert Desnos *Born* 1900 Paris, France

Died 1945

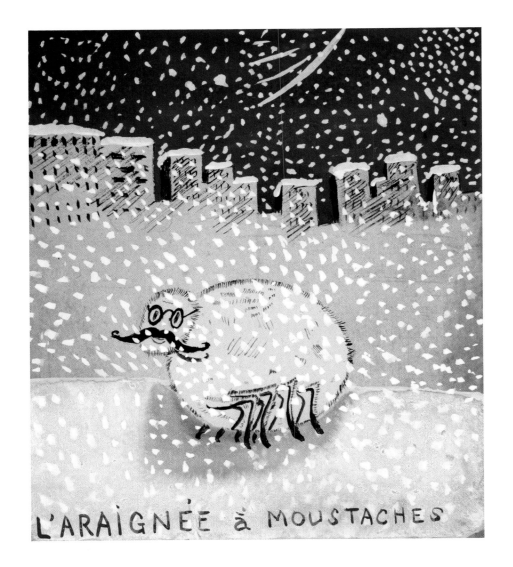

L'ARAIGNÉE à MOUSTACHES

Moore, Henry

Reclining Figure – Four Piece Composition, 1934

Courtesy of Mayor Gallery, London, UK/www.bridgeman.co.uk/© The work illustrated on page 33 has been reproduced by permission of the Henry Moore Foundation

In Britain during the 1930s a gulf had opened between the artistic sensibilities of the Surrealists on the one hand and the Abstractionists on the other, becoming a somewhat acrimonious and public affair. In an effort to appease the situation, Henry Moore, who had a foot in both camps, stated, 'All good art has both abstract and surreal elements in it, just as it contains both classical and romantic elements'. Unlike most of his Continental contemporaries, or the later British Surrealists, Moore remained effectively apolitical in his use of Surrealism.

Reclining Figure – Four Piece Composition remains, like most of Moore's work, indebted to both Abstraction and Surrealism. In that respect he is clearly a disciple of Hans Arp, in his study of biomorphic and metamorphic forms. Where this particular work rubs shoulders with Surrealism is in Moore's experimentation with the notion of chance or accident as in the game of *Cadavre exquis* ('Exquisite Corpse'), rather than the fragmentation of Abstraction. Moore's inspiration for much of this work came from non-Western art; particularly that of pre-Columbian, African and Peruvian sources and he remained committed to the 'inexhaustible thoughts and ideas based on the human figure'.

MEDIUM

Bronze

PERIOD/MOVEMENT

Surrealism/Abstraction

SIMILAR WORKS

Hans Arp, *Two Thoughts on a Navel*, 1930

Henry Moore *Born* 1898 Yorkshire, England

Died 1986

Hugo, Valentine; Breton, André & Eluard, Paul & Nusch

Exquisite Corpse, 1934

Another image from the game *Cadavre exquis* ('Exquisite Corpse'), this collaboration included two women artists, Eluard's second wife Nusch and Valentine Hugo (1887–1968), in this erotic depiction of the female form. The inclusion of women in the group signified a change in attitude by the Surrealists who wanted to change a bourgeois society that was repressive, particularly towards women and issues of femininity. Writing in 1945 André Breton stated, 'The time should come to assert the ideas of woman at the expense of those of man, the bankruptcy of which is today so tumultuously complete'.

Artists within the Surrealist movement therefore subverted the traditional forms of masculinity and patriarchy by appropriating the otherness of the 'feminine'. Today, in a postfeminist era, this shift can be seen as idealist, but Surrealism did attempt to change existing definitions of sexual difference. In many of the works sexual difference is conflated by showing the human form as androgynous, paying homage to Freud's theories concerning the pre-oedipal child who has no fixed gender identity until it is determined by and within a repressive patriarchal society.

CREATED

Paris

MEDIUM

Crayon on paper

SIMILAR WORKS

Yves Tanguy, André Breton, Marcel Duhamel and Max Morise, *Cadavre exquis*, 1920–40

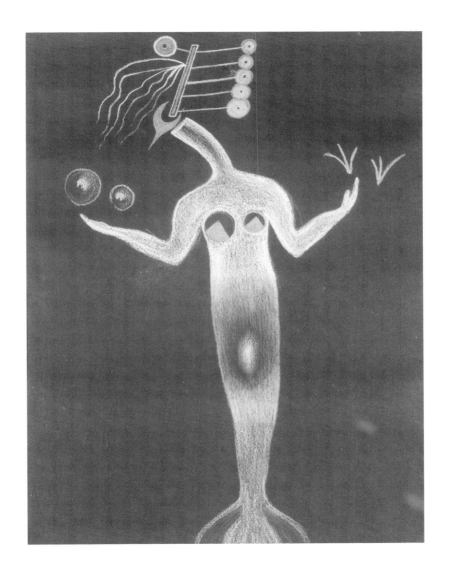

Miró, Joan

Cover of Surrealist journal *Minotaure*, 1935

Founded in 1933 by Albert Skira, *Minotaure* became the official Surrealist journal, replacing the then-defunct *Le Surréalisme au service de la Révolution*. Unlike its predecessor, this avant-garde review was presented in a luxurious format, the cover illustrations being commissioned from many of its leading artists such as Joan Miró, as seen here, Pablo Picasso (1881–1973) and Max Ernst. Apart from articles on art by such diverse figures as Salvador Dalí (1904–89) who wrote a theory on the 'new colours of spectral sex-appeal' and André Breton on 'Picasso in his element'; the journal reproduced a number of rare documents and highlighted aspects of Surrealism in past paintings. There were also articles on psychoanalysis by Jacques Lacan and poems by, for example, Breton who sought self-analysis in his work *La Nuit du tournesol* ('The Night of the Sunflower').

The Minotaur was a Greek mythological bull-headed man. The creature and its legend became the inspiration for a number of artists both in the Classical and Romantic traditions that continued well into the twentieth century and the modern movements. Catalan artists such as Miró and Picasso had a particular affinity with the depiction of the creature through their cultural heritage of bullfighting.

CREATED

Paris

MEDIUM

Journal cover page

SIMILAR WORKS

Pablo Picasso, *Minotaur and Horse*, 1935

Joan Miró *Born* 1893 Barcelona, Spain

Died 1983

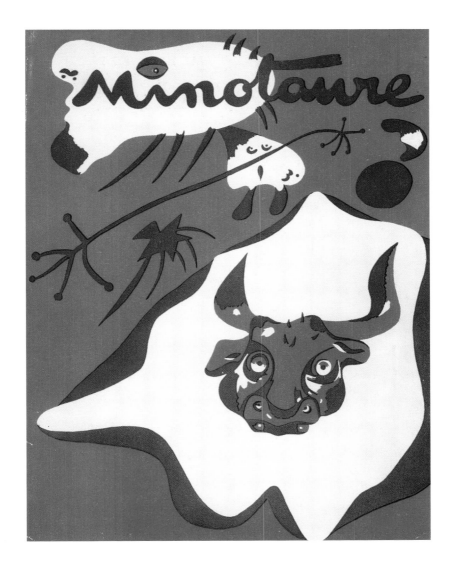

Eluard, Paul

La Comedie de la mort ('The Comedy of Death'), c. 1935

Although essentially a poet, Paul Eluard produced a number of art works such as this collage, commenting on a number of issues relating to modernity that had occupied the minds of intellectuals. As Europe was sliding inevitably towards Fascism or totalitarian regimes, was humankind destined to self-destruct? Had we learnt nothing from the First World War and its futility? The image of a zombie-like man refers to the notion of the human being as automaton, proletarian cannon fodder for the ruling classes to be slain yet again.

The image is also inextricably linked to Freud's ideas of the 'Death Instinct' in which humans (and all animals) defend themselves against all threats of death that are not 'natural'. For Freud the 'Death Instinct' or 'Thanatos' is appropriated by humans to prolong life. The notion of the 'uncanny' or unfamiliar is a common motif through aspects of Surrealism, inspired by the metaphysical paintings of Giorgio de Chirico (1888–1978). This Italian artist had spent time in Paris as well as other major cities worldwide. In 1923 Eluard and his first wife Gala visited de Chirico in Rome, becoming the subject of a double portrait.

CREATED

Paris

MEDIUM

Collage

SIMILAR WORKS

Ithell Colquhoun, *Gouffres Amers*, 1939

Paul Eluard *Born* 1895 Sain-Denis, France

Died 1952

Dalí, Salvador & Duchamp, Marcel

Venus de Milo with Drawers, 1936

Michelangelo's *Venus de Milo* is seen as an archetypal Classical sculpture. During the late 1920s and 1930s the Surrealists were reacting against a number of modernist artists who were seeking a 'return to order', a return to Classicism that affected artists, including Picasso, seeking to ameliorate the effects of the First World War by being apolitical in their work. Although the work is essentially Dadaist in concept, the Dada movement ceased to exist as a cohesive strategy of anti-art with the publication of Surrealism's *First Manifesto* in 1924 and Marcel Duchamp's 'retirement' in the same year.

This work was clearly designed in the Dada spirit to upset the bourgeois sensibilities and Dali is also poking fun at their prudishness by inserting drawers as a replacement for the breasts, leaving them half open and adding fluffy white fur pompoms on the drawer knobs. The artist also alluded to Freud's notions of suppressed desires and fetishism. Dali made a number of versions of this motif, including castings in bronze, although most were then given a white patina to replicate a plaster cast, a further attempt by him to undermine the 'aura' of a work of art.

CREATED

Probably Paris

MEDIUM

Bronze and plaster with fur pompoms

SIMILAR WORKS

Max Ernst, *The Attirement of the Bride*, 1940

Salvador Dalí *Born* 1904 Figueres, Spain

Died 1989

Marcel Duchamp *Born* 1887 Blainville-Crevon, France

Died 1968

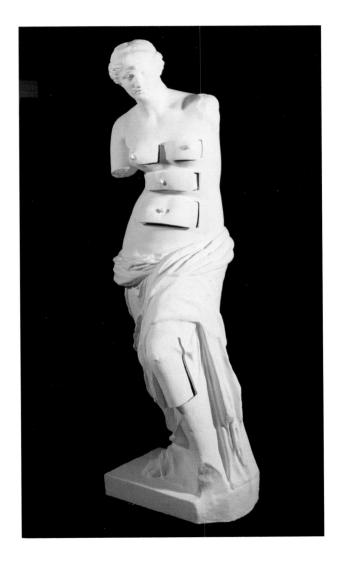

Brauner, Victor

Composition, 1936

Although born in Romania, Victor Brauner spent most of his artistic life in Paris, having moved there permanently in 1930, sharing the same apartment block with Yves Tanguy (1900–55). His now infamous painting *Self-Portrait with Enuclated Eye*, which he executed the following year, probably persuaded André Breton to allow him to join the Surrealist movement in 1932.

The illustrated work shows Brauner's obsession with eyes, a motif that was to be used by many of the other Surrealists because of its association with sleep and dreams. In Brauner's case his obsession was to prove prophetic. In 1938 he was involved in an altercation at the studio of Oscar Dominguez (1906–58) and in the ensuing fight he lost an eye that was severely lacerated by glass. Later he was to recall that it was the most painful and important fact of his life, and that what followed were a number of self-reflective paintings demonstrating his conviction that he was in fact clairvoyant. Many of his post-Second World War works contain elements of alchemy and magic. He was eventually excluded from the Surrealist group in 1948 following his refusal to distance himself from his fellow Surrealist and personal friend Roberto Matta (1911–2002).

CREATED

Paris

MEDIUM

Watercolour, gouache and pen and ink on card

SIMILAR WORKS

Roberto Matta, *Composition*, 1938

Victor Brauner *Born* 1903 Piatra-Neamt, Romania

Died 1966

Escher, M. C.

Dag en Nacht ('Day and Night'), *c.* 1938

Maurits Cornelis Escher was actually a graphic artist rather than a painter and did not belong to either the Surrealist group or any other movement. After finishing his education in Haarlem he moved to Italy, settling in Rome until 1935. Having learnt and refined his printmaking skills, his developing style was one of purposeful line drawings. Following a visit to the Alhambra in 1936, Escher became fascinated by the character of Moorish art, with its playful use of spaces and the 'Regular Division of the Plane'.

Despite remaining apolitical and outside of the avant-garde centres of Europe, Escher's art is seen as having a resonance with Surrealism in its use of fantasy and the metamorphosis of forms so redolent of Hans Arp and Henry Moore. The illustrated work is an adaptation of one of his most famous paintings *Metamorphosis I and II*, which shows the metamorphosis of organic forms, in this case birds in flight. Much of his other work is concerned with the use of space, particularly in buildings, and the structuring of that space using mathematical principles.

MEDIUM

Woodcut printed in black and grey

SIMILAR WORKS

David Gascoyne, Illustration for Book Cover, *A Short History of Surrealism*, 1935

Maurits Cornelis Escher *Born* 1898 Leeuwarden, Netherlands

Died 1972

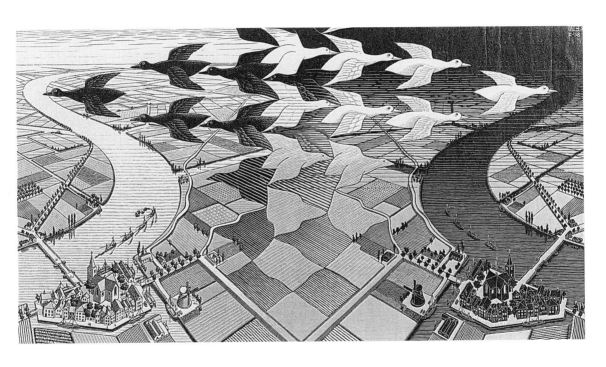

Prévert, Jacques

The Dove

Three Surrealists, Marcel Duhamel (1900–66), Yves Tanguy and Jacques Prévert shared accommodation in Montparnasse from 1922. The address of 54 rue du Château became significant as an important meeting place for the Surrealists; it was there, for example, that the Surrealist game of the *Cadavre exquis* was invented. Like Robert Desnos, Prévert was a poet but still enjoyed collage as a medium for expressing his ideas.

This collage demonstrates the political agenda of the Surrealists in their condemnation of Fascism. The smouldering volcano symbolizes the impending death and destruction of anything in its path. The two Teutonic knights stand at the summit and the foot of the volcano, ready to add their own might to that volcanic power. *The Dove*, a somewhat ironical title, has been partially metamorphosed into the ugly black eagle of the Third Reich. The viewer is confronted by the 'bird' with its dual role signalling the farewell of the dove and with it hopes of peace, and the arrival of the macabre black eagle and its impending doom. Its arrival from the heavens greeted by the waving Puritans hints ironically at its divinity and endorsement by Protestantism.

MEDIUM

Collage

SIMILAR WORKS

Paul Nash, *Landscape from a Dream*, 1936–39

Jacques Prévert *Born* 1900 Paris, France

Died 1977

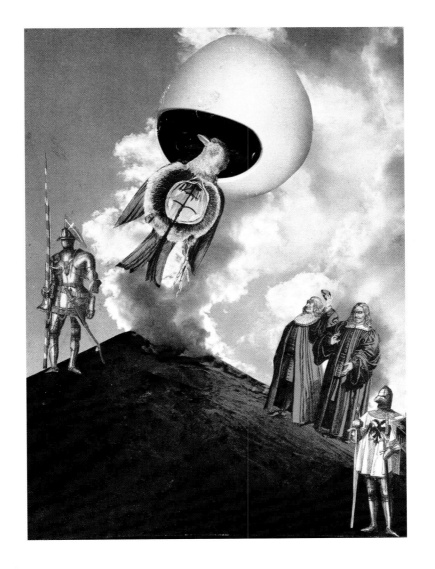

Paalen, Wolfgang

Paysage Meduse, 1937

Originally from Vienna, Wolfgang Paalen arrived in Paris in 1928 and joined the Abstractionist group, *Abstraction-Création*, later joining the Surrealists in 1935. At this time he developed a technique he called *fumage* in which he replicated the Surrealist ideals of Automatism by drawing on his canvas with the smoke from lighted candles. This method allowed him to create a very sombre nocturnal background as a foil to his more colourful mystical figures. His development of this technique reflected his own theories about what he called the 'super-conscious' or state of ecstasy, in which he saw Surrealism as a vehicle for its exploration.

In 1938 Paalen and others within Breton's Surrealist group helped to organize the Exposition Internationale du Surréalisme, at the Galerie des Beaux-Arts in Paris. This was an opportunity for the artists to show how creative and shocking they could be beyond their own work. Although remaining in contact with Ernst and Miró, Paalen left Europe for Mexico at the end of the Second World War, where he met and befriended the Mexican painter Diego Rivera (1886–1957). He remained in Mexico until his death in 1959, continuing to paint in a Surrealist manner using new experiments of what he termed 'multi-dimensional space'.

CREATED

Paris

MEDIUM

Mixed media

SIMILAR WORKS

Wilfredo Lam, *The Jungle*, 1943

Wolfgang Paalen *Born* 1905 Vienna, Austria

Died 1959

Dominguez, Oscar

Lion, Bicycle, 1937

Another artist who brought a new dimension to Automatism during the 1930s was Oscar Dominguez, a painter from Tenerife who held a 'surrealist' exhibition in his native country in 1933 without having met any of its practitioners or even having been to Paris. Dominguez fully embraced Surrealism after meeting Breton and Eluard in Paris the following year and introducing them to his Automatism, which he called decalcomania. The process involved the casual or 'accidental' blotting of a gouache drawing, into an alternative, sometimes sexual, image. His most remarkable paintings from this period are the fantastical landscapes imbued with a sense of lunar or planetary terrain. In the illustrated 'chance' painting, Dominguez has used decalcomania to produce a metamorphosis of beast and machine.

Dominguez continued to be an influential figure within the Surrealist group, participating in the international shows of Surrealism in Copenhagen and London during 1936, and Tokyo, Paris and Amsterdam the following year. He was also represented at the Dada and Surrealism exhibition held at the Museum of Modern Art in New York in 1936. Like a number of other artists belonging to the Surrealism group, Dominguez also produced Surrealist objects for exhibition.

CREATED

Paris

MEDIUM

Ink on paper

SIMILAR WORKS

Joan Miró, *Personage, oiseau, étoile*, 1942

Oscar Dominguez *Born* 1906 La Laguna, Spain

Died 1958

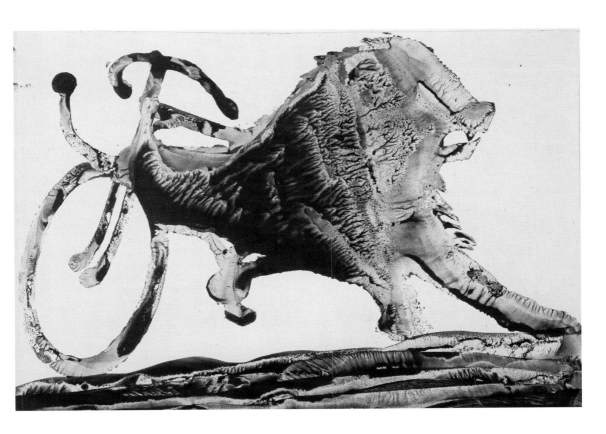

Dalí, Salvador

Metamorphosis of Narcissus, 1937

In many ways it is Salvador Dalí who does more to engage with and depict Freud's ideas in Surrealist painting. Dalí became interested in paranoia as a subject for painting following the publication of a translation of Freud's work on the subject in 1932. A younger psychoanalyst, Jacques Lacan, who had recently published his own thesis on paranoia, supported Freud's ideas. Lacan contributed articles on the subject to the Surrealist magazine, *Minotaure*, in 1933 and many of his ideas found a resonance with the Surrealists, particularly Dali who had already written on the subject as early as 1930.

In *Metamorphosis of Narcissus* Dalí seeks to explain the correlation between narcissism and paranoia. According to Freud there are two forms of narcissism: normal and abnormal. The first emanates from childhood in the development of the ego, or the search for the mirror self. In normal development the narcissistic libido is transferred to other people in adulthood although part of that self-love is retained. Abnormality occurs when that libido is withdrawn and directed back to the self, resulting in the erotic attachment to the person's own ego. This can lead to a regression of infantile narcissism that can cause paranoia.

CREATED

Paris

MEDIUM

Oil on canvas

SIMILAR WORKS

René Magritte, *Not to be Reproduced*, 1937

Salvador Dalí *Born* 1904 Figueras, Spain

Died 1989

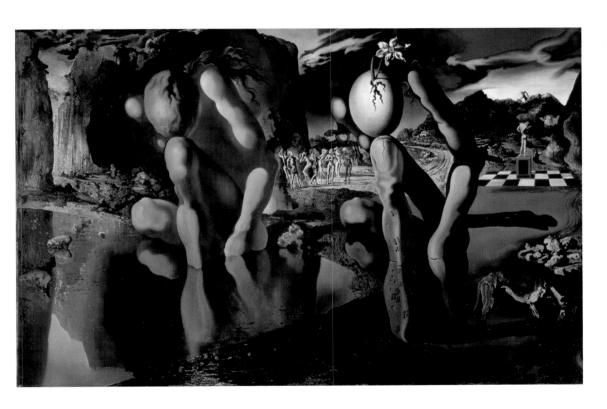

Nash, Paul

Circle of Monoliths, 1937

The landscape artist Paul Nash had already established his credentials as a Surrealist in his evocative paintings of the First World War such as the famous *We Are Making a New World*, a reminder of the utter devastation and futility of war. Like so many of his artistic contemporaries, the effects of war changed the way that he considered art, its purpose and its modes of representation. As Nash remarked, 'I was launched into a turbulent sea where the dramatic adventures of life and art were breaking anew'.

Nash's interest in Georgio de Chirico's metaphysical paintings during the late 1920s led him to embark on a series of pictures, most notably *Landscape at Iden* (1929), in which he explored the depiction of landscape that was not just devoid of people, but quite obviously and quite deliberately so. His pictures depict nature not crushed by modernity but displaced by it, suggesting not Arcadian sentiment but a landscape of evocative memories and associations. For Nash one of the enduring features of the English landscape, which he repeatedly used as a motif, were the pre-historic monolithic structures such as Stonehenge. He saw these as timeless and certain to outlive mankind.

CREATED

England

MEDIUM

Oil on canvas

SIMILAR WORKS

Max Ernst, *Garden Aeroplane Trap*, 1935

Paul Nash *Born* 1889 London, England

Died 1946

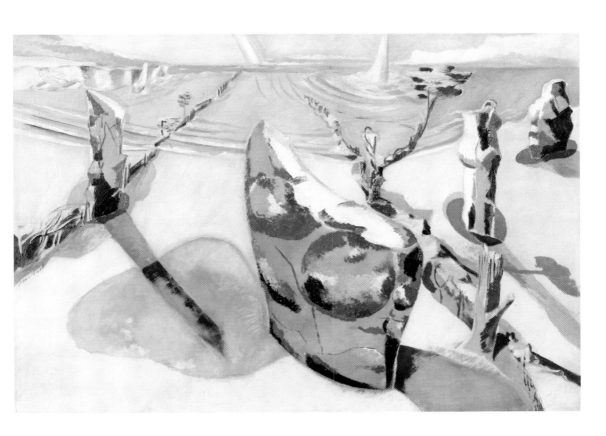

Mednikoff, Reuben

Two Children and a Monster, 1938

Courtesy of Private Collection/www.bridgeman.co.uk/© Estate of Reuben Mednikoff 2005

Although there was not an official or structured Surrealist group in Britain in the same way as that organized by André Breton in Paris, a small group of enthusiasts including the artists Paul Nash and Henry Moore, the artist/collector Roland Penrose and the critic Herbert Read decided to hold the first ever international Surrealist exhibition in June 1936. They persuaded Breton to open the exhibition accompanied by Salvador Dalí, who appeared wearing a diving suit. The poet Dylan Thomas was also present, accosting the visitors with cups of water containing boiled string and asking them, 'Do you prefer it weak or strong?'.

Among the British artists shown, Breton singled out Reuben Mednikoff and Grace Pailthorpe for particular praise because of their daring explorations of the subconscious. After meeting at a party, the two worked together; she was 52 and he was 28. Grace had studied medicine and become a surgeon, but was more interested in Freudian psychology. Mednikoff was a trained artist. His interest in psychoanalysis led him to discuss all his fantasies, repressed desires and anxieties with her, particularly his castration complex. Grace began painting as well and their pictures are some of the most vivid and disturbing works of Surrealism.

CREATED

England

MEDIUM

Oil on panel

SIMILAR WORKS

Salvador Dalí, *Le Sommeil*, 1937

Reuben Mednikoff *Born* 1906 England

Died 1976

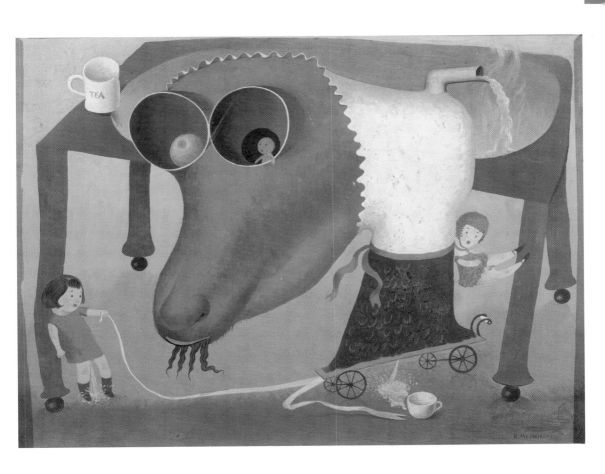

Penrose, Roland
Bien vise ('Good Shooting'), 1939

Perhaps the most vociferous campaigner for Surrealism in Great Britain, both in politics and as an artist, at least before the Second World War, was Roland Penrose. After completing a Cambridge education he worked in Paris as a painter until he returned to London in 1935, where he set up the British Surrealist group the following year. During his time abroad he counted among his friends and close acquaintances, Picasso and Max Ernst. He was an enthusiastic collector of the work of the European Surrealists, most notably René Magritte, Salvador Dalí, Joan Miró and of course Picasso. In 1938 he also purchased Paul Eluard's entire collection of Surrealist works. Much of this work and his own collection formed the basis for exhibitions on Surrealist works shown in London. Penrose was to become one of the founder members of the Institute of Contemporary Arts in London, introducing many aspects of modern art to Britain.

Bien vise demonstrates Penrose's commitment to Surrealism. Although a painting it is based on the ideas of collage, opening up the spaces in the picture plane to reveal others. The violence of the rape and shooting and the subsequent release from her bondage reveal her mind's salvation and liberation into tranquillity, unattainable within her mortal life.

CREATED

England

MEDIUM

Oil on canvas

SIMILAR WORKS

René Magritte, *Titanic Days*, 1928

Roland Penrose *Born* 1900 London, England

Died 1984

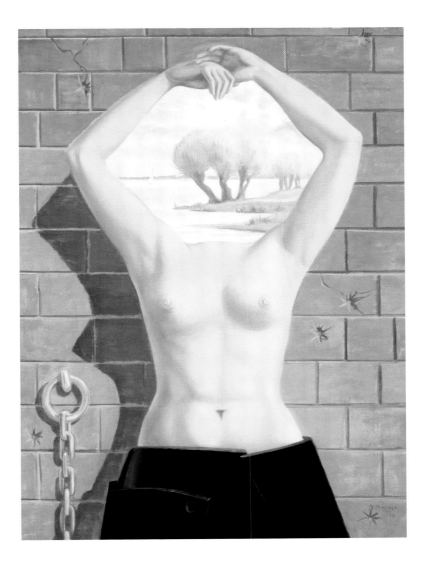

Agar, Eileen

Muse of Construction, 1939

Eileen Agar and her art were thrust into the spotlight at the International Surrealist Exhibition in London in 1936, when she was invited by Roland Penrose to exhibit three of her works there. As she wryly remarked, 'One day I was an artist exploring personal combinations of form and content, and the next day I was calmly informed I was a Surrealist!'. Her inclusion demonstrated the Surrealist commitment to highlight the 'otherness' of the constructed femininity in a patriarchal society, with Agar herself appearing to endorse its ethos rather than to make any kind of proto-feminist statement.

Agar's work is about using feminine sexual archetypes and stereotypes in a symbolic way that had a resonance with the work of André Masson. Like Masson's, her work is also linked to Automatism, as shown in *Muse of Construction*. Her use of playful lines and shapes reveals the 'birth' of a genderless human form. In traditional painting the female muse is a motif for the (male) painter and the (bourgeois) viewer of his finished work. The viewer is therefore looking at the muse 'constructed' by the artist. *Muse of Construction* is a comment on this 'birth' of the image, refusing to let the viewer's eye settle through the picture's restless tirade of colours and disparate forms.

CREATED

England

MEDIUM

Oil on canvas

SIMILAR WORKS

André Masson, *Gradiva*, 1939

Eileen Agar *Born* 1899 Buenos Aires, Argentina

Died 1991

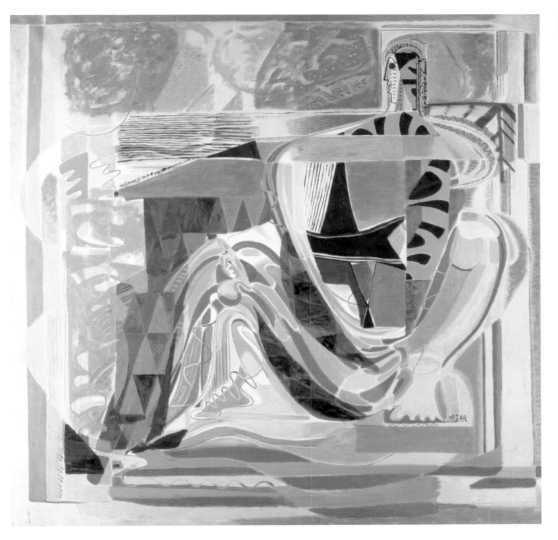

Labisse, Félix

Main surréaliste

The theme of metamorphosis is continually repeated in Surrealism, not just in the biomorphic shapes of Hans Arp and Henry Moore, but also by the work of artists such as Félix Labisse. Labisse frequently depicted human and plant forms in various stages of transmutation. Examples are *The Inconstancy of Jason* (1955) in which tree trunks and humans are transmuted, or the illustrated *Main surréaliste* ('Surrealist Hand').

Labisse was not a member of the Surrealist group but, as a friend of Robert Desnos and René Magritte as well as André Breton, he was attuned to the basic tenets of Surrealism and sympathetic to its aims. He was however a 'super-real' painter, rather than a Surrealist, a painter of a specific image rather than the unimaginable. An example can be seen in his *Charlotte Corday* (1942), a modern portrait of Marat's assassin. The image is a subversion of Jacques-Louis David's famous portrait of the dead Marat in his bath, a political portrait of the brutality of the Republican cause. Labisse's painting depicts a naked Corday in the hip bath, conforming to the Surrealist virtue of *amour fou* or the 'extravagant love' of the woman as guardian goddess.

MEDIUM

Oil on canvas

SIMILAR WORKS

René Magritte, *The Natural Graces*, 1963

Félix Labisse *Born* 1905 France

Died 1982

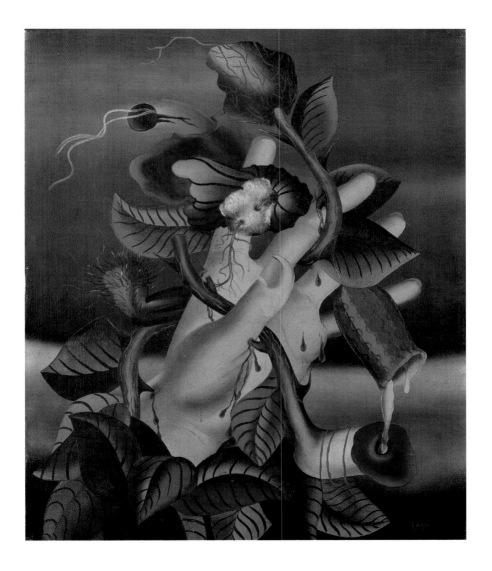

Bellmer, Hans

Portrait of Max Ernst at Les Milles, 1940

Hans Bellmer is often reviled as a misogynistic pornographer, images of eroticized dismembered dolls being his stock-in-trade that are usually misunderstood and misrepresented as perverse fantasies of paedophilia. This misunderstanding has some justification, however, since according to the artist they are representations of his repressed desire for his 15-year-old cousin, which he sublimated in his creation of the doll. Bellmer justified their making, highlighting a key aspect of the Surrealist idiom, the continual state of tension that exists in desire, its inspiration, rejection and repression. The idea for the 'dolls' came to Bellmer after seeing a stage production of *The Tales of Hoffman* in which two of the principle characters are the automaton doll Olympia and its creator Coppelius who is trying to bring her to life.

This unusual homage to Max Ernst is from an unsettling period in Bellmer's life. His wife died in 1938 and he subsequently decided to leave the oppressive Nazi regime of his native Germany. He was also escaping the tyranny of his father's brutal behaviour, which was in sympathy with Fascist aims. Such brutality had a resonance with the infamous Marquis de Sade whom Man Ray had portrayed using a similar brick-like mosaic patterning for Sade's face.

CREATED

Paris

MEDIUM

Oil on canvas

SIMILAR WORKS

Man Ray, *Imaginary Portrait of D.A.F. de Sade*, 1940

Hans Bellmer *Born* 1902 Kattowicz, Germany

Died 1975

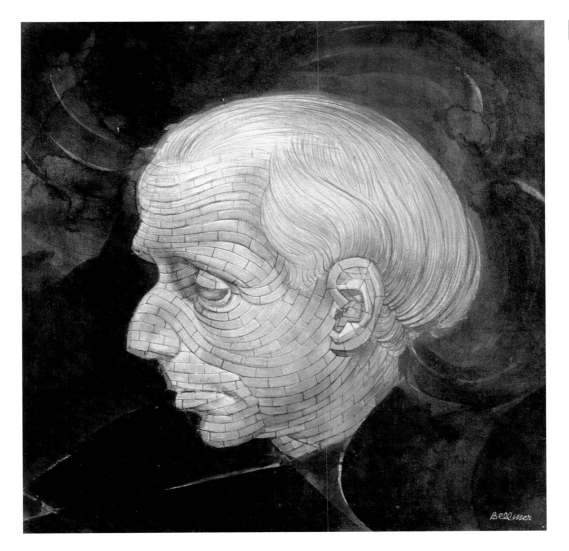

Oelze, Richard

With the Zufalligen Family, 1955

Courtesy of Private Collection/www.bridgeman.co.uk/© Estate of Richard Oelze

Surrealism did not find a home in Germany. With the end of the Dada period in Cologne in 1922, *Neue Sachlichkeit* or 'New Objectivity' filled Germany's avant-garde void. Its main proponents were Otto Dix (1891–1969) and George Grosz (1893–1959) whose deeply cynical paintings of Social Realism seemed to encapsulate the mood of Germany in the 1920s and early 1930s, conditioned by the aftermath of the First World War. The movement was deeply critical of evil governments and operated throughout the major cities of Germany until it was declared 'degenerate' by the Nazi government in 1935, when it was disbanded.

Richard Oelze became interested in *Neue Sachlichkeit* painting before seeing a number of Surrealist works by Max Ernst. Following the Nazi persecution of 'degenerate' art, Oelze moved to Paris, staying until 1936 and working with the Surrealist movement. During this period he worked on the theme of dreams and premonitions, his work reflecting the potential of transmutation between animals and plants, plants and humans and humans into animals. His most famous work, now in the Museum of Modern Art in New York, is *Expectation* (1936) in which a group of people are standing and looking at the darkening sky, reflecting his and many people's concerns about the impending doom of Nazi oppression.

SIMILAR WORKS

Roberto Matta, *Inscape (Psychological Morphology)*, 1939

Richard Oelze *Born* 1900 Magdeburg, Germany
Died 1980

Lam, Wifredo

The Great Jungle or *Light in the Forest*, 1943

In 1926 André Breton wrote an essay on Surrealism and revolution, in which he was highly critical of the cultural values of France, namely the continued adherence of the Greco-Roman tradition that was prejudicial to other non-Western cultures. Breton's interests in 'otherness' extended beyond issues of 'the feminine' to include issues of French colonialism and the misappropriation of its motifs in art. At the Colonial Exhibition of 1931, held in Paris, Breton produced a protest pamphlet designed to disrupt the West's self-assured arrogance and its misrepresentation of 'the primitive'.

Breton and others within the Surrealist movement made a scientific study of ethnography and anthropology, and from the 1930s, many of the members travelled to learn from other cultures at first hand. Others, such as Wifredo Lam who was Cuban but of mixed ethnicity, already had a very clear idea of ethnography in his paintings, which drew on those traditions. As a child, Lam had been initiated into the religious system of Santeria, a combination of African tribal belief and Catholicism, which originated in the Caribbean. Lam's first exhibition in 1938 was enthusiastically received by his contemporaries, particularly Picasso, who had acted as mentor to him.

MEDIUM

Oil on canvas

SIMILAR WORKS

René Magritte, *The Encounter*, 1929

Wifredo Lam *Born* 1902 Sagua la Grande, Cuba

Died 1982

O'Keeffe, Georgia

Pelvis with the Distance, 1943

Although the American artist Georgia O'Keeffe was not a Surrealist and did not belong to a group, there are aspects of her work that lend themselves to its aesthetic. O'Keeffe belonged to a loose collective of artists known as 'Precisionists' that flourished in America during the 1920s. They were not a formal group, but sometimes exhibited together, displaying works that were devoid of humanity and lacking any kind of social comment. They touch base with the so-called Magic Realism of artists such as René Magritte who used photographic naturalism in strange juxtapositions to convey a feeling of the uncanny. The term 'Magic Realism' gained currency in America, particularly Latin America, following an exhibition in 1943 at the Museum of Modern Art in New York called American Realists and Magic Realists, in which Alfred Barr, the museum's director, referred to the artists who, 'try to make plausible and convincing their improbable, dreamlike or fantastic visions'. Barr was a significant figure in developing American Modernism, through his acquisitions of key works of European modern art for the museum.

O'Keeffe's brand of Magic Realism was inspired by the photographic use of soft focusing of the landscape, a technique she had learned from her husband, the photographer Alfred Stieglitz.

CREATED

New Mexico

MEDIUM

Oil on canvas

SIMILAR WORKS

Paul Nash, *Landscape of the Summer Solstice*, 1943

Georgia O'Keeffe *Born* 1887 Wisconsin, USA

Died 1986

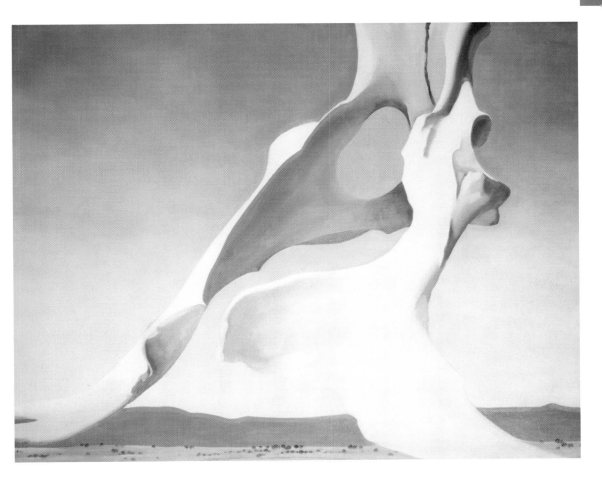

Masson, André

La sibylle dictant—La sibylle aux présages, 1945

Courtesy of Christie's Images Ltd/© ADAGP, Paris and DACS, London 2005

Writing in 1939, André Breton referred to André Masson's art as a 'chemistry of the intellect'. This followed a period of crisis in the Surrealist movement following the publication of Breton's *Le Second Manifeste du surréalisme* in 1929 in which he expelled Masson from the group. Breton had formulated a new search for a 'state of mind in which reality and the imaginary cease to be perceived as contradictory' and in which Automatism ceases to be the sole preoccupation for Surrealism. In essence he wanted a more concerted effort towards an exploration of the relationship between dreams and the unconscious.

Until that rift Masson's paintings and drawings had dominated Surrealism. One of his 'automatic' techniques involved the use of glue randomly and 'unconsciously' painted on a surface, on to which sand was then sprinkled. After his reconciliation with Breton in 1937, Masson changed his style to a more traditional mode of representation akin to that of Salvador Dali. However, by 1939 and throughout the Second World War in exile in the United States, Masson returned to the 'automatic' paintings that were his hallmark. During his stay in America he sought local inspiration and *La sibylle dictant—La sibylle aux présages* demonstrates his use of the vibrant autumnal colours of Connecticut where he was living.

CREATED

Connecticut, USA

MEDIUM:

Tempera and sand on canvas

SIMILAR WORKS

Arshile Gorky, *Painting*, 1945

André Masson *Born* 1896 Balagny-sur-Thérain, France

Died 1987

Tanning, Dorothea
The Friend's Room, 1950–52

Courtesy of Private Collection/www.bridgeman.co.uk/© ADAGP, Paris and DACS, London 2005

After visiting the Fantastic Art, Dada, Surrealism exhibition in New York in 1936, Dorothea Tanning left her home town of Chicago, where she had studied art, moving to New York to become a Surrealist artist.

Due to the Nazi persecution of 'degenerate' art and their subsequent occupation of Paris, a number of the European Surrealists found refuge in America, which became a temporary home for Surrealism during the 1940s. After meeting one of the exiled Surrealists, Max Ernst, in 1942, Tanning became one of their number and produced a selection of works that were subsequently exhibited in 1944 at the Julien Levy gallery in New York. The catalogue foreword was written by Max Ernst (whom she later married), who stated, 'Precision is her mystery. This precision has allowed her to attain the power to guide us with the confidence of a sleepwalker through the real world as well as through the imagination'. Tanning's images are based on her childhood experiences with her two sisters in Chicago, in which her prepubescent characters, imbued with a sense of nocturnal fear, are in revolt against a puritanical upbringing.

CREATED

Probably Sedona, Arizona USA

MEDIUM

Oil on canvas

SIMILAR WORKS

Conroy Maddox, *The Conspiracy of a Child*, 1946

Dorothea Tanning *Born* 1910 Illinois, USA

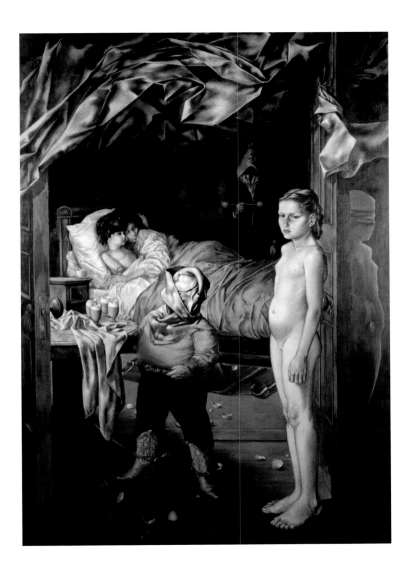

Gorky, Arshile
Untitled, 1946

Arshile Gorky was an unashamed plagiarist who nevertheless helped to influence the postwar American art of the Abstract Expressionists. Gorky borrowed very heavily from the Surrealist work of Joan Miró and more particularly Roberto Matta in developing his idiosyncratic style of painting. His work combined Automatism with compositional discipline and saw him tirelessly reuse the same composition, only altering the paint handling or use of colour. To the untrained eye, Gorky's work appeared abstract, with no reference to outside sources. But his use of complex washes of paint often hid the detailed and structurally relevant drawings underneath. As with much American work from this period on, Gorky acted as his own apologist, creating an aura about him and his work based on myth. As an Armenian refugee escaping Turkish tyranny at the end of the First World War, Gorky claimed to have been a disciple and student of Wassily Kandinsky (1866–1944), even to the Museum of Modern Art's acquisitions committee. He also claimed to be a relative of the Russian writer Maxim Gorky, from whom he 'borrowed' his name, not realizing ironically that his name was in fact a pseudonym.

CREATED

New York

MEDIUM

Oil on canvas

SIMILAR WORKS

Joan Miró, *Constellation: Awakening at Dawn*, 1941

Arshile Gorky *Born* 1904 Khorkum, Armenia

Died 1948

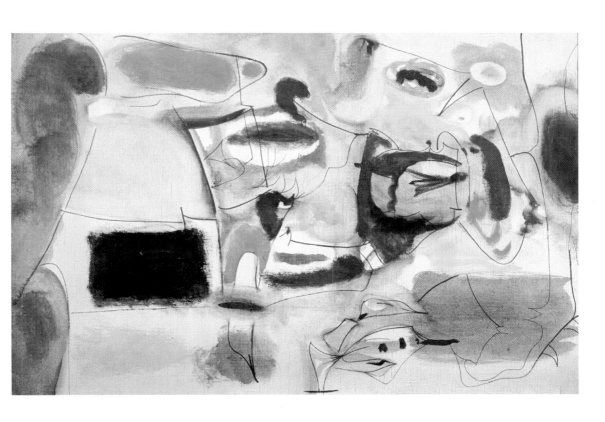

Carrington, Leonora
Plain Chant, 1947

In her book *En bas* ('Down Below'), published in 1943, Leonora Carrington related the trauma of her incarceration at a Spanish sanatorium for the insane in 1940. She had escaped to Spain following the arrest and detainment, as an enemy alien, of her then lover Max Ernst, with whom she had been living in Paris since 1937. Far from regarding the experience negatively, Carrington regarded it as a godsend, writing of 'the absolute necessity of having a healthy body to avoid disaster in the liberation of the mind'.

Women artists, even those within the Surrealist coterie, still found themselves outside the circle that formulated Surrealist theories, though they nevertheless contributed significantly to its language. The erotic violence in the art of their male counterparts was replaced by an art of magical fantasy that still managed to shift the depiction of the female within a male-dominated movement. In place of depicting woman as 'other', as her male contemporaries had done, women artists such as Carrington depicted woman as 'self', anticipating the female artists of the 1970s by some 40 years or so. Carrington's *Self Portait* (1938) is the beginning of that process by other women Surrealists such as Frida Kahlo (1907–54).

CREATED

Mexico

MEDIUM

Oil on canvas

SIMILAR WORKS

Emmy Bridgwater, *Transplanted*, 1947

Leonora Carrington *Born* 1917 Lancashire, England

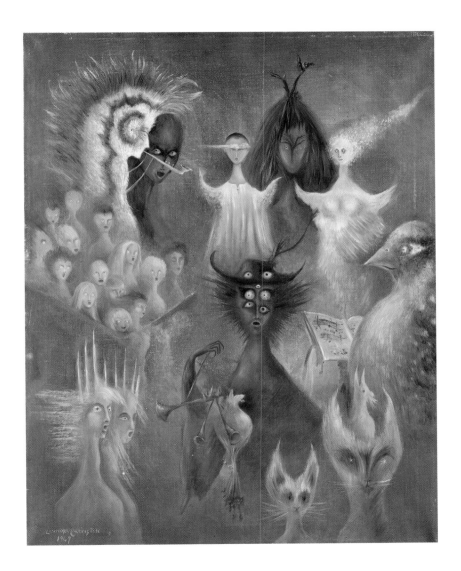

Matta, Roberto
Composition, 1956

In 1939 the Chilean artist Roberto Matta along with the other Surrealist émigrés left Europe bound for New York to flee the Nazi persecution. This followed a period of about six years in Europe, where he worked at different times alongside Le Corbusier (1887–1965) and Walter Gropius (1883–1969). His work at the Spanish Republican Pavilion at the Paris International Exhibition of 1937 brought Matta face to face with Picasso's painting *Guernica* (1937), whose scale and aesthetic had a profound effect on him.

During his exile Matta began to paint Surrealist works on a large scale, enjoying the success of his first exhibition at Pierre Matisse gallery in New York. André Breton reviewed the show in which he wrote, 'Matta remains extremely exacting towards himself, never remaining contented with the extraordinary gifts with which nature has endowed him'. Three years later Breton was writing again of his protégé, 'Matta is concerned with representing the inner man and all the elements that go to make him up. Not with the ridiculous task of showing his body in relation to the objects immediately surrounding him'. Matta returned to Europe in 1948, an artist who no longer enjoyed the support of the Surrealists or the support of the powerful American critic Clement Greenberg, who was ready to embrace the new art of Surrealism's successor, Abstract Expressionism.

CREATED

Europe

MEDIUM

Oil on canvas

SIMILAR WORKS

Desmond Morris, *Endogenous Activities*, 1950

Roberto Matta *Born* 1911 Santiago, Chile

Died 2002

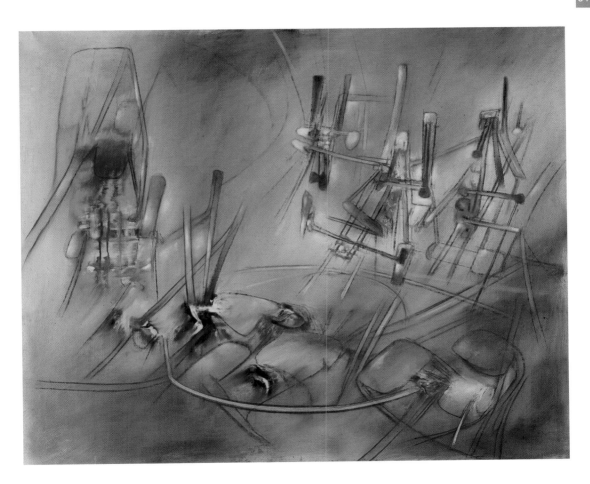

Surrealism

Influences

Picabia, Francis

L'Oeil cacodylate ('The Cacodylic Eye'), 1921

Courtesy of Musée National d'Art Moderne, Centre Pompidou, Paris, France, Lauros/Giraudon/www.bridgeman.co.uk/© ADAGP, Paris and DACS, London 2005

Francis Picabia, like most Dada artists, is difficult to classify in terms of a 'style' since the type of art that they produced was designed to be an 'anti-style'. There are disputed theories as to how Dada got its name, but there is no doubt about what it stood for. It was essentially art's iconoclast, which debunked the hierarchical canons of reason, taste and discipline in society. Dada was against reason and refused to conform to bourgeois sensibilities; it was based on chance, serendipity and anarchy, and was designed to shock and provoke anger among the 'chattering classes' by being nonsensical, outrageous or just plain silly.

During the First World War, Picabia jumped military ship while staying in New York on route to Cuba and became a deserter. While there he met Marcel Duchamp (1887–1968) who introduced him to the concept of the 'ready-made' work of art. It was while he was in Barcelona from 1916, however, that he started to publish the journal *391* in which he developed a Dada language. *L'Oeil cacodylate* is a large work that depicts the names of several Dada artists in a graffiti-like way. The (bourgeois) viewer is almost compelled to read the names in much the same way as he would 'read' a conventional painting, to try and make sense of it. The 'stinking' eye alludes to the eye of the bourgeois beholder.

MEDIUM

Oil on canvas

PERIOD/MOVEMENT

Dada

SIMILAR WORKS

Raoul Hausmann, *Dada Cino*, 1920–21

Francis Picabia *Born* 1879 Paris, France

Died 1953

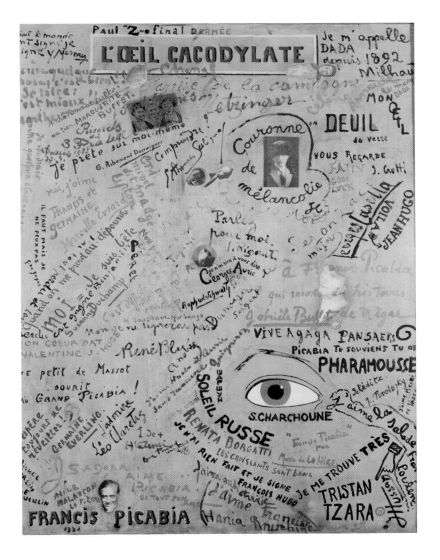

Picabia, Francis

Machaon, c. 1926–27

Once the impetus of Dada had been lost and 'institutionalized' within the more disciplined Surrealist movement under André Breton (1896–1966), Francis Picabia left Paris and settled in the south of France. He began to produce works that were based on more iconic ideas, which in fact subverted his own previous avant-garde challenges and were a foil to the Surrealists' aspirations of exploring the subconscious. He used recognizable motifs and appropriated aspects of the traditional art of the Renaissance.

In this work, which is essentially a collage, Picabia has used a number of recognizable motifs. The background is a map of Europe containing images of a blonde woman, a butterfly and two masked naked lovers. The butterfly was used in Christian paintings to symbolize the resurrected soul. The lovers appear in a number of paintings from the Renaissance on, and the lone woman appears in countless paintings as the object for man's consumption. This is Picabia's take on European Western art. His repeated use of the butterfly motif is possibly referring to his own transformations and the ever-changing repertoire of work at this time. His work of this period was an important precursor to the post-Second World War Pop artists both in Britain and America.

MEDIUM

Watercolour, pen and ink on paper in a red box frame with butterflies

PERIOD/MOVEMENT

Dada

SIMILAR WORKS:

André Breton, *Objet-poème*, 1937

Francis Picabia *Born* 1879 Paris, France

Died 1953

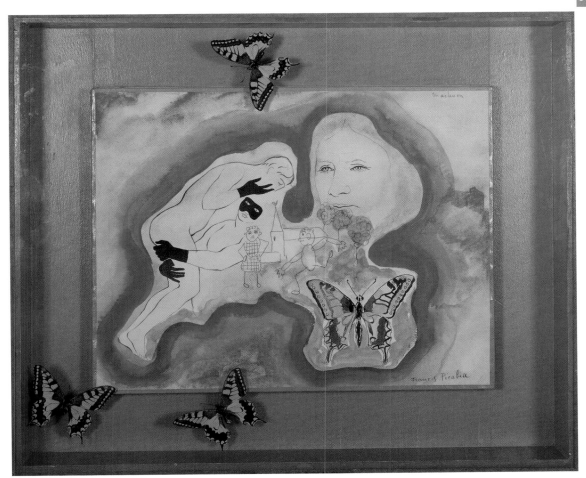

Picabia, Francis
Spanish Night, 1922

Courtesy of Private Collection, Lauros/Giraudon/www.bridgeman.co.uk/© ADAGP, Paris and DACS, London

Since Edouard Manet's (1832–83) scandalous showing of his painting *Olympia* at the Salon in 1863, artists have been depicting woman as 'other', the object of a man's gaze and desires. In the last quarter of the nineteenth century, women were depicted by some male artists as willing participants in this scenario (Pierre-Auguste Renoir and Paul Gauguin) and by some (albeit ambiguous) as victims of a bourgeois patriarchal society (Manet and Edgar Degas, 1834–1917). At the turn of the last century there were artistic moves across Europe, particularly those allied to Symbolism, to portray the woman as *femme fatale* (Gustav Klimt and Gustave Moreau). The depiction of woman as 'other' therefore became a concern for the Surrealists prior even to the publication of the *Manifesto of Surrealism*. Dada ideas had already been formulated that suggested the depiction of woman as 'other', woman as the object of men's gaze and desires. In this work, Picabia depicts an unrequited advance by a clothed man to a naked woman, specifically highlighting the targeted genital zones of his victim. The allusion of defilement in this picture continued to be a subject for the Surrealists such as René Magritte (1898–1967) and had already been alluded to in Edgar Degas' *Interior* of 1868–69.

MEDIUM

Oil on canvas

PERIOD/MOVEMENT

Dada

SIMILAR WORKS

René Magritte, *Gigantic Days*, 1928

Francis Picabia *Born* 1879 Paris, France

Died 1953

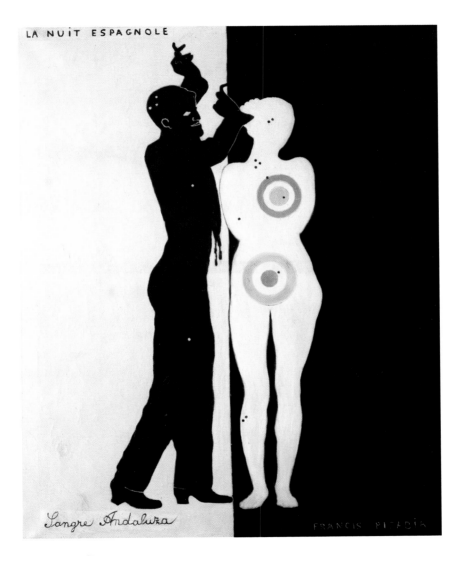

Schwitters, Kurt

Merzzeichnung 229, 1921

Courtesy of Loan to the Hamburg Kunsthalle, Hamburg, Germany/www.bridgeman.co.uk/© DACS 2005

The use of collage was adapted from the Cubists, particularly Pablo Picasso (1881–1973) and Georges Braque (1882–1963), whose art the Dadaists now considered bourgeois rather than avant-garde. Apart from Max Ernst (1891–1976) the greatest exponent of the use of collage for Dada was Kurt Schwitters, who turned his back on Expressionist painting after meeting Hans Arp (1887–1966) and became the sole representative of Dada in Hanover. His own style of collage, which he called *Merz*, used detritus collected from the street, including bus tickets, tin lids and cigarette stubs. It is often described as Abstract Assemblage. Schwitters was like all modern artists exploring Charles Baudelaire's ideas of modernity expressed half a century before as, 'the ephemeral, the fugitive, the contingent, the one half of art whose other half is the eternal and immutable'.

His use of detritus as collage, or as he called it *Merzbild* and its veneration as a medium alongside that of paint, was to be an important contribution to the post-Second World War generation of Dadaists in America, such as Robert Rauschenberg (b. 1925) and Jasper Johns (b. 1930) who paved the way for the subsequent generation of Pop Art.

CREATED

Hanover

MEDIUM

Paper and textile collage on card

PERIOD/MOVEMENT

Dada (*Merz*)

SIMILAR WORKS

Max Ernst, *Massacre of the Innocents*, 1921

Kurt Schwitters *Born* 1887 Hanover, Germany

Died 1948

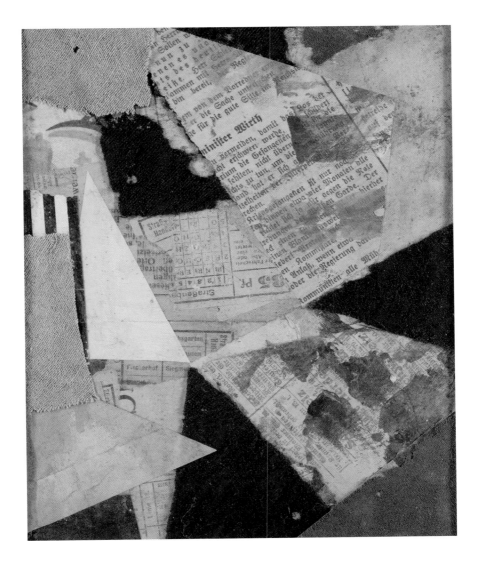

Schwitters, Kurt

Composition, 1930

From about 1922, and following his experiments with *Merzbild*, Schwitters began to be influenced by the Dutch *De Stijl* of Theo van Doesburg (1883–1931) and the Russian Constructivism of El Lissitzky (1890–1941). Schwitters began producing a magazine called *Merz* in 1923 and many of its subsequent issues contained articles on these two styles. His own compositions of this period are much more rectilinear in style than previously, although he stopped short of the harsh geometrical forms of El Lissitzky, maintaining a more fluid and organic approach to his collages.

The setting up of his own advertising and design agency in the mid 1920s also made Schwitters' influence important in the promotion of new typography and product identity in Germany, particularly for companies such as Pelikan Inks. His work in this regard was in line with the new designs emanating from the Bauhaus, which had been also influenced by El Lissitsky and the *De Stijl* group. The last eight years of Schwitters' life were spent in England making collages mainly from old commercial journals, including popular images from American magazines. His work had important implications for British Pop artists such as Richard Hamilton (b. 1922).

CREATED

Hanover

MEDIUM

Collage on paper

PERIOD/MOVEMENT

Dada (*Merz*)

SIMILAR WORKS

Max Ernst, *The Voice of God the Father*, 1930

Kurt Schwitters *Born* 1887 Hanover, Germany

Died 1948

Man Ray
Aviary, 1919

Modern art arrived in America with the famous 'Armoury' exhibition, held in New York in February and March of 1913. Based on the two Post-Impressionist exhibitions held by Roger Fry in London, the Armoury show was more comprehensive in its coverage, which included works by Wassily Kandinsky (1866–1944) and Marcel Duchamp as well as showing a more detailed collection of Georges Braque's and Pablo Picasso's Cubist works. Its subsequent tour of two other cities in America provided an opportunity for over 300,000 people to see the works and ensured that European, particularly Parisian, art was made known to a receptive new audience. The Armoury show transformed the art market and marked the arrival of modernism in America.

One of the visitors to the exhibition who was greatly influenced by its content was Man Ray, a New Yorker who had already been introduced to European art of the avant-garde by his visits to Alfred Steiglitz's influential gallery, 291. Steiglitz was an inspirational photographer who influenced Man Ray in his aspirations to become a photographer. *Aviary* is based on a photographic studio session in which we see a mannequin in place of the usual fashion model. Man Ray already anticipates the use of mannequins in Surrealism.

CREATED

New York

MEDIUM

Gouache, pencil, pen and ink on cardboard

PERIOD/MOVEMENT

Dada

SIMILAR WORKS

Hannah Höch, *Da-Dandy*, 1919

Man Ray *Born* 1890 Philadelphia, USA

Died 1976

Man Ray
Le Violon d'Ingres, 1924

Although Man Ray had, with Marcel Duchamp, set up New York Dada movement in 1921, it was short-lived with the realization that Paris was where it was happening. Man Ray therefore made Paris his home for the next 20 years, becoming a society photographer and an integral part of the Dada and Surrealist circles around André Breton. He came into contact with writers and artists of the avant-garde including Jean Cocteau (1889–1963) and Pablo Picasso, as well as influential collectors such as Gertrude Stein.

Le Violon d'Ingres is a photograph that has been retouched to convey a number of associative meanings. The composition is based on a famous painting by the French Classical artist Jean-Auguste-Dominique Ingres (1780–1867), in which his sitter is located in a Turkish bath with her back to the viewer. The appropriation by Man Ray of the 'f' holes refers to the still-life works of Picasso and Braque in which musical instrument motifs were used. Man Ray is therefore commenting on the sterility and impotence of Cubism and its inability to imbue their works with life. The title also suggests the correlation between music-making and lovemaking so often alluded to in traditional painting.

CREATED

Paris

MEDIUM

Black and white photograph, retouched with Indian ink

PERIOD/MOVEMENT

Dada

SIMILAR WORKS

Claude Cahun, *Untitled*, c. 1925

Man Ray *Born* 1890 Philadelphia, USA

Died 1976

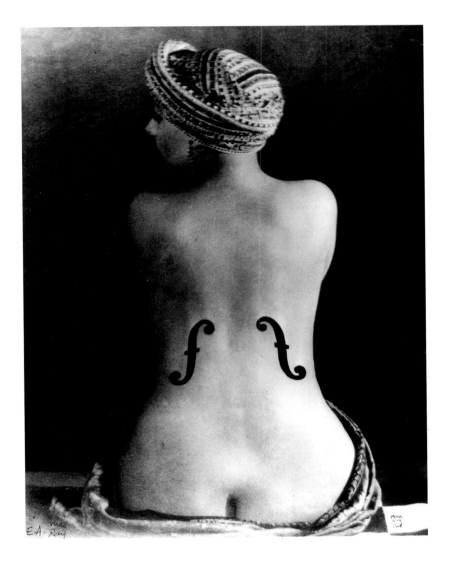

Man Ray

The Eye in the Keyhole – Composition II, 1928

Man Ray's entrée into Surrealism was in the production of his so-called Rayograms in which he exposed ordinary objects to photosensitive paper using a light source. By this means, objects and the shadows they cast appeared as white ghost-like silhouettes and, because of the high degree of chance and accident in the work, André Breton welcomed Man Ray's work as supportive of Surrealism's ideals.

However, Man Ray's work was not limited to photography and collage and he was involved in the difficulties associated with Surrealism and painting, which manifested themselves in the mid 1920s. These difficulties concerned the interpretation in paint of what was, after all, a literary movement. Following an opening salvo by the artist Max Morise (1903–73), Breton responded in a number of articles in the journal *La Révolution Surréaliste*, in which he laid out some of the criteria for Surrealist painting. Breton maintained that 'The eye exists in a primitive stage' and that 'a painting must open onto something beyond its appearance'. Man Ray's response to this were a number of paintings such as *The Eye in the Keyhole – Composition II*, in which Breton's criteria are met in this voyeuristic enigma that hints of the fetishistic object beyond the keyhole.

CREATED

Paris

MEDIUM

Oil on canvas

SIMILAR WORKS

Salvador Dali, *The Enigma of Desire*, 1929

Man Ray *Born* 1890 Philadelphia, USA

Died 1976

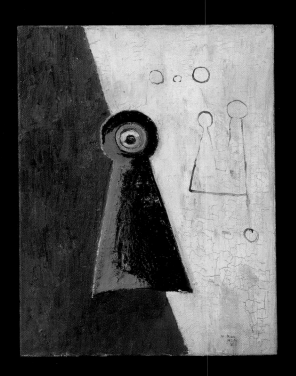

Hausmann, Raoul

The Spirit of Our Time, c. 1919–21

Far from embracing the positive dynamic attributes of Modernism as expressed by the Futurists in 1909, Dada artists such as Raoul Hausmann saw the effects of the city as detrimental to the human mind. The Dadaists, when considering issues of the freedom of the mind, also used Henri Bergson's philosophies, which had had such a catalytic effect on the development of Futurism. For Dada and Hausmann in particular, the minds of city dwellers were vacuous and their faces expressionless. For Hausmann, 'An everyday man only has the capacities chance has glued to his cranium; his brain is empty'. *The Spirit of Our Time* is the culmination of Hausmann's ideas of the rejection of progress, of the notion that nature can be tamed and of the rationality and arrogance of man.

These ideas gained currency in the early 1920s among the avant-garde Dadaists in Paris and Berlin, both individual hotbeds of Dadaism. However, the use of the term 'ism' was anathema to any self-respecting Dada who eschewed any kind of aspiration or acceptance of their work as 'art object'. For them, art conferred 'permanence' on a modern art that was by its nature ephemeral.

MEDIUM

Assemblage

PERIOD/MOVEMENT

Dada

SIMILAR WORKS

Georg Grosz, *Remember Uncle August the Unhappy Inventor*, 1919

Raoul Hausmann *Born* 1886 Vienna, Austria

Died 1971

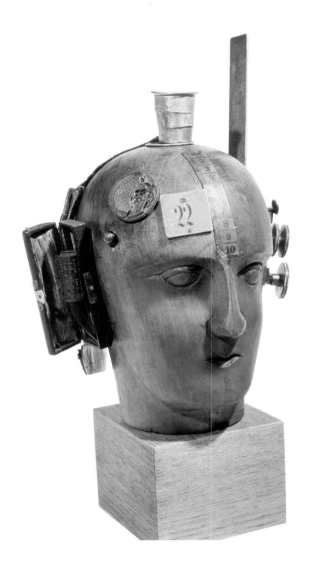

Hausmann, Raoul

P – 1921, 1921

Nowhere was more committed to the political ethos of Dada than Berlin, which in the 1920s was beginning to feel the effects of the socio-economic consequences of the Treaty of Versailles. This was fertile ground for the Dadaists who were seeking a return to the natural order, rather than the one that had been 'constructed' by the bourgeoisie and had led them to war. At the First International Dada Fair in 1920, Berlin Dadaists supported the ideas of the Russian Constructivists with the slogan 'Art is Dead' and showing work such as Hausmann's *Tatlin at Home* (1920), a collage of magazine photographs depicting the substitution of a machine for a man's brain.

In *P – 1921* Hausmann pays tribute to the mock-Romantic poem '*An Anna Blume*' published in 1919 by Kurt Schwitters in *Der Sturm*, which had proved very successful as a Dada work in Germany. Hausmann is also paying homage to the work of *De Stijl* who had been influential in the development of modern typography in Germany. In a parallel development in Berlin, Hannah Höch (1889–1978), an intimate friend of Hausmann, was instrumental in developing photomontage as a medium. Working with Hausmann on this medium, she provided a critique of Expressionism in Berlin that had by this time passed into an acceptable bourgeois art.

MEDIUM

Collage

PERIOD/MOVEMENT

Dada

SIMILAR WORKS

Kurt Schwitters, *MZ 439*, 1922

Raoul Hausmann *Born* 1886 Vienna, Austria

Died 1971

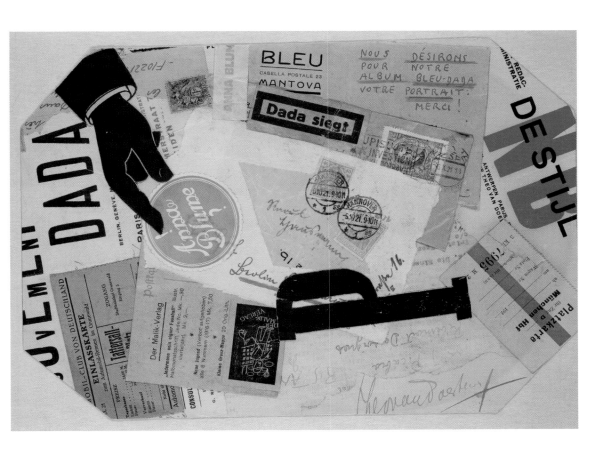

Duchamp, Marcel
Hat Rack and Urinal, 1917

Originally a Cubist painter, Marcel Duchamp declared that movement dead in 1913 with the first of his Dada statements: a bicycle wheel and forks mounted upside down on a stool. Although not then defined as a so-called 'ready-made' by Duchamp, he had begun to ask himself the question about the possibility of creating a work of art that was not motivated by aesthetic considerations. In 1917 Duchamp, now an exile living and working in New York, was invited to participate in the jury-less first exhibition of the Society of Independent Artists at the city's Grand Central Palace. Duchamp submitted a urinal purchased at a plumber's merchant, which he placed on its back, entitled *Fountain* and inscribed with the name of the 'artist' and date, 'R. Mutt 1917'. The exhibit, rejected by the organizing committee as not being a work of art, became a cause-célèbre. Duchamp's subsequent edict on the subject read:

> Whether Mr Mutt with his own hands made the fountain or not has no importance. He CHOSE it.
> He took an ordinary article of life, placed it so that its usual significance disappeared under the new
> title and point of view – created a new thought for that object.

This had a significant influence on aesthetic considerations in the twentieth century, particularly for conceptual art.

MEDIUM

Ready-made objects in metal and ceramic

PERIOD/MOVEMENT

Dada

SIMILAR WORKS

Man Ray, *Coat Stand*, 1920

Marcel Duchamp *Born* 1887 Blainville-Crevon, France

Died 1968

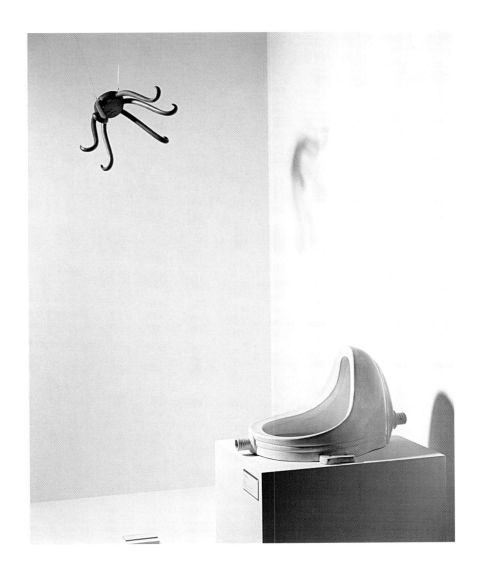

Duchamp, Marcel

L.H.O.O.Q, Mona Lisa with a Moustache, 1919/1930

During the second half of 1919, Marcel Duchamp returned to Paris, making contact again with members of the Parisian avant-garde, particularly the Dadaists around André Breton and Paul Eluard (1895–1952). Although there for only six months he made one of the most famous Dada statements by inscribing a reproduction of Leonardo da Vinci's *Mona Lisa* with the letters 'L.H.O.O.Q' and drawing a moustache on her face. The letters when spelt out in French read phonetically as *Elle a chaud au cul*, which translates as 'She's got a hot arse'.

This work constitutes an 'assisted' ready-made in which Duchamp would purchase an everyday item and re-appropriate its use as an art work, either by redefining its nomenclature or defacing it in some way as in the *Mona Lisa*. During the period of his exile in New York, Duchamp made a number of works that he defined as 'ready-mades' such as *In Advance of a Broken Arm*, in which he propped a snow shovel against the wall, and the 'assisted' *50cc of Paris Air* in which he presented an empty glass ampoule that he had purchased in Paris. Duchamp's work at this time was very radical and had a considerable influence on the artists of the 1960s such as Piero Manzoni (1933–1963).

MEDIUM

Ready-made postcard and pencil

PERIOD/MOVEMENT

Dada

SIMILAR WORKS

Francis Picabia, *Dada Portrait*, 1920

Marcel Duchamp *Born* 1887 Blainville-Crevon, France

Died 1968

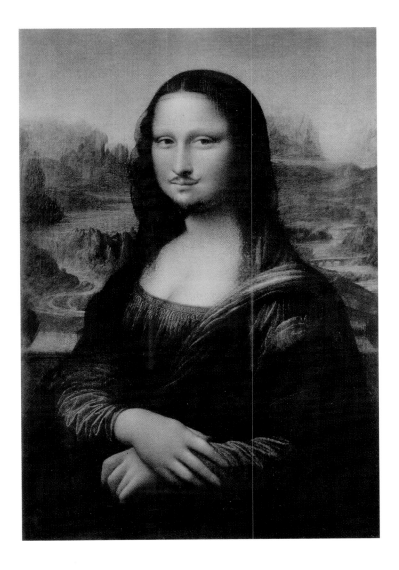

Duchamp, Marcel

Study for Given: 1. The Waterfall, 2. Illuminating Gas, 1946–49

In his final years spent in New York, Duchamp worked virtually in total secrecy on his last major project *Given: 1. The Waterfall, 2. Illuminating Gas* also known as *Etant donnés*. The work consists of a peepshow that is accessed through the cracks in a large old Spanish door. The 'show' consists of a naked woman lying on her back in some undergrowth and in the background is a waterfall. The viewer cannot see her face, but her legs are splayed to reveal her shaven genitalia. Her left arm is outstretched to the side and in her hand she is holding a lighted gas lamp. This incongruous and enigmatic vista is a more overt sexual display than *The Large Glass* alluded to. Duchamp spent some 20 years working on this in order to perfect the detail, for example using leather for the replication of human skin. During this period he made a number of preliminary sketches and the model of the woman shown here.

Although this work was produced in secrecy and not shown to the public until after Duchamp's death, the depiction of woman as victim continued to be a recurrent theme in Surrealism during the 1950s and 1960s.

CREATED

New York

MEDIUM

Painted leather on plaster relief

SIMILAR WORKS

Meret Oppenheim, *Cannibal Feast*, 1959

Marcel Duchamp *Born* 1887 Blainville-Crevon, France

Died 1968

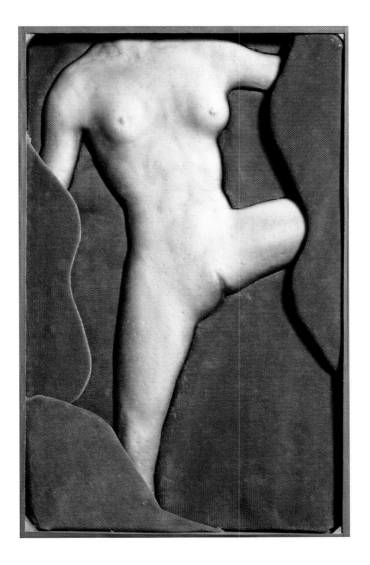

Duchamp, Marcel & Hamilton, Richard

The Bride Stripped Bare by her Bachelors, Even, 1915–23, replica 1965–66

Probably the most enigmatic of all Duchamp's work, *The Large Glass*, as it is also known, occupies a place in the pantheon of modern art. Originally conceived as a Cubist image in 1912, Duchamp became interested in the conflation of human and mechanical forms, a theme that his friend Francis Picabia enjoyed as a motif too. Duchamp also became interested in the juxtaposition of opposing sexual identities. *The Bride Stripped Bare by her Bachelors, Even* as a drawing was the culmination of those two thoughts.

In 1915 Duchamp began work on its construction as an object. It consisted of two glass panels divided across the centre with the bride's section at the top and the bachelors' below. Duchamp explained that he got the idea for 'winning' the bride from a funfair game in which contestants throw balls at the figure of the bride in order to 'tip her out of bed'. What is not clear and remains a mystery is whether the bachelors succeed in their desire, or whether it is an allegory on the processes of courtship. This illustrated version is a recreation of the original made by the British Pop artist Richard Hamilton (b. 1922) with Duchamp's approval, demonstrating its importance as an artefact of Modernism.

CREATED

Original created in New York. Replica created in London

MEDIUM

Oil, lead, dust and varnish on glass

PERIOD/MOVEMENT

Dada

SIMILAR WORKS

Francis Picabia, *Girl Born Without a Mother*, 1920

Marcel Duchamp *Born* 1887 Blainville-Crevon, France

Died 1968

Richard Hamilton *Born* 1922 London

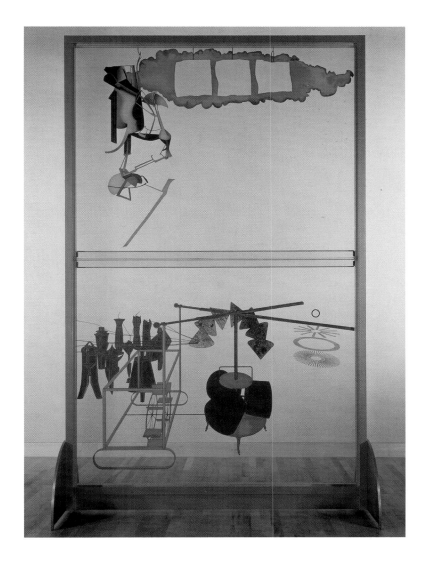

Arp, Hans
Before my Birth, 1914

The publication of *Über das Geistige in der Kunst* ('Concerning the Spiritual in Art') in 1912 by Wassily Kandinsky was a key moment in the development of modern European art for many artists, including Hans Arp. Kandinsky sought a 'pure' art that expressed only the 'inner and essential' feelings of the artist. In December of the previous year, Arp visited an exhibition in Munich of the *Blaue Reiter* group of artists, which included Kandinsky and in which he (Kandinsky) had written the catalogue preface, stating: 'In this small exhibition we do not seek to propagate a precise or special form, but aim to show in the diversity of the forms represented how the inner desire of artists shapes itself in manifold ways.'

The *Blaue Reiter* group was a fusion of German and Russian artistic talents that included Paul Klee (1879–1940), August Macke (1887–1914), Franz Marc (1880–1916) and, of course, Kandinsky. The effect of Arp's visit was to free his own art from the constraints of academic and representational considerations. In *Before My Birth*, Arp explored the purely formal qualities of colour, shape and line. His antipathy towards the old order is summed up in a text written by him in 1915 in which he describes his work of this period as 'a denial of human egotism'.

MEDIUM

Collage

PERIOD/MOVEMENT

Abstraction

SIMILAR WORKS

Paul Klee, *Abstract: Coloured Circles with Coloured Bands*, 1914

Hans Arp *Born* 1887 Strasbourg, France

Died 1966

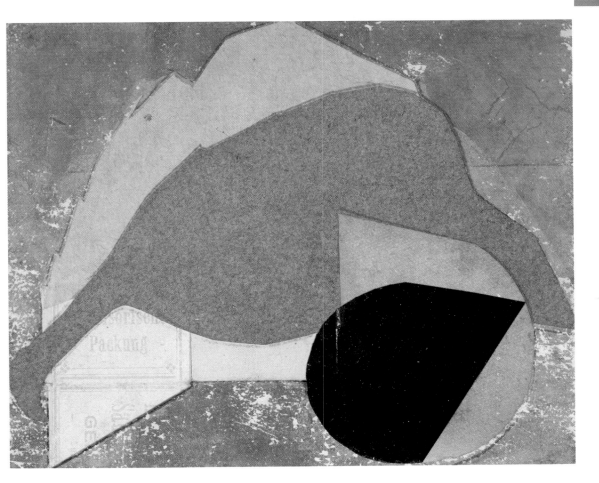

Arp, Hans

The Flower Hammer, 1916

Hugo Ball (1886–1927), the Zurich Dadaist, described the city in 1915 as 'like being in a bird-cage surrounded by lions'. As Switzerland was militarily neutral his comments referred to the war, but the country's lack of a significant artistic history or tradition also suggests an analogy with the sterility of Swiss art, surrounded as it was by the various artistic Secessions such as those in Munich and Vienna. Nevertheless Zurich was where Hans Arp decided to seek refuge during hostilities, joining Tristan Tzara's (1896–1963) Dada group in 1915. Unlike Tzara, Arp was not interested in the political aspirations of Dada; his concern was the 'freedom' to create. For him, 'the spirit of abstract art represents a widening of man's sense of liberty. I believe in a brotherly art. This is man's mission in society, it must serve towards the formation of a new man'.

This period of Arp's work is marked by his meeting with Sophie Taeuber, who was to become his wife in 1922. She introduced him to the non-objective abstractions of the *De Stijl* artists Piet Mondrian (1872–1944) and Theo van Doesberg. He began collaborating with Taeuber on collages and embroideries with the emphasis on pure formalism and anonymity of execution.

MEDIUM

Relief

PERIOD/MOVEMENT

Dada

SIMILAR WORKS

Georgia O'Keeffe, *Evening Star III*, 1917

Hans Arp *Born* 1887 Strasbourg, France

Died 1966

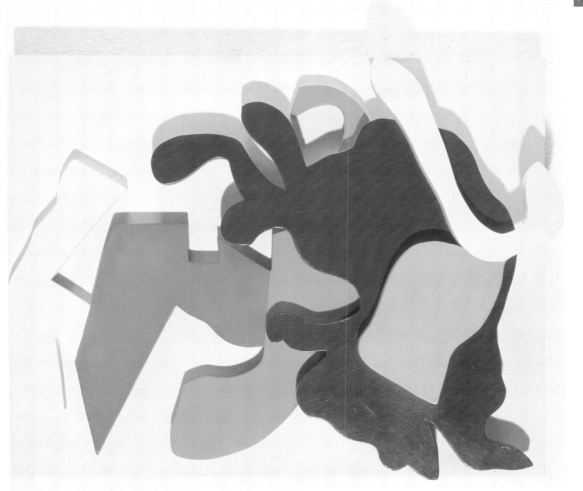

Arp, Hans
The Great Dancer, 1926

Hans Arp's Dada period was determined not by the nihilism of so many Dada artists, but by a positive belief in the healing properties of art. During this period he would throw pieces of coloured paper on to the floor in order to simulate chance, which for him was the key in his search for essential order. In his coloured 'reliefs' he had the shapes made by a carpenter and then painted in different colours to disguise the aesthetic qualities of the raw material, before assembling the pieces. This would also ensure the anonymity of the work.

His association with the Surrealist group in Paris from the 1920s onwards provided Arp with the opportunity to develop his experiments in primordial forms. Set within an empty spatial context, he played with biomorphic shapes, often transforming humans into animals or other objects. Their appearance was frequently amoeba-like and cellular, or hinting at a human part of the anatomy such as a navel or eye. For Arp these represented a model of primordial being in a natural world that was in a constant state of flux. *The Great Dancer* is just such a witty transmutation of a dancer.

CREATED

Paris

MEDIUM

Oil on wood

SIMILAR WORKS

Joan Miró, *Portrait of a Lady in 1820*, 1929

Hans Arp *Born* 1887 Strasbourg, France

Died 1966

Arp, Hans
Crown of Buds, c. 1936

Henry Moore's credo, that 'All good art has both abstract and surreal elements in it', was equally applicable to Hans Arp. The two artists met on a number of occasions in the 1930s. Although Arp had a strong affinity to the Surrealists, both he and his wife also had close links with the Constructivist groups such as *De Stijl*. Arp had also founded *Abstraction-Création* and *Art Concret*, leading to his own experiments during the 1930s into what he called *Concretions*, sculptures modelled in plaster or carved in wood or stone. There is a feeling of lightness or weightlessness to them combined with a solidity of form. The rounded contours of the works suggest female forms and are usually lacking in a sense of orientation, suggesting that the work can be viewed from a number of differing vantage points. Arp was very prolific in his sculptures of this period and enjoyed infinite variations of the motif. His relationship with both Henry Moore and Barbara Hepworth (1903–75), who joined *Abstraction-Création* in 1933, ensured a mutually satisfactory cross-fertilization of ideas over the Channel, which manifested itself in their respective oeuvres.

CREATED

Paris

MEDIUM

Concrete

SIMILAR WORKS

Henry Moore, *Composition*, 1933

Hans Arp *Born* 1887 Strasbourg, France

Died 1966

de Chirico, Giorgio
Melancholy of Departure, 1914

The first group exhibition of Surrealism held at the Parisian Galerie Pierre in 1925 was not dominated by the Surrealists themselves, but by a more disparate group of artists that included Paul Klee, Pablo Picasso and Giorgio de Chirico. De Chirico, although not a Surrealist, was an influential figure in the concerns and subsequent aesthetic of many Surrealists, including René Magritte and Salvador Dalí (1904–89). He was an artist of the self-styled *Pittura Metafisica* or metaphysical painting, characterized by a fictive, subverted pictorial space. Typically his work was of disturbing city squares, bordered by arcades with long shadows and steeply rising perspectives, creating a sense of isolation, melancholy and alienation.

De Chirico began these works in about 1912, following his intense readings of the works of Friedrich Nietzsche (1844–1900) from about 1910. In particular de Chirico became interested in metaphysics, or the reality of objects and experience. Based on notions of Nietzsche's 'eternal return' de Chirico wanted to explore pictorially what is hidden behind the reality of appearances and how this manifests itself. In *Melancholy of Departure* de Chirico depicts the railway station at Montparnasse in Paris. The long shadows add to the feeling of melancholy as the train departs; or is it arriving? The artist leaves the viewer to contemplate the enigma.

MEDIUM

Oil on canvas

PERIOD/MOVEMENT

Pittura Metafisica

SIMILAR WORKS

Max Ernst, *Two Children are Threatened by a Nightingale*, 1924

Giorgio de Chirico *Born* 1888 Vólos, Greece

Died 1978

de Chirico, Giorgio
Child's Brain, 1914

Child's Brain is the picture that provoked André Breton famously to leap off a bus to inspect it when it was in the gallery window of the dealer Paul Guillaume. For Breton it represented the repressed sexual desires or Oedipus complex referred to in the writings of Sigmund Freud (1856–1939). Freud explored the universal psychological truths found in the Greek myth of Oedipus, who blinds himself after discovering that he has married his own mother. This revelation, leading to the notion of repression, became the subject of Freud's hypothesis that all males in childhood fall in love with their mother and become jealous of their father.

Although not a Surrealist himself, de Chirico may also well have been exploring these ideas for himself, particularly as his own father had died in 1905 when the artist was only 18. De Chirico was well read and Freud's ideas had a currency in informed circles at this time. He befriended the poet Apollinaire (1880–1918), painting his portrait in 1914, who in turn introduced him to Picasso and Paul Guillaume who became his first dealer. *Child's Brain* was also shown in London at the First International Surrealist Exhibition, where it inspired British Surrealists such as Roland Penrose (1900–84).

MEDIUM

Oil on canvas

PERIOD/MOVEMENT

Pittura Metafisica

SIMILAR WORKS

Max Ernst, *Pietà*, 1923

Giorgio de Chirico *Born* 1888 Vólos, Greece

Died 1978

de Chirico, Giorgio

Piazza D'Italia

Metaphysical paintings examine the actual reality of objects by neutralizing the object from its usual setting and juxtaposing it with a different setting. This setting is often an imaginary space in which the viewer comes face to face with himself and his emotions. This idea, seized upon by Breton, is that we face repressed thoughts and fears within our own subconscious when confronted with these paintings.

The theme of *Piazza D'Italia* is Ariadne, one of a number of works that de Chirico painted from 1912 based on the Classical Greek legend. According to the legend, Ariadne fell in love with Theseus, giving him a length of silk thread to escape the labyrinth of the Minotaur whom he had gone to kill. Theseus had promised to marry Ariadne, but once he had escaped the labyrinth, he betrayed and abandoned her at Naxos, until her rescue by Dionysus. The legend had a particular significance for Nietzsche, who saw the labyrinth as a metaphor for the chaos of life, and the thread as an enabler to negotiate a way through. In this painting Ariadne is seen as a statue in the centre of a piazza that is devoid of life, a symbol of contemporary urban alienation.

MEDIUM

Oil on canvas

PERIOD/MOVEMENT

Pittura Metafisica

SIMILAR WORKS

Paul Delvaux, *The Echo*, 1943

Giorgio de Chirico *Born* 1888 Vólos, Greece

Died 1978

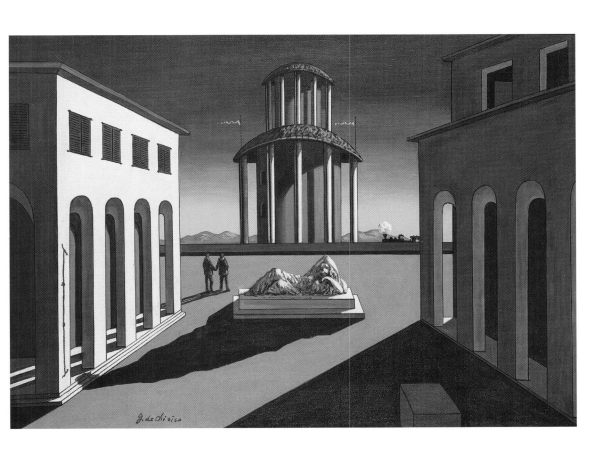

de Chirico, Giorgio

Trovatore

Another feature of Giorgio de Chirico's painting is the use of mannequins, so that the (human) object of the painting has been emptied of its emotional significance, in order merely to convey an ambiance. De Chirico said, 'in the face of the increasingly materialistic and pragmatic orientation of our age, it would not be eccentric in the future to contemplate a society in which those who live for the pleasures of the mind will no longer have the right to demand their place in the sun'. For de Chirico, as with so many other artists, the consequence of the First World War was the nihilism of life.

The use of mannequins by de Chirico underpinned the notion of silence in his work and suggested the idea of life as a meaningless and futile puppet show, set on an urban stage. In this case the urban space was Ferrara, the northern Italian city that de Chirico was sent to as his first military posting in 1915. The city was, for de Chirico, imbued with a tension of industrial modernity juxtaposed with a medieval and Renaissance history that included the Este castle, an ideal backdrop to these enigmatic figures.

MEDIUM

Oil on canvas

PERIOD/MOVEMENT

Pittura Metafisica

SIMILAR WORKS

Carlo Carra, *The Enchanted Bedroom*, 1917

Giorgio de Chirico *Born* 1888 Vólos, Greece

Died 1978

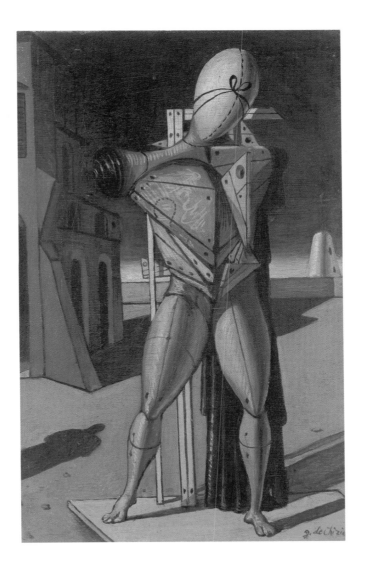

Picasso, Pablo

Theatre Curtain for 'Parade', c. 1917

Poet and writer Jean Cocteau had courted the artistic favours of Pablo Picasso from 1915, for collaboration with himself and with the Ballet Russes of the impresario Sergei Diaghilev. The first of these was *Parade*, a synthesis of ballet, circus and variety show. Cocteau was something of a raconteur who had little trouble wooing Picasso, acting as a foil to the artist's melancholy following his lover Eva Gouel's early death. Cocteau had temporarily replaced Picasso's friendship of Guillaume Apollinaire, who was at the Front, and Max Jacob who was out of favour as Picasso's 'court jester'.

This period marked a significant change in Picasso's life and oeuvre, as he returned to figurative painting after his Cubist period, using a plurality of styles still including Cubism, which became a feature of his future work. Exempt from military service, Picasso travelled in Italy and began to introduce aspects of Classicism and Classical myth into his work, such as the winged horse Pegasus in this design. A turning point in Picasso's personal life was the meeting of the prima ballerina Olga Koklova, whom he later married. Perhaps more pertinently, Apollinaire wrote the introductory notes for the programme of *Parade*, in which he coined the term 'surrealism' for the first time.

MEDIUM

Textile

PERIOD/MOVEMENT

Proto-Surrealism

SIMILAR WORKS

René Magritte, *The Encounter*, 1929

Pablo Picasso *Born* 1881 Málaga, Spain

Died 1973

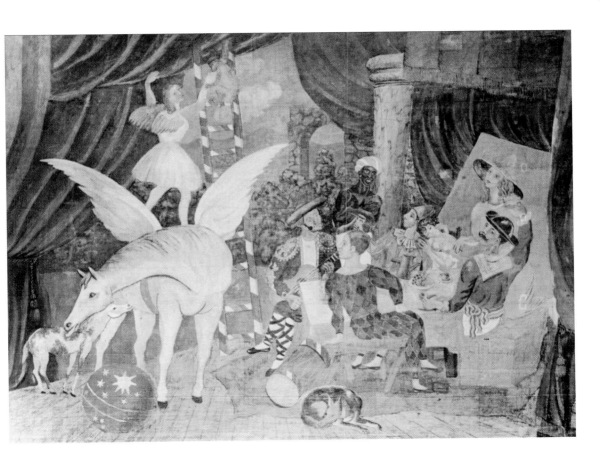

Picasso, Pablo

Mandolin and Guitar – Juan les Pins, 1924

The fusion of styles that became a feature of Picasso's work are evident in *Mandolin and Guitar – Juan les Pins*. The stringed musical instruments played a vital role as a motif in the Analytical Cubism of his work during the period 1910–11. His collages and papier collé from 1912 contain ready-made elements of modern life such as newspapers, bus tickets and fragments of sheet music, as well as detritus such as wood shavings, string and sand. For Picasso, these fragments of modern life were a new form of representation that was not only reinterpretive of pictorial space, but also offered a new visual language in which objects functioned as signs. The subsequent period of Picasso's oeuvre is known as Synthetic Cubism in which he developed more considered ways of pictorial meaning, by, for example, using a more colourful palette to express his ideas. Picasso stated, 'I paint things as I think them not as I see them'.

Mandolin and Guitar – Juan les Pins was painted on the cusp of his involvement with Surrealism in which André Breton claimed Picasso as 'one of ours' in his article *Le Surréalisme et la Peinture* published in its entirety in 1928.

CREATED

Juan les Pins, France

MEDIUM

Oil and sand on canvas

PERIOD/MOVEMENT

Synthetic Cubism

SIMILAR WORKS

René Magritte, *Personal Values*, 1925

Pablo Picasso *Born* 1881 Málaga, Spain

Died 1973

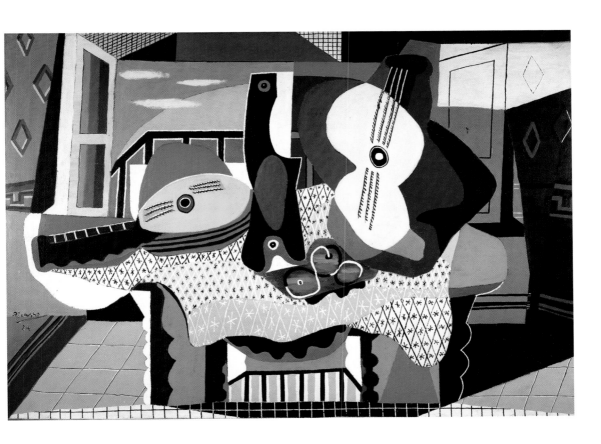

Picasso, Pablo

Bather with a Beach Ball, 1932

In the period from the summer of 1928, which coincided his involvement with Surrealism, Picasso began a series of beach scenes that overtly explored sexuality. His early years in Paris reveal an obsession with sexuality and in particular a neurosis about sexually transmitted diseases. His sketchbook from 1927, when he was in Cannes, reveal an obsession with a phallus-centred sexuality in which he depicts strange anthropomorphic androgynous figures.

Picasso's art of this period is a reflection of his own personal life. In 1927 he met a new model Marie-Thérèse Walter, at a time when his relationship with his wife Olga was beginning to sour. Although he did not separate from Olga until 1935, he continued a secretive affair with Marie-Thérèse during this period and his work is reflective of the inevitable tension. Many of these beach scenes are sexually explicit in their depictions and are usually of the amply proportioned Marie-Thérèse as in *Bather with a Beach Ball*. The predatory nature of her lover in this picture is a theme that Picasso returned to later, in his depictions of the myth of the Minotaur, a key theme of Surrealism.

CREATED

Boisgeloup

MEDIUM

Oil on canvas

SIMILAR WORKS

Salvador Dali, *The Great Masturbator*, 1929

Pablo Picasso *Born* 1881 Málaga, Spain

Died 1973

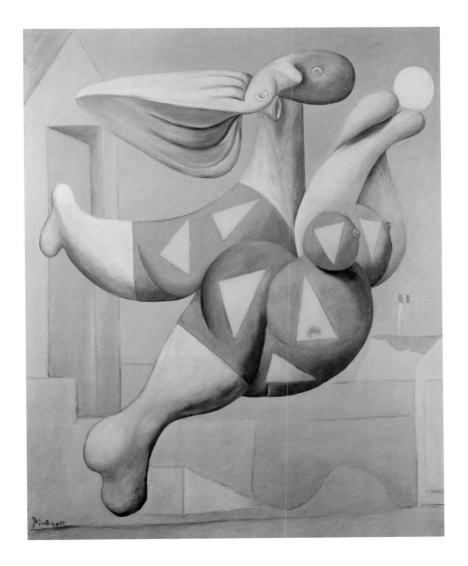

Picasso, Pablo

Guernica, 1937

Courtesy of The Art Archive/Reina Sofia Museum Madrid/© Succession Picasso/ DACS 2005

The sheer physical scale of the picture and the enormity of the subject matter make *Guernica* the most politically powerful of Picasso's paintings. Picasso's nightmarish vision is based on the terrible atrocity meted out to the northern Spanish town of Guernica by the Nazi Luftwaffe in 1937. The painting marks the end of Picasso's apolitical stance, which he had maintained despite the machinations of the Surrealist group. The brutal suppression of Republicanism at Guernica, a northern Basque stronghold, by General Franco with the support of the Fascists in Germany and Italy, led to the Spanish Civil War. The war, which lasted until March 1939, claimed the lives of one and a half million people including many foreign nationals who joined the Republican cause to suppress Fascism.

Originally the official Republican government of Spain commissioned Picasso to paint a mural for their pavilion at the forthcoming Paris World Fair. The news about Guernica radically altered Picasso's original ideas for the mural. His depiction shows the barbarity of this act of terrorism on a non-military target, in which the dismembered and disfigured bodies of humans and animals are imbued with a sense of carnage and suffering that epitomized Guernica and the ensuing civil war.

CREATED

Paris

MEDIUM

Oil on canvas

SIMILAR WORKS

Wilhelm Freddie, *Monument to War*, 1936

Pablo Picasso *Born* 1881 Málaga, Spain

Died 1973

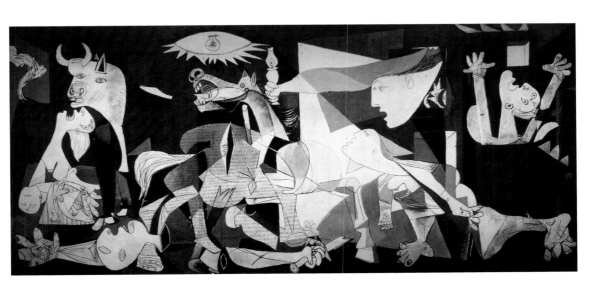

Giacometti, Alberto

Cage, 1930

Cage was developed by Alberto Giacometti, not as a sculpture but as an 'object'. In 1931 Giacometti published a series of drawings, one of which was the preparatory drawing for *Cage* in which he referred to *objets mobiles et muets* ('objects that move but cannot speak'). Giacometti's 'objects' suggest repressed sexual desire or fetishism, but need the viewer's participation. They are redolent of Man Ray's *Gift*, a Dada 'object' in which we are invited to try ironing with an iron that has spikes on its plate.

Giacometti's 'objects' are based on items within his own dreamt memories, which he recalls, sketches and makes as a rough plaster cast, before commissioning a cabinet-maker to make the actual object, retaining an element of chance that was independent of the artist's hand. The artist was responding to the 'second phase' of Surrealism in which André Breton, now confident in its visualization, suggested that artists seek motifs of the imagination and dreams as a response to Freud's *Interpretation of Dreams*. Breton invited both Giacometti and Salvador Dalí to join the Surrealist group in 1929, aware of their potential to respond to this call. It was Dalí who was to realize the true potential of the 'Surrealist Object' in the 1930s, but he always acknowledged his indebtedness to Giacometti.

CREATED

Paris

MEDIUM

Wood

SIMILAR WORKS

Gala Éluard, *Object of Symbolic Function*, 1931

Alberto Giacometti *Born* 1901 Borgonovo, Switzerland

Died 1966

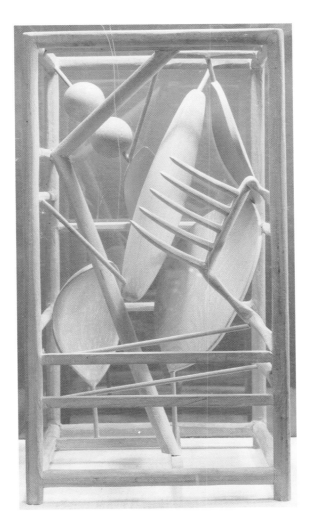

Giacometti, Alberto
Walking Woman, 1932–33

Courtesy of Private Collection, Lauros/Giroudon/www.bridgeman.co.uk/© ADAGP, Paris and DACS, London

Following on from the enigmatic 'objects', Giacometti returned to a more figurative approach in his sculpture, finally relinquishing his 'brush' with Surrealism in 1935. His final Surrealist work was *The Invisible Object*, a totem of an elongated female figure wearing a 'primitive' mask that, according to André Breton, Giacometti and he had 'discovered' in a flea market they were visiting and which became the missing piece of the sculpture. The figure has slightly outstretched hands suggesting an 'invisible object', hence the name of the work. For the Surrealists, the relationship between human being and object became a crucial step towards the 'Surrealist object'.

Walking Woman moves towards that understanding and is also related to the Freudian notion of totemism and incest. According to Freud, totemism, the incarnation of a tribal custom linked to exogamy, socially conditions incest in all civilizations. Based on Darwin's theories of the 'primal myth' in which the powerful patriarch was killed by the younger males to access the females, Freud suggested that the patriarchs used tribal totemic laws against incest and murder, overturning this order. According to Freud the subsequent repressed sexual desire in the unconscious stood at the beginning of all human culture. It is this aspect that appealed to the Surrealists.

CREATED

Paris

MEDIUM

Bronze

SIMILAR WORKS

Salvador Dali, *Hysterical and Aerodynamic Female Nude*, 1934

Alberto Giacometti *Born* 1901 Borgonovo, Switzerland

Died 1966

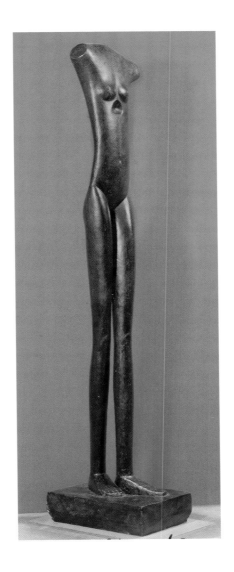

Pollock, Jackson

Undulating Paths, 1947

Courtesy of The Art Archive/Galleria d'Arte Moderna Rome/Dagli Orti/© ARS, NY and DACS, London 2005

Max Ernst arrived in America in 1941, seeking refuge from Nazi oppression and a war-ravaged Europe. During his experiments in New York he developed 'oscillation', an 'automatic' process in which he pierced a can containing liquid paint with a number of holes and swung it a number of times over a canvas. He would then interpret the paint marks, transforming them into recognizable subjects. A typical painting of this period is *Napoleon in the Wilderness* from 1941.

This process was shown to Jackson Pollock, a young easel painter working on the government-subsidized Works Progress Administration's Federal Art Project, which provided a subsistence wage to artists during the Depression. Following several months in hospital in 1938 for psychiatric treatment for alcoholism, Pollock worked with two Jungian psychoanalysts as part of his therapy and was introduced to notions of the unconscious and the pictorial Symbolism of Picasso and Jean Miró (1893–1983),. The use of Ernst's technique was a significant breakthrough for Pollock in about 1947, when he adapted its use in his 'drip' technique. Although the style was incorporated in what became known as Abstract Expressionism, it had its roots in the Automatism of Surrealism.

MEDIUM

'Drip' painting on canvas

PERIOD/MOVEMENT

Abstract Expressionism

SIMILAR WORKS

André Masson, *Fish Drawn in the Sand*, 1927

Jackson Pollock *Born* 1912 Wyoming, USA

Died 1956

Kahlo, Frida

What the Water Gave Me, 1938

André Breton visited and stayed with Frida Kahlo and her husband Diego Rivera during his visit to Mexico in 1938, acknowledging that she was a self-invented Surrealist. The fact that Breton wrote the preface to Kahlo's exhibition did not qualify her as a Surrealist; in fact, she eschewed the term. Although her pictorial fantasies are often associated with a Surrealist aesthetic, she painted not her dreams or imagination but what she saw as her own nightmarish reality.

In 1925 a serious road-traffic accident left her very badly disabled. Often confined to a hospital bed for weeks undergoing reconstructive surgery, she constructed an image of 'Two Fridas' in order to exorcize the pain and yet maintain a sense of reality. She subsequently discovered that she was unable to conceive children and in a particularly poignant self-portrait, *Henry Ford Hospital* (1932), Kahlo is seen haemorrhaging after suffering a miscarriage. Although her husband Diego Rivera supported her artistically, the relationship was always very tense, overshadowed by the fact that Rivera was Mexico's most famous living artist. Kahlo depicted this dominance in the painting *Frida and Diego Rivera* (1931), while their separation and her subsequent loneliness was depicted in *The Two Fridas* (1939).

CREATED

Mexico

MEDIUM

Oil on canvas

SIMILAR WORKS

Léonor Fini, *The Secret Festival*, 1964

Frida Kahlo *Born* 1907 Coyoacán, Mexico

Died 1954

Surrealism

Styles & Techniques

Masson, André
Furious Suns, 1925

In the *First Manifesto of Surrealism*, its author André Breton (1896–1966) made its testimony clear: 'SURREALISM, noun. Pure psychic automatism by which it is intended to express, either verbally or in writing, the true function of thought. Thought dictated in the absence of all control exerted by reason, and outside all aesthetic or moral preoccupations.'

At this stage, Breton had not included visual artists in his manifesto. Nevertheless he had around him a group of friends that included André Masson, an artist who had fallen under the spell of the charismatic Breton. Masson had already met another future Surrealist, Joan Miró (1893–1983), who persuaded him that Dada was now dead and that Breton held the key to future painting. What appealed to both Masson and Miró was the concept of Automatism, an automatic writing technique developed by Breton since 1919, influenced by Sigmund Freud (1856–1939). In 1924 Masson began making the first of his 'automatic' drawings using pen and ink. Often in a trance-like state he would allow the pen to amble rapidly over the paper, to produce an incoherent series of lines. Masson, on examining the paper, would then either develop the work or leave it in a suggestive state, adding a title to make it coherent.

CREATED

Paris

MEDIUM

Pen and ink on paper

SIMILAR WORKS

Joan Miró, *The Calculation*, 1925

André Masson *Born* 1896 Balagny-sur-Thérain, France

Died 1987

. SOLEILS FURIEUX .

Masson, André
Battle of Fishes, 1926

In the development of his work André Masson became interested, mainly due to the arrival of Hans Arp (1887–1966) in Paris in 1926, in the actual moment of metamorphosis, when an unconscious mark or line became a recognizable motif. Because the drawings lacked vibrancy and could be sombre in tone, Masson was unable to use oil paint in the same way as drawing because of the lack of fluidity of the medium. He therefore decided to draw inspiration from the Dada collages of Max Ernst (1891–1976) and the Cubist collages of Pablo Picasso (1881–1973). Masson began using glue poured on to the canvas in an 'automatic' manner and added sand, even randomly throwing it on to the canvas. Then, tipping the canvas on its side he would shed the sand that had not adhered to the glue, revealing an 'automatic' or chance pattern. To this, Masson would add touches of oil paint or add a few lines until an image manifested itself to him. In *Battle of Fishes* the use of sand, the addition of line and the red paint representing blood, have revealed fish being pursued by birds, as it would be viewed through water.

CREATED

Paris

MEDIUM

Sand, gesso, oil pencil and charcoal on canvas

SIMILAR WORKS

Salvador Dali, *Bird – Fish*, 1927–28

André Masson *Born* 1896 Balagny-sur-Thérain, France

Died 1987

Masson, André
La Chasse a l'élan, 1942

Long after Automatism ceased to be a primary concern for André Breton, André Masson was continuing his versions of automatic paintings even in exile in the United States, where he was living from 1941. As Masson explained, 'The automatic drawing, having its source in the unconscious, must appear like an unpredictable birth. In the second stage the image would re-appear and claim its own right'. By this period Masson's paintings had become more lyrical as he moved away from the angst and violence of the previous decade, when he had been experimenting with a more representational style that reflected his involvement in the Spanish Civil War.

The background to the work suggests the inside of a cell-like structure, creating a sense of depth that is limited by a membrane wall. The metamorphosis of the moose and the hunter, alluded to in the title, suggests that Masson's continued concerns of this period are the unity of humanity with the natural world through an integrated relationship between colour, line and form. With America now having entered the Second World War, Masson's paintings are a reminder of the fragility of life.

CREATED

New York

SIMILAR WORKS

Arshile Gorky, *The Leaf of the Artichoke is an Owl*, 1944

André Masson *Born* 1896 Balagny-sur-Thérain, France

Died 1987

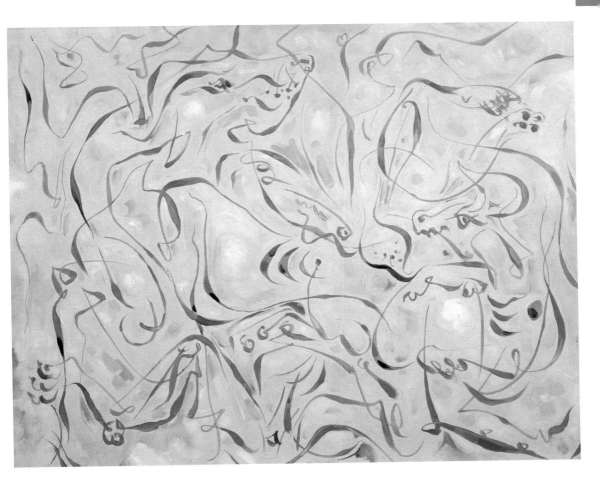

Masson, André
Antilles, 1943

Key to understanding André Masson's work is how it and 'automatic' Surrealism differ from their contemporaries, not just within the movement but also, more especially, within Western painting. Masson explained that he began without an image or even a plan in his mind, relying on 'impulses' to direct him, which led him to view the emergence of the marks to give order to the composition. In a meeting he had in the 1930s, he explained this to Henri Matisse (1869–1954) who took a diametrically opposed view in his own work, saying that he took a motif as his starting point, but at the end he had moved so far away from it that he was hardly aware of the subject any more.

In the early 1940s New York had become, for a while, the centre of Surrealism, facilitated by the opening of Peggy Guggenheim's Art of this Century gallery. Masson's 'automatic' work of the 1940s informed a younger generation of artists who were to form the group of artists that became Abstract Expressionists. Like Masson, they were moved to use paint as an expression of their unconscious or inner self that was not a representation of a motif.

CREATED

New York or Connecticut

MEDIUM

Oil tempera and sand on canvas

SIMILAR WORKS

Willem de Kooning, *Pink Angel, c.* 1947

André Masson *Born* 1896 Balagny-sur-Thérain, France

Died 1987

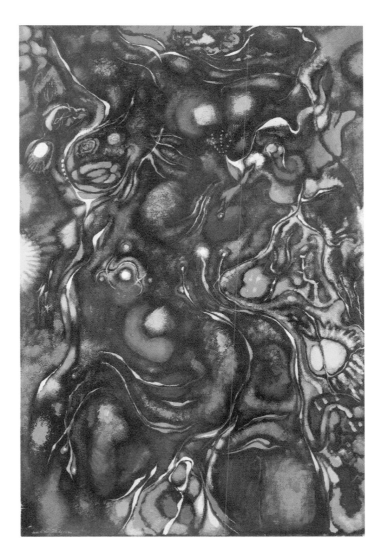

Ernst, Max

Oedipus Rex, 1922

In his collages of 1920–21 Max Ernst was not motivated by the aesthetic qualities of the materials used, unlike the Cubists. Rather he was attracted by their symbolic and more importantly representational values. In 1936 he recalled how he had been motivated in 1919 by the illustrations in a scientific journal of juxtaposed disparate objects that revealed the endless possibilities of visual representations. His subsequent collages enabled him to explore the possibilities of those representations, a period that coincided with his introduction to the work of Giorgio de Chirico (1888–1978) through the collections of both André Breton and Paul Eluard (1895–1952).

In many ways Ernst was the bridge between Dada and Surrealism. His Dada was essentially apolitical in purpose and not allied to the formal considerations of, for example, Hans Arp in Zurich. Neither was it allied to Berlin Dada, for whom Hannah Höch's (1898–1978) photomontage was an important aspect of Social and Political Realism. Ernst's early oil paintings, anticipating Surrealism's aesthetic and concerns, convey a sense of the fantastic use of illusionistic space and form, the foundations of which he laid in his earlier collages. *Oedipus Rex is* one such painting.

MEDIUM

Oil on canvas

PERIOD/MOVEMENT

Dada/proto-Surrealism

SIMILAR WORKS

René Magritte, *Pleasure*, 1926

Max Ernst *Born* 1891 Brühl, Germany

Died 1976

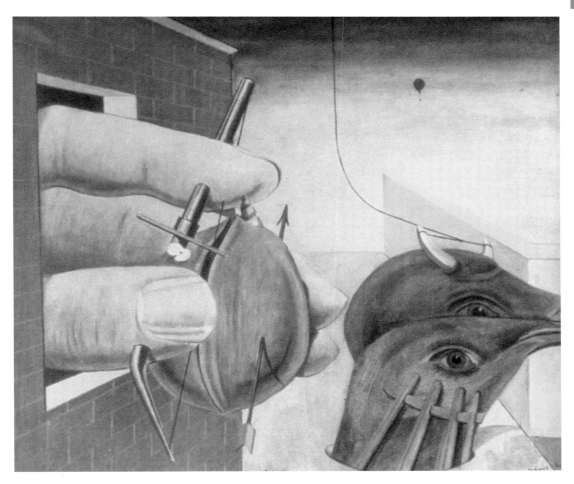

Ernst, Max

Pietà ou La Révolution la Nuit
('Pietà or Revolution by Night'), 1923

Courtesy of Tate, London/© ADAGP, Paris and DACS, London 2005

Max Ernst's paintings of the pre-Surrealist period are all based on memories of childhood and associations with people, places or objects recalled from that period. Often jumbled as in a dream, they anticipate the second phase of Surrealism when dreams became a pre-occupation for André Breton and the Surrealists. One of the themes of Ernst's work was the oppressive regime of his father during his childhood, alluded to in his painting *Oedipus Rex*, loosely based on Sophocles' tragic play, which deals with the moral concept of punishment and reward and its associations of guilt.

In a contemporary work, *Pietà ou La Révolution la Nuit*, Ernst utilizes the same theme and combines it with an iconoclasm of religious motifs and traditions. Brought up a Catholic, Ernst's rebellion is understandable given the atrocities committed in the First World War, in which he had served. His most infamous work of iconoclasm in this period is *The Virgin Spanking the Infant Jesus before Three Witnesses* (1928). In *Pietà* Ernst is seen sitting on the lap of his father, a scene redolent of the Madonna and Child, in which the child seeks protection and reassurance from a father who has already denounced him as an artist.

MEDIUM

Oil on canvas

PERIOD/MOVEMENT

Dada/proto-Surrealism

SIMILAR WORKS

René Magritte, *The Man of the Open Sea*, 1926

Max Ernst *Born* 1891 Brühl, Germany

Died 1976

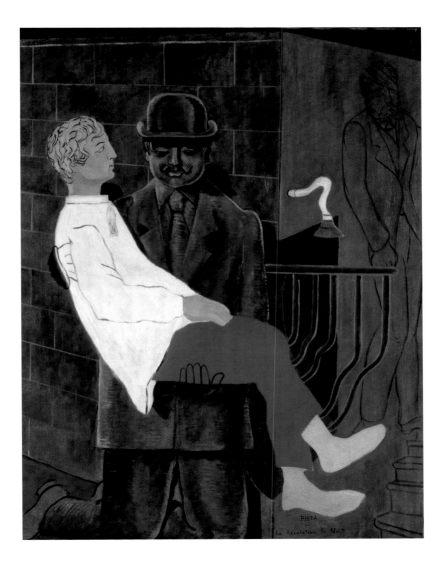

Ernst, Max

Arbre solitaire et arbres conjugaux ('Solitary Tree and Married Trees'), 1940

Courtesy of The Art Archive/Thyssen-Bornemisza Collection/Dagli Orti/© ADAGP, Paris and DACS, London 2005

During the latter part of the 1920s, Max Ernst developed a process that he called 'frottage', an 'automatic' form of painting that he adopted in response to André Breton's *First Manifesto of Surrealism* of 1924. He first employed this technique in his 'Natural History' series of 1926, adapting the technique to painting for his 'forest' series, depicting natural forms that were inspired by the Romanticism of, among others, Caspar David Friedrich (1774–1840). For Ernst, the Romanticism was of a familiar landscape of timeless natural forms.

At the outbreak of the Second World War, Ernst was interned as an enemy alien in France and was unable to flee to New York until the summer of 1941. During that period he produced *Arbre solitaire et arbres conjugaux*, a painting that encapsulated many of his concerns at this time: his imminent departure from a familiar European landscape was a preoccupation. Ernst had already been married and divorced twice and was living with the English painter Leonora Carrington (b. 1917), who, as a result of his arrest and their subsequent separation, had a nervous breakdown during this period. The painting brings together recognizable forms, but ones that are marred by the uncertainty and insecurity of his European homeland and his personal life. The style that he used to convey these feelings suggests a return to his earlier experiments with collage.

CREATED

France

SIMILAR WORKS

Emmy Bridgwater, *Remote Cause of Infinite Strife*, 1940

Max Ernst *Born* 1891 Brühl, Germany

Died 1976

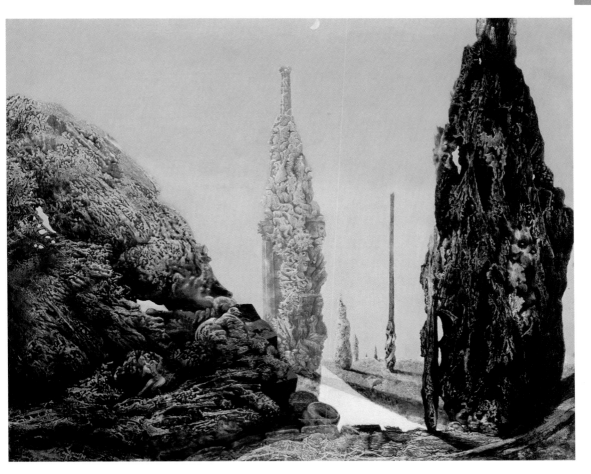

Ernst, Max
Capricorn, 1948/64

Despite gaining American citizenship in 1945, Max Ernst returned to France with his fourth wife Dorothea Tanning (b. 1910) – a Surrealist painter herself – in 1953, becoming a naturalized French citizen in 1958. During the summer of 1945, Ernst became interested in chess and in line with his previous notions of representational potential he saw the figures used in the game in terms of their literary qualities and values. Ernst was fond of the writings of Lewis Carroll, whose heroine Alice encountered chess pieces in *Through the Looking Glass*. In *Capricorn*, a work developed between 1948 and 1964, Ernst depicts the king and queen. The 'King' is Pan, the Greek god of shepherds and flocks, Ernst depicting him with goat horns, human torso and arms, and complete with his crook. But who is his queen? Is it Penelope, Pan's mother, who resisted her suitors after her husband left home for over 20 years? Is there a resonance with Ernst's first wife who he had abandoned 30 years before, only for her to die in Auschwitz? Surrealist depictions were so often imbued with these strange enigmas and Ernst was no exception.

Capricorn is a life-size bronze, designed almost certainly for an external site – he made a concrete version of it to place outside his and Tanning's Arizona homes.

MEDIUM

Bronze

SIMILAR WORKS

Pablo Picasso, *Goat Skull, Bottle and Candle*, bronze sculpture, 1951–53

Max Ernst *Born* 1891 Brühl, Germany

Died 1976

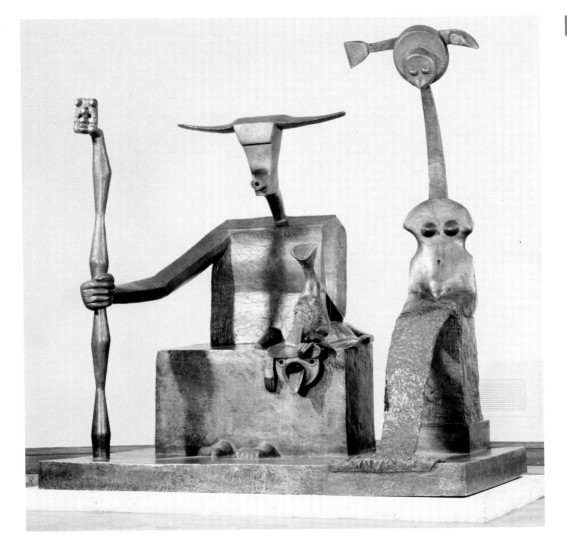

Miró, Joan

Peinture, 1926

When Joan Miró arrived in Paris from Barcelona in 1920, he was fortunate that within a few months he found an empty studio that was next door to André Masson, bringing him into contact with the avant-garde. However, he also spent time in the Louvre looking at the masters including Leonardo da Vinci (1452–1519). From Leonardo's work, Miró would have been made aware of the use of random and chance stains that are often incorporated in his work as a part of the creative process. This, of course, came at a time when Automatism was being discussed in the group around André Breton.

Peinture is a work based on Breton's notions of 'automatic' writing. In 1925, following Breton's *Manifesto of Surrealism*, Miró produced a small drawing entitled *Photo – that is the Colour of my Dreams* in which he placed a single smudged blue dot on a plain ground with the words of the title written in calligraphy. Margit Rowell, a former curator at the Museum of Modern Art in New York, has suggested it is a visual conception of Mallarmé's poem '*Un coup de des jamais n'abolira le hazard*', which loosely translated means 'One toss of the dice will never abolish chance'. In *Peinture*, aptly named as devoid of anecdote, the colour blue becomes the actual subject of the work, namely of his dreams.

CREATED

Paris

MEDIUM

Oil on canvas

SIMILAR WORKS

Hans Arp, *Still Life: Table, Mountain, Anchors and Navel*, 1926

Joan Miró *Born* 1893 Barcelona, Spain

Died 1983

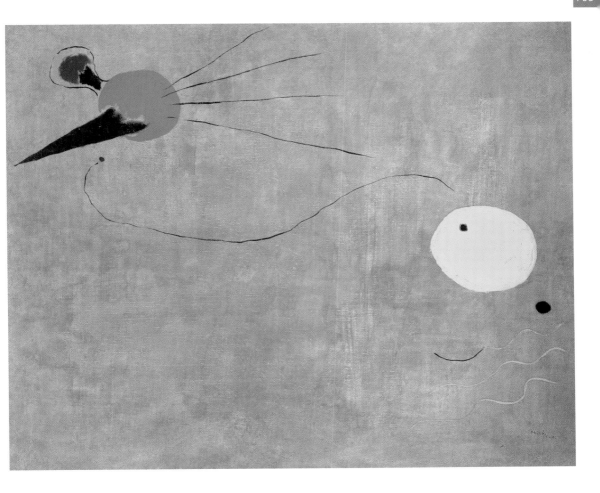

Miró, Joan

Le Fermier et son épouse, 1936

Courtesy of Christie's Images Ltd/© Successio Miro, DACS, 2005

In perhaps Miró's most celebrated work, *The Farm*, a Catalan landscape from 1921 to 1922, the artist moved away from the soft lyricism of his earlier landscapes and began incorporating symbols such as squares and circles to emphasize key aspects of the work and which were derivative of Francis Picabia's (1879–1953) 'machine' aesthetic. In a subsequent work, *The Tilled Field* (1923–24), Miró made a further move away from pure representation by incorporating signs and colours in the work that made the work more sensuous than cerebral. The Catalan landscape with its red soil is still an integral part of the work, but the inclusion of a number of apparently disparate objects requires the viewer to analyse the work. The incorporation of a large ear and eye together with French and Catalan motifs suggests his awareness of the duality of his life both personally and as an artist, not just anecdotally but sensually.

Le Fermier et son épouse is yet another development of the theme of a Catalan landscape in which the red soil is depicted in the foreground and the sea in the background. The yellow sky, acting as a complementary colour to the blue, imbues the picture with a sense of the heat. There is now no attempt to show illusionistic space and the work is completely devoid of anecdote.

MEDIUM

Gouache on board

SIMILAR WORKS

Yves Tanguy, *Your Tapers Taper*, 1929

Joan Miró *Born* 1893 Barcelona, Spain

Died 1983

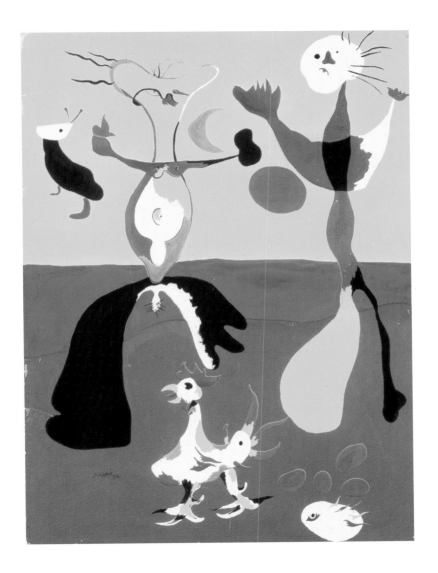

Miró, Joan

The Hands Play a Big Part
(Snail, Woman, Flower, Star), 1934

A common myth around the story of the Impressionist painters was that they executed their work entirely *en plein air*, the reality being that most of the painting was in fact carried out in the studio. There is an analogy here with the work of Miró: despite notions of Automatism in his work, he in fact planned his paintings meticulously. He would begin with a number of sketches that often contained descriptions of the colours to be used, before 'scaling-up' the work, often on to large canvases such as this, which measures nearly two metres (six and a half feet) in height.

Miró's dream-like visions are created on a complex ground, made up of glazed layers of paint. The figures in the composition are fractured, often having a whimsical or humorous quality, being images of playfully distorted animal forms or twisted organic shapes. Yet they always had a point or points of reference, symbolized either by recognizable shapes, written notations or both. Sometimes these ethereal organic forms are reduced to simple lines or spots, but nearly always with splashes of colour. This period is marked by a number of experiments with collage following a particular crisis when he affirmed the 'murder of painting'. These experiments are self-evident in *Snail, Woman, Flower, Star*.

MEDIUM

Oil on canvas

SIMILAR WORKS

René Magritte, *The Key of Dreams*, 1936

Joan Miró *Born* 1893 Barcelona, Spain

Died 1983

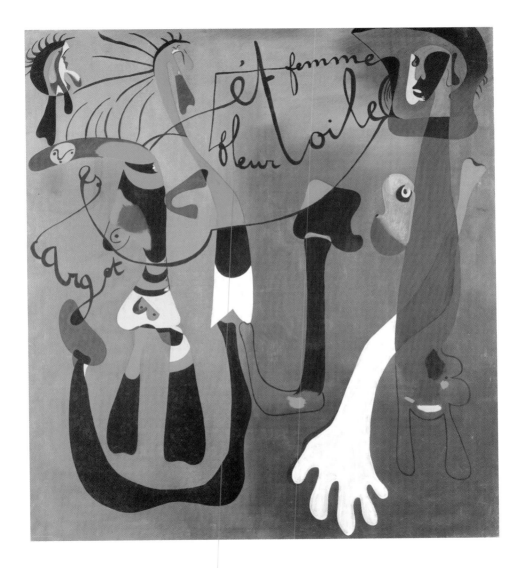

Miró, Joan

Hommage à Paul et Nusch Eluard

Courtesy of Christie's Images Ltd/© Successio Miro, DACS, 2005

Even prior to his involvement with the Surrealists, Miró was articulating his ideas: 'I am working hard towards an art of concept, using reality as a point of departure, never as a stopping place.' Painting, for Miró, was never about anecdote, but was a visual parallel of Surrealist poetry. It was never about abstraction, which Miró eschewed, but about removing extraneous material from the motif to arrive at a metaphysical truth. In the Surrealist journal *Documents*, the writer Michel Leiris likened Miró's work to Tibetan ascetics in which a perfect image, such as a garden, is then mentally stripped of everything piece by piece until you are left with nothing but the idea or concept, thus enabling a better comprehension of the metaphysical world once the physical has been eliminated.

The Surrealist poet Paul Eluard wrote, 'The true materialistic interpretation of the world cannot exclude the one who reports it'. It was he who commissioned Miró to illustrate a collection of his poems *A toute épreuve*. This collaboration, over a ten-year period, began when Eluard's first wife Gala left him for Salvador Dalí (1904–89). *Hommage à Paul et Nusch Eluard* is a celebration of that collaboration and his continuing friendship with Paul and his second wife Nusch, whom he married in 1934.

MEDIUM

Oil on board, metal coat hook with painted wooden knob, painted wooden mallet

SIMILAR WORKS

Pablo Picasso, *Night Fishing at Antibes*, 1939

Joan Miró *Born* 1893 Barcelona, Spain

Died 1983

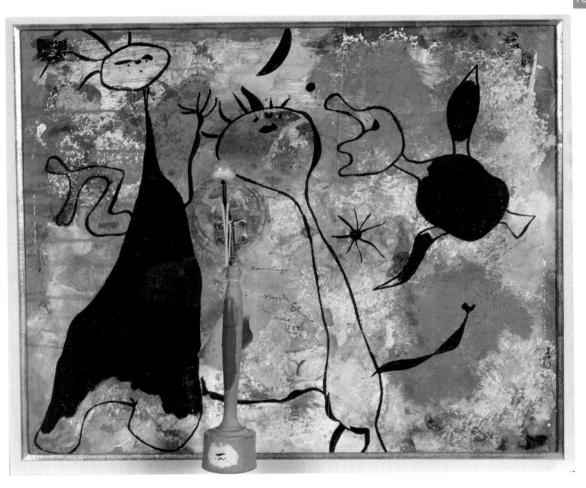

Matta, Roberto

The Bachelors Twenty Years After, 1943

When Marcel Duchamp (1887–1968) completed his *The Bride Stripped Bare by her Bachelors, Even*, or *Large Glass* in 1923, in line with Dada's 'anti-art' principles he definitively designated it 'unfinished'. He had executed the work in New York during his exile from the First World War, a place that he returned to in 1942 to escape the Nazi occupation of Paris. While there he met Chilean-born Roberto Matta, another European exile. Not much is known about Duchamp's work during the second period of his exile, except that he spent most of it working in secret on his *Etant donnès*, a manifestation of his abstract *Large Glass*, an enigmatic work of sexual explicitness. Although his work was secret, it seems likely that he confided in one or two close friends, among whom may have been Matta.

Matta's *The Bachelors Twenty Years After* is a witty updating of Duchamp's *Large Glass*, in which the two halves of 'Bride' and 'Bachelors' have now been conflated in a dynamic riot of various motifs from the work. The metamorphosed face of the 'Bride' in the bottom right-hand corner appears tortured. Is this the missing face to Duchamp's own *Etant donnés?*

MEDIUM

Oil on canvas

SIMILAR WORKS

Arshile Gorky, *The Betrothal II*, 1947

Roberto Matta *Born* 1911 Santiago, Chile

Died 2002

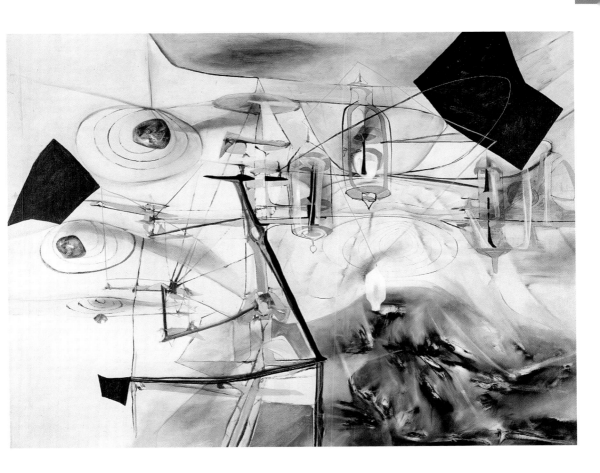

Matta, Roberto

The Prisoner of Light, 1943

Although a late arrival to Surrealism in 1938, when Automatism had been superseded as a leitmotif, Roberto Matta brought a new dimension to its use in his own work. For him, Automatism was about spatial depictions of an inner landscape that he referred to as 'psychological morphologies' or 'the graphic trace of transformations which result from the emission of energies and their absorption in the object from its first appearance to its final form in a geodesic, psychological environment'. Influenced by Albert Einstein's theory of relativity, Matta was convinced that visual art could depict time, change and growth within these 'psychological morphologies'.

Originally an enthusiast of Matta's work, André Breton described him as a 'four dimensional artist who creates landscapes with several horizons'. Breton saw a new enthusiasm for Automatism in Matta's work, suggesting in 1944 that from his earliest works: 'He has been master of an entirely new range of colours; perhaps the only new one, and certainly the most fascinating one, offered to us since Matisse. This range, the gradation of which is based upon a by now famous quick-changing purple rose which Matta seems to have discovered is arranged according to a complex prismatic pattern. Above all he seems to have revolutionized the symbolic interpretation of colours.'

MEDIUM

Oil on canvas

SIMILAR WORKS

Arshile Gorky, *Water of the Flowery Mill*, 1944

Roberto Matta *Born* 1911 Santiago, Chile

Died 2002

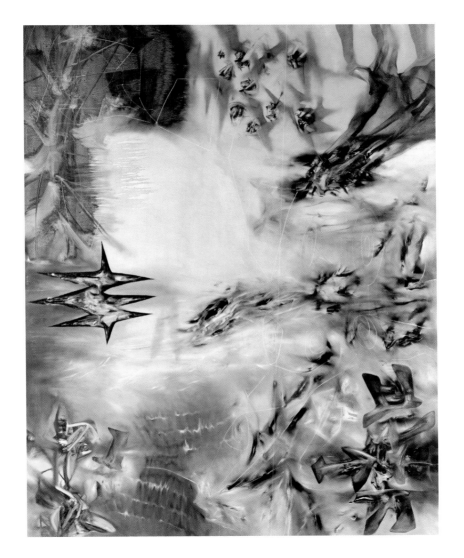

Matta, Roberto

Wraparound, 1955

Roberto Matta left America in 1948, a victim of both a Communist neurosis that was prevalent at this time and the ire of the leading art critic Clement Greenberg, who felt (unjustifiably) that Matta had betrayed his Abstract-Surrealist roots in favour of a more figurative aesthetic. Having returned to Europe, Matta was expelled from the Surrealist group by Breton for much the same criticism that Greenberg had levelled at him, but also because he had had an affair with Arshile Gorky's (1904–48) wife and was held partly responsible by Breton and many others for Gorky's suicide. Nevertheless he continued painting on a much larger scale. His work, often political in content, was exhibited in factories and public buildings rather than the (bourgeois) art galleries. He was reinstated to the group in 1959.

Matta, a disciple of Duchamp, continued seeking paintings that were not in his mentor's words 'retinal'. His influences were often outside mainstream Surrealism and included Picasso and Wassily Kandinsky (1866–1944), but his time in postwar America had created other 'pop culture' sources as diverse as comic books, graffiti and films. Matta also developed a penchant for neologisms such as 'conscienture', which was his word for the painting of the conscious. *Wraparound* is a work of neologism that explores, like most of Matta's work, the discovery of space, which he felt art had hitherto not explored fully. It is not a depiction of space, but an invitation for the viewer to explore that which the artist has suggested.

MEDIUM

Oil on canvas

SIMILAR WORKS

Asger Jorn, *A Soul for Sale*, 1958–59

Roberto Matta *Born* 1911 Santiago, Chile

Died 2002

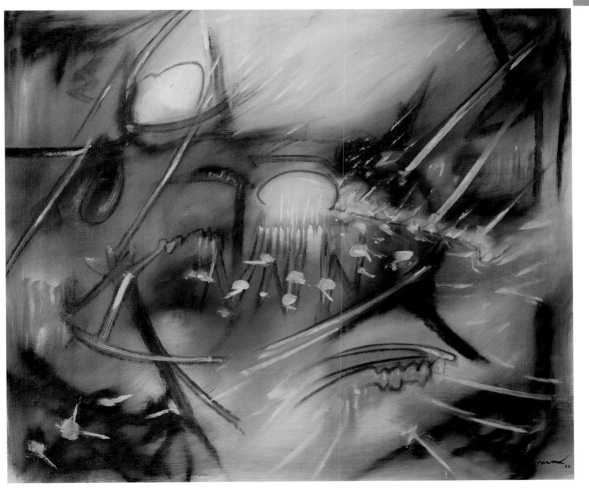

Hérold, Jacques
The Night Game, 1936

Although André Breton had emphasized the significance of Sigmund Freud in his *Manifesto of Surrealism*, it was only in his later *Le Second manifeste du surréalisme* (1929) that he articulated how Freud might influence painters as well as writers: Breton encourage them to search for the 'point of the mind at which life and death, the real and the imagined, past and future, the communicable and incommunicable, the heights and depths, cease to be perceived as contradictions'. In essence Breton wanted artists to examine the depiction of dreams and relate them to desire, both manifest and repressed.

By the early 1930s artists had begun to respond to this call in various depictions of Freud's *The Interpretation of Dreams*. According to Freud, dreams represent both 'wish fulfilment' (which is usually, but not always sexual) and evidence of neuroses in the unconscious. In *The Night Game*, the Romanian painter Jacques Hérold deals with neurosis in dreams. The painting depicts a woman in whose eyes are reflected the radiating light from an unattached penis, a reference to Oedipal rivalry that according to Freud causes castration anxiety in males and 'penis envy' in females.

CREATED

Paris

MEDIUM

Oil on canvas

SIMILAR WORKS

Salvador Dali, *The Great Masturbator*, 1929

Jacques Hérold *Born* 1910 Romania

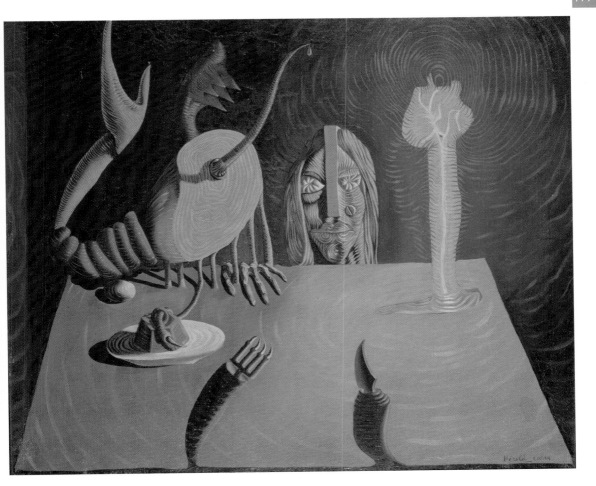

Hérold, Jacques
The Germ of the Night, 1937

Breton's novel *Nadja*, written in 1928, invented a new type of narrative relating the strangest encounters, the inexplicable coincidences of his life. As a guarantee of its authenticity he included photographic illustrations, thus creating a new genre that explored the relationship between the conscious state and dreams. As a result of this and Breton's Second Surrealist Manifesto, Dali began to move the Surrealist painters towards a new style of art with the publication of his own *L'Ane pourri*, a theoretical literary contribution to Surrealism in which he developed what he called a 'paranoiac-critical method' of representation. Dali, whose theories and paintings were so influential to other artists during this period, became obsessed by the lost paradise of the prenatal world, through representations of phantasms within a uterine world such as his *Imperial Monument to the Child-Woman, Gala (Utopian Fantasy)*, (1929).

There is a sense of the inter-uterine world in Jacques Hérold's painting *The Germ of the Night*. The germ, analogous to spermatozoa, fertilizes the ovum within the open and receptive red-lined uterus. To the right is the tentacled end of the fallopian tube connected via a network of sinuous muscle that protects its precious contents.

MEDIUM

Oil on canvas

SIMILAR WORKS

Salvador Dali, *Imperial Monument to the Child-Woman, Gala (Utopian Fantasy)*, 1929

Jacques Hérold *Born* 1910 Romania

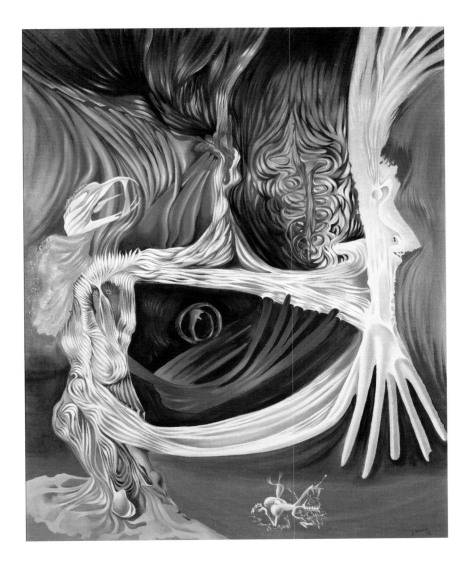

Hérold, Jacques
The Heads, 1939

In effect Salvador Dalí moved Surrealism beyond the recording of the mental message to a reinterpretation of perception itself. Dalí's idea was to give a structured encouragement to the mind's power to look at one thing and yet see another. As he put it he wanted to, 'materialize the images of concrete irrationality with the most imperialist fury of precision, in order that the world of the imagination ... may have the same objective evidence, the same consistency, the same persuasive, cognitive and communicable thickness as the exterior world of phenomenal reality'. According to Dalí, his invention of the 'paranoiac-critical' method – the controlled and lucid simulation of mental disease – would allow artists to reveal the double significance of things, that is the manifest and the latent. He went on to state that, 'thanks to this spontaneous method of irrational knowledge based on the interpretative critical association of phenomena which leads to delirium', the painter would act as though suffering from psychosis and yet be cognizant of his actions. Dalí modelled the manifestation of his ideas on the paintings of Giuseppe Arcimboldo, a sixteenth-century artist whose images, when inverted, revealed an entirely different representation.

These ideas found a resonance in, for example, Jacques Hérold's *The Heads*, in which scrutinizing the picture from different angles reveals a number of heads – human, animal and mythological.

MEDIUM

Oil on canvas

SIMILAR WORKS

Remedios Varo, *Vegetal Puppets*, 1938

Jacques Hérold *Born* 1910 Romania

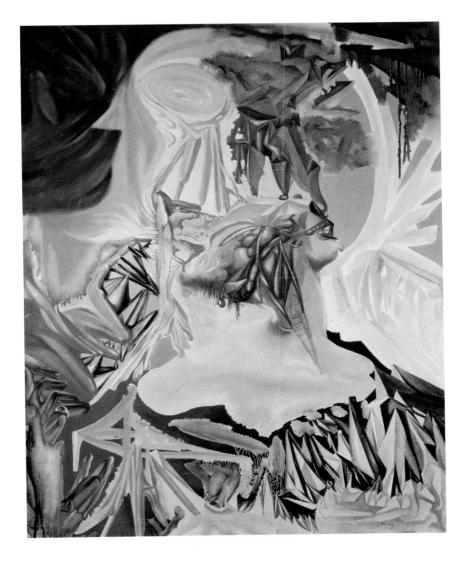

Lam, Wifredo
Untitled (Havane), 1944

Wifredo Lam left Cuba for Spain in 1923 and remained there until 1938, when he left for Paris, having spent the previous year fighting for the Republican cause in the defence of Madrid. His visit to Paris lasted until 1940 when he fled France for Martinique en route back to Cuba. His absorption of European culture included many of the precursors of Surrealism such as the paintings of Hieronymus Bosch (*c.* 1450–1516) and Francisco Goya (1746–1828), whose work he would have seen in Madrid's Prado Museum. Pablo Picasso, who befriended and encouraged Lam as a mentor, also introduced him to the avant-garde that included Fernand Léger (1881–1955) and the Surrealists around André Breton. When Lam arrived in Martinique he met the poet Aimé Césare who introduced him to his Negritude movement, a neologism for the indigenous black culture.

This fusion of influences played a critical role in Lam's development as an artist on his arrival back in Cuba. In *Untitled (Havane)* the aesthetic of André Masson's Automatism is imbued with a sense of the soft vegetal-animal forms inspired by Lam's familiarity with the tropical plants he studied at Havana's botanical gardens when he was a student.

MEDIUM

Oil on paper

SIMILAR WORKS

Victor Brauner, *Oneiric Transmutation*, 1946

Wifredo Lam *Born* 1902 Sagua la Grande, Cuba

Died 1982

Lam, Wifredo
Le Rideau Grenade, 1944

Courtesy of NYC Christie's Images Ltd/© ADAGP, Paris and DACS, London 2005

At the turn of the nineteenth century many modernists adopted and adapted ritualistic or totemic motifs from Africa, the Indian subcontinent and Oceania – in fact from most places that were European colonies. The use of these misappropriated motifs can be found in the so-called 'primitive' aesthetics of Paul Gauguin's (1848–1903) Post-Impressionism, the Cubism of Picasso and Georges Braque (1882–1963), much of Germanic Expressionism and some of the Fauvism of Matisse. However, Surrealism differed in this regard thanks largely to the multiethnicity of its group and a genuine interest in anthropology, beyond its use as a motif, through their connection with anthropologists such as Claude Lévi-Strauss.

Wifredo Lam was genuinely fascinated by the mythologies of 'primitive' people, particularly those of an Afro-Cuban culture. Having travelled from France to Martinique with both Breton and Levi-Strauss, there was a general consensus that they could better comprehend metaphysics by understanding these 'primitive' cultures. These were the inheritors of an understanding of myth and reality that had not been tainted by Western social mores. Often Lam's paintings are populated by spiritual figures set against a sacred jungle as in *The Jungle* (1943). His art, although schooled in the European tradition, moves towards a distinctly non-European mode of representation that is not imbued with a sense of colonial 'otherness', offering instead an alternative modernism.

MEDIUM
Oil on paper, laid down on canvas

SIMILAR WORKS
Roberto Matta, *To Yennes*, 1938

Wifredo Lam *Born* 1902 Sagua la Grande, Cuba

Died 1982

Wifredo Lam

Femme Cheval ('Woman-Horse'), 1947

Courtesy of Christie's Images Ltd/© ADAGP, Paris and DACS, London 2005

The *Femme Cheval*, a mythical figure based on Afro-Cuban culture that is able to communicate with the natural world, first made its appearance in Wilfredo Lam's painting *The Jungle* in 1943 as a masked figure vying for space with the other figures and dense vegetation of the rainforest. The same motif was used in *Femme Cheval*, a less menacing but dominant anthropomorphic figure that is no longer sharing the space with other figures. Instead the viewer is invited to focus and concentrate on her.

In 1946, Lam travelled with André Breton to Tahiti, extending his anthropological knowledge of African rituals and divinities by attending voodoo ceremonies. His paintings after this date reflect that growing interest in non-Western civilizations, incorporating mysterious totem-like images, often expressing violence and witchcraft, with anthropomorphic figures set against a foil of monochromatic backgrounds. In many ways there is an affinity with the art of Pablo Picasso his one-time mentor. However, as one writer has observed, 'For Lam, revolutionary violence was a means of liberation; in his hands, the victim in Picasso's canvas has become the aggressor'.

MEDIUM

Gouache on brown paper

SIMILAR WORKS

Pablo Picasso, *Woman Crying*, 1937

Wifredo Lam *Born* 1902 Sagua la Grande, Cuba

Died 1982

Tanning, Dorothea
The Truth about Comets and Little Girls, 1945

Courtesy of Christie's Images Ltd/© ADAGP, Paris and DACS, London 2005

The Truth about Comets and Little Girls is a reactionary painting by Dorothea Tanning against the rhetorical use of the *femme-enfant* by André Breton and other male Surrealists. In 1927 *L'Ecriture automatique* was published, showing the prototypical *femme-enfant*, a young pubescent woman whose naivety and purity would enable men to gain access to an unconscious that was untrammelled by social mores. She is depicted in a semi-hypnotic state sitting at a desk, poised to pen her 'automatic' thoughts. Max Ernst adopted this theme marrying a *femme-enfant* that inspired his own collage novel, *Dream of a Little Girl Who Wanted to Enter a Convent*. The girl, Marie-Berthe Aurenche, was still a minor when she left the convent where she was being educated to elope with Ernst, 16 years her senior. He was later to abandon her in the same way that he had already left his first wife in 1922, later marrying Tanning in America.

In 1944 Breton published *Arcane 17*, a novel based on the notion of the *femme-enfant* as the source of creation. The title is based on a tarot card 'the star', the symbol for hope, expressing Breton's belief in the power of love for a young woman, identifying her with the legend of Melusine, half woman, half fairy, who is in touch with the unconscious.

CREATED

Mexico

MEDIUM

Oil on canvas

SIMILAR WORKS

Paul Delvaux, *All the Lights*, 1962

Dorothea Tanning *Born* 1910 Illinois, USA

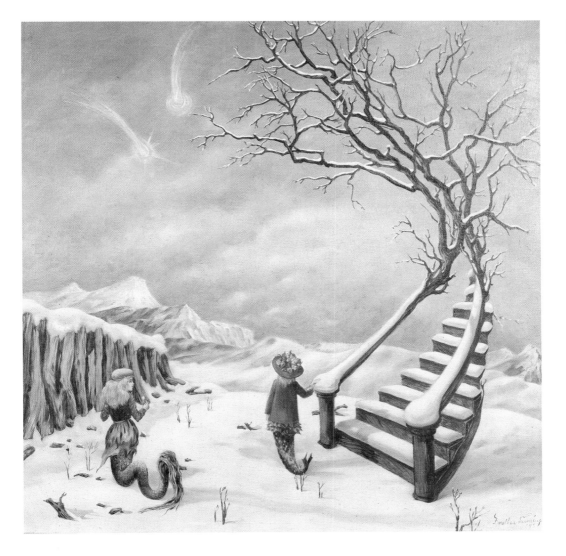

Tanning, Dorothea

Pincushion to Serve as Fetish, 1965

Courtesy of Tate, London/© ADAGP, Paris and DACS, London 2005

During the early 1930s, a number of the male Surrealists adopted the idea of the Surrealist 'object', a fetish expression for desire, manifest as a substitution for a part of the female anatomy or an item of women's clothing. Fetishism as a discourse had been in existence since the nineteenth century through the writings of the sexologist Richard von Krafft-Ebing; a discourse that Sigmund Freud entered into, arguing that 'the fetish is a substitute for the woman's (mother's) penis that the little boy had once believed in'. Freud proposed that these ideas remained repressed until adulthood, when if the masculine ego was threatened would re-emerge as anxieties that led to unconscious fantasies, which if he was unable to express would resort to the fetish as a substitute for the woman (mother).

Male Surrealists tended to express fetishism as sexually deviant, but of course in anthropology it is a concept of devotion to objects themselves. This is particularly relevant to the worship of spirits through the devotion of specific objects, for example in parts of Africa and Haiti where voodoo is practiced. Dorothea Tanning's *Pincushion to Serve as Fetish*, is both a humorous sideswipe at the male ego (its motif taken from Man Ray's *Untitled* of 1933) and the more serious anthropological comment on superstitious magic and the Hermetic tradition that female Surrealists found so appealing.

CREATED

France

MEDIUM

Cotton velvet, lead, steel pins, plastic funnel, sawdust and wool

SIMILAR WORKS

Man Ray, *Untitled*, 1933

Dorothea Tanning *Born* 1910 Illinois, USA

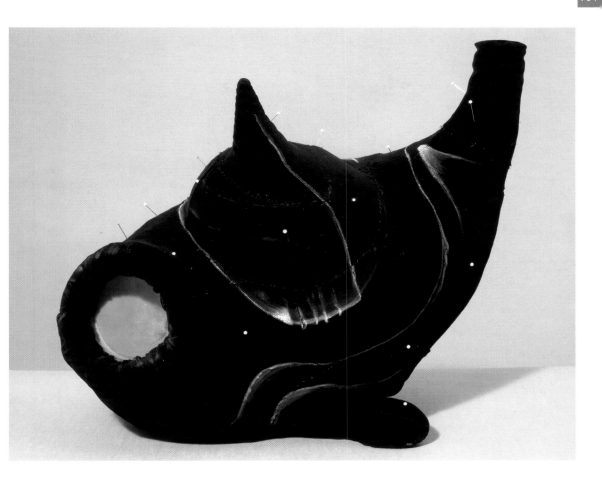

Tanning, Dorothea

La Mort et la jeune fille
('Death and a Young Girl'), 1953

Courtesy of Christie's Images Ltd/© ADAGP, Paris and DACS, London 2005

Dorothea Tanning's first exposure to Surrealism was in New York at the Fantastic Art, Dada and Surrealism exhibition in 1936, where she would have seen Max Ernst's *Two Children Threatened by a Nightingale*, which was one of the exhibits. It depicts two children one of whom is reaching out of the picture's plane to a door handle that has been glued on to the frame. In 1942 Tanning met Max Ernst in New York, an émigré escaping the European war, and it is clear from this point on that Tanning was influenced by him. However, although she used, for example, the door motif in much of her work, Tanning added her own childhood memories to the *mise en scène*.

Pubescent or pre-pubescent girls experiencing the tension between reality and fantasy, metaphysical conundrums of the visible world and the unconscious forces that can inhabit that same world, often populate Tanning's pictures. In *La Mort et la jeune Fille* we are left to ponder the fate of the young girl. Tanning's work is never sexually explicit, but it is charged with emotional sexuality particularly aimed at the advent of puberty. She wrote, 'Today you have been born out of abysmal sorrow and knowledge, out of hates and holocausts, love and the devil'.

MEDIUM

Oil on canvas

SIMILAR WORKS

René Magritte, *Gigantic Days*, 1928

Dorothea Tanning *Born* 1910 Illinois, USA

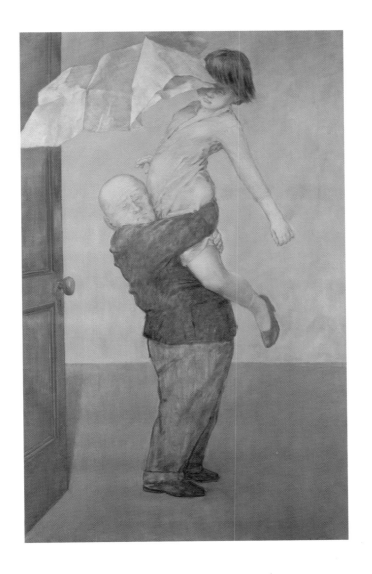

Tanning, Dorothea

Birthday, 1942

Birthday was painted by the artist on the occasion of her thirtieth birthday and marked the beginning of her work under the influence of Surrealism. In its aesthetic it resembles the Magic Realism of Pierre Roy (1880–1950), the illusionary qualities of Magritte and the strange and sometimes menacing images of Max Ernst whom she was later to marry.

As with most self-portraits, particularly within Surrealism, there is a duality of being; the person observed and the observer. For Tanning and other women Surrealists, the self-portrait is also a metaphor for their attempt to determine the inner and outer realities. In Tanning's case these 'realities' were a key aspect of her upbringing. On one side her Swedish father instilled a strict Lutheran discipline in the household, while her mother dressed Dorothea and her sisters in expensive gowns and dreamed of a theatrical career for them. *Birthday* demonstrates this tension well. Dorothea is dressed in the remnants of silk and taffeta and yet her feet are bare and her breasts exposed in a rebellious manner, reflecting the oppositional forces of conformity and fantasy. The creature in the foreground, although mythical, resembles a lemur, a creature associated with the spiritual world and the unconscious as revealed in dreams.

MEDIUM

Oil on canvas

SIMILAR WORKS

Léonor Fini, *Self Portrait*, 1942–43

Dorothea Tanning *Born* 1910 Illinois, USA

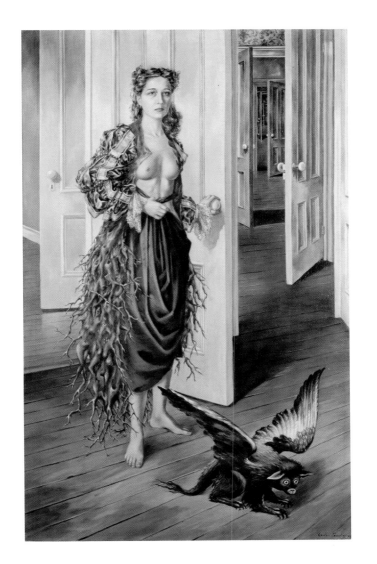

Seligmann, Kurt
The Alchemists, 1949

Kurt Seligmann's *The Alchemists* is typically an example of the influences generated by André Breton's *Second Manifesto of Surrealism* in which he refers to notions of mysticism and alchemy. Breton regarded himself as the successor to the alchemic tradition that had sought the philosopher's stone in the days of the great fifteenth-century French alchemist Nicholas Flamel. Flamel, who owned a bookshop at the back of the church of St Jacques, whose tower was still present in Breton's Paris, had claimed to have discovered the secrets of transmutation. This secret, originally manifest to Flamel in a dream, was published as a treatise in the eighteenth century. For Breton this treatise would add authenticity to his own ideas of an alchemy that would 'take brilliant revenge on the inanimate'.

Seligmann, a Swiss-born artist, had from an early age shown more than a passing interest in the occult and ethnology. This had linked him with the interests of Breton, who welcomed him as a member of his group in 1937, although he was only ever considered a peripheral member. Seligmann's other influence would have been another Swiss-born artist Johann Heinrich Füssli (later anglicized to Henry Fuseli), whose eighteenth-century nightmarish depictions would have been known to him.

MEDIUM

Oil on canvas

SIMILAR WORKS

Edward Burra, *Dancing Skeletons*, 1934

Kurt Seligmann *Born* 1900 Basel, Switzerland

Died 1962

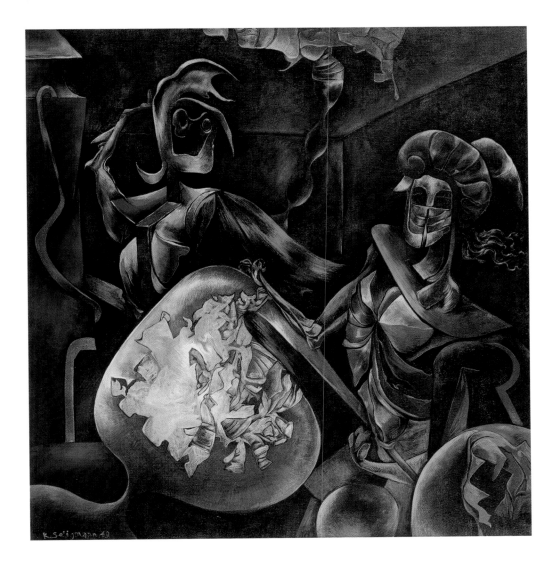

Fini, Léonor
Os Lyaque, c. 1948

Like many of the women Surrealists, Léonor Fini found André Breton overbearing. Nevertheless her friendships with many of Surrealism's protagonists including Max Ernst and René Magritte enabled her to participate in Surrealist ideas if not within Breton's group itself. Fini was self-taught, fiercely independent and in 1943 spent time in Corsica beginning a number of paintings based on nature's repetitive life cycle.

Writing in 1931 Breton found a poetic parallel between women and nature, or in his case women's anatomical parts and flora and fauna: 'My wife with the armpits of marten and beechnut/And Midsummer night/Of privet and wentletrap nests/With the arms of the sea-surf and mill-dam foam/And of wheat and mill mixed.' These metaphors linking women and nature are a recurrent theme of (male) artists across previous artistic generations, but with Surrealism these notions were also adopted by its female protagonists, most notably Fini and Georgia O'Keefe (1887–1986). In *Os Lyaque*, Fini combines a bleached bone whose partial metamorphosis reveals the head of a dinosaur. Its juxtaposition with autumnal leaves and the new shoots of growth together represent an unchanging life cycle that finds a resonance with humanity, implying that one individual does not represent the survival of the species.

CREATED

Paris

MEDIUM

Oil on canvas

SIMILAR WORKS

Georgia O'Keeffe, *Mule's Skull with Pink Poinsettias*, 1937

Léonor Fini *Born* 1908 Buenos Aires, Argentina

Died 1996

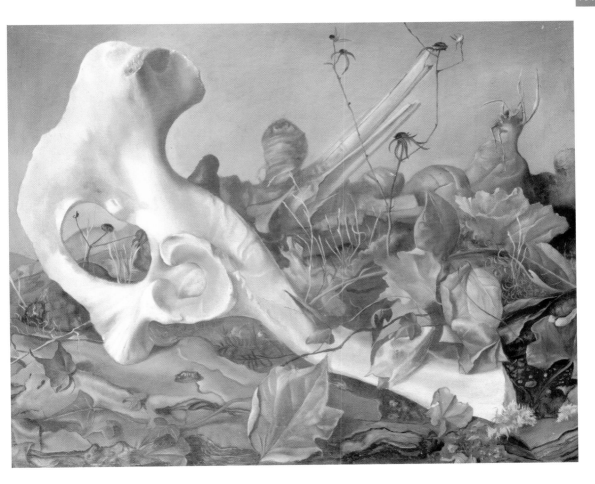

Fini, Léonor

Composition with Figures on a Terrace, 1939

Courtesy of Ex-Edward James Foundation, Sussex, UK/www.bridgeman.co.uk/© ADAGP, Paris and DACS, London 2005

Léonor Fini's was a precocious talent, nurtured from an early age, and she believed passionately in an autonomous and independent (feminine) art. Her knowledge of European art history was gleaned from hours of study in her uncle's library where she learned to appreciate Mannerist paintings, which were dominated by a male protagonist and a submissive or passive female. In *Composition with Figures on a Terrace* Fini subverts this stereotype in which she plays the dominant role, dressed in a voluminous skirt and with an accentuated hairstyle that gives her presence. By contrast the male is passive, his sword, so often a symbol of male strength in historical narrative paintings, removed and propped against the wall in the background. His passivity and that of the other male in the distance is emphasized by the presence of the other two women. The one in the foreground sits at a higher level than the man next to her, while the distant woman appears to dominate (in scale) the man leaning against the railings.

Although Fini's pictures such as this are imbued with a sense of male and female sexual confrontation and tension, her compositional strategies refuse to allow the woman to be objectified by the 'male gaze'.

MEDIUM

Oil on canvas

SIMILAR WORKS

Leonora Carrington, *Self Portrait*, 1938

Léonor Fini *Born* 1908 Buenos Aires, Argentina

Died 1996

Brauner, Victor
Chimera, 1939

At the time of painting *Chimera*, Victor Brauner was recovering from the loss of an eye after a brawl, but still produced some of his most inspirational Surrealist paintings, causing André Breton to remark that his work contained, 'that same sense of the most startling scene in a "modern gothic" novel'. Brauner, like his father, had always had a passionate interest in spiritualism and the occult. The period after his accident is marked by a series of paintings that reflect his interest in mythology, which he interprets using a modern idiom. Chimera is traditionally a mythical female beast with the head of a lion that breathes fire, the middle part of a goat and the tail of a dragon, its total exemplifying the complexities of evil. The creature was slain by Bellerophon, riding on his winged horse Pegasus.

In Brauner's interpretation, the figure on the left is chimeric, a hybrid of grafting one organism on to another. Only the head and face have recognizable human form, the torso and legs appear to be a mannequin similar to those used in many of Giorgio de Chirico's paintings and adopted as a motif by René Magritte.

CREATED

Paris

MEDIUM

Oil on canvas

SIMILAR WORKS

René Magritte, *The Birth of the Idol*, 1926

Victor Brauner *Born* 1903 Piatra-Neamt, Romania

Died 1966

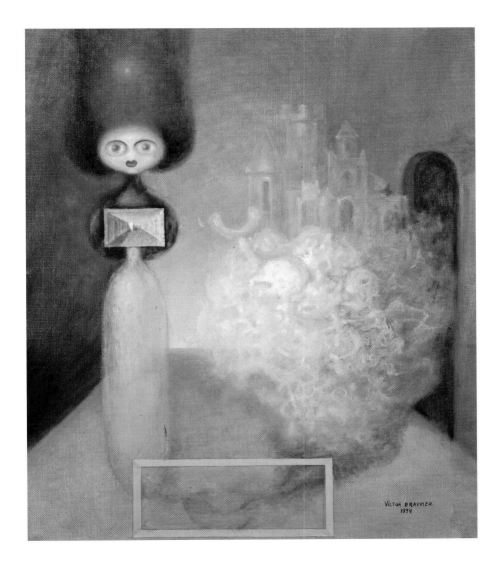

Brauner, Victor
Les Prestiges de L'air, 1934

André Breton officially included Victor Brauner in the circle of Surrealists in 1932, having seen his now-infamous *Self Portrait with Enucleated Eye* painted in 1931. Two years later he wrote the introduction for the catalogue of his first one-man exhibition at the Galerie Pierre, which probably included *Les Prestiges de L'air*. In this work Brauner continues to harvest his preoccupation with the occult using an Egyptian motif. The inspiration for this motif may well have emanated from his discussions with Georges Hénein, an Egyptologist with Trotskyite sympathies who was living in Paris at this time.

Although most of the Surrealists under Breton had sympathized with the Communist cause, mainly as a counteraction to the growth of Fascism in Europe, there was a growing concern about the totalitarianism exercised in the Soviet Union by Stalin. In its place Breton and others were looking to Leon Trotsky, the exiled former member of the Politburo who was ousted from the Soviet Russia in 1929. Variously living in France, Turkey and Norway before finally settling in Mexico, Trotsky continued to be an influential dissident writer and orator of the Marxist cause, not least on the more political activists within the Surrealist group.

MEDIUM

Oil on canvas

SIMILAR WORKS

Valentine Hugo, *Le Harfang des Neiges*, 1932

Victor Brauner *Born* 1903 Piatra-Neamt, Romania

Died 1966

Brauner, Victor
Cup of Doubt, 1946

Courtesy of Museu de Arte, Sao Paulo, Brazil/www.bridgeman.co.uk/© ADAGP, Paris and DACS, London 2005

After fleeing Paris during the Nazi occupation, Victor Brauner lived in the Hautes-Alpes. Deprived of art materials, he began a series of paintings in which the canvas was primed with melted candle wax. Once again the motif used was based on myth and the Hermetic tradition. *Cup of Doubt* appears to be based on an Egyptian hieratic motif that included a dog or wolf in the lower right of the picture. The wolf makes an appearance in a number of Brauner's works of this period, including his infamous Surrealist 'object', *The Wolf Table* (1947).

After a successful one-man exhibition at the Galerie Pierre Loeb in 1946, Brauner made a number of new works for the Exposition Internationale du Surréalisme at the Galerie Maeght in 1947. The exhibition, organized by André Breton and Marcel Duchamp, was designed to put new impetus into the Surrealist group after Breton and those of his circle had returned from exile. Designed as an 'event' for the visitors, the exhibition posed a number of obstacles to the viewing of the works. For example, the visitor had to pass through the 'Hall of Superstitions', in which Max Ernst had painted a number of mythical shapes on the floor that were designed to disturb, before proceeding into the next room.

MEDIUM

Wax on cardboard

SIMILAR WORKS

Jacques Hérold, *La Femmoiselle*, 1945

Victor Brauner *Born* 1903 Piatra-Neamt, Romania

Died 1966

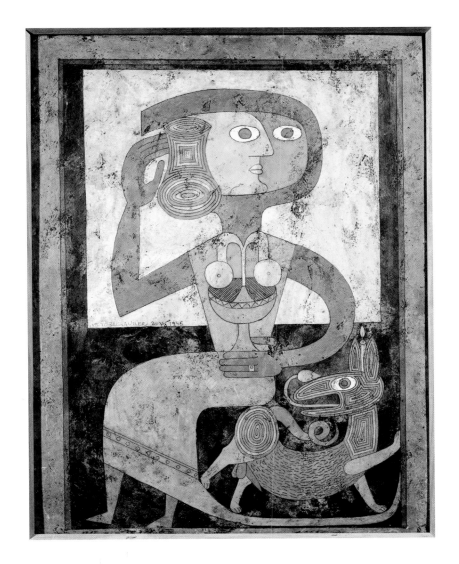

Dominguez, Oscar

Souvenir de Paris, 1932

Oscar Dominguez was something of a peripatetic Surrealist. Originally from Tenerife he lived in Paris from 1927, coming under the influence of the avant-garde, which after 1929 included the Surrealists. In 1933 he held a one-man exhibition of his work at the Circulo de Bellas Artes in Tenerife and was instrumental thereafter in disseminating Surrealist ideas throughout his native Canary Islands. He contributed to its art journal *Gaceta de arte* and organized another group exhibition of Surrealist work at the Ateneo, Santa Cruz de Tenerife in 1935. Dominguez's work was included in the Fantastic Art, Dada, Surrealism exhibition in New York and he helped to organize the international Surrealist exhibitions in Copenhagen and London in 1936; and Tokyo, Paris and Amsterdam in 1937.

Souvenir de Paris is something of an enigma in much the same way as Henri Matisse's *Souvenir de Biskra* is. Is this a genuine and nostalgic reminiscence or an ironic ambiguity? The Eiffel Tower refers to Paris in the distance, but there is an ambiguity in the direction of the tunnel. Analagous to de Chirico's 'trains' we are unsure of arrival or departure. The figure in the middle distance seems to be moving away from Paris and yet the tunnel's entrance seems to draw the viewer towards the city.

MEDIUM

Oil on panel

Oscar Dominguez *Born* 1906 La Laguna, Spain
Died 1958

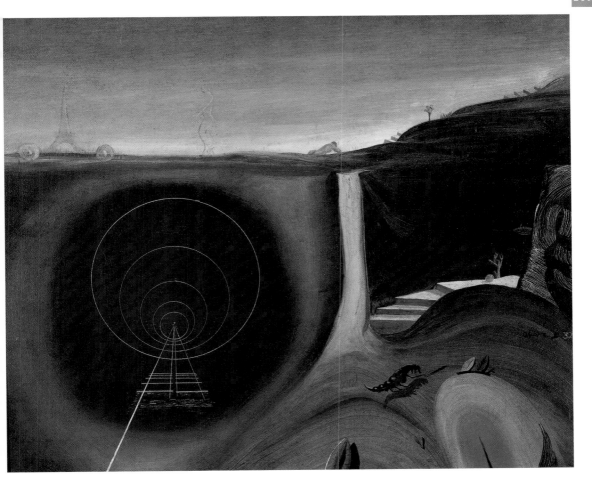

Dominguez, Oscar
Decalcomania, 1935

The full title of these works was 'Decalcomania without any preconceived aim', a series of paintings developed by Oscar Dominguez in 1935. They were based on Max Ernst's frottages in which an 'automatically' produced work could be left as a product of random choice, or developed using the original marks. Dominguez applied paint randomly to a smooth surface, pressed a second sheet on to it and then peeled it off to reveal random paint marks. This was usually repeated and sometimes turned or even deliberately smudged to create a series of marks in layers. Depending on the colours used, the images had an ambiguity that could reveal themselves in different ways. More often than not Dominguez would leave the ambiguity in place for the viewer by titling the works simply by the process used, *Decalcomania*.

The technique was used by European writers of the nineteenth century, the shapes providing inspiration, but it was used extensively in the 1920s by the psychologist Hermann Rorschach in what came to be known as the Rorschach test, an analytical test that would reveal clues as to the subject's personality. It was this aspect, with its elements of chance and inner reflexivity, which was probably appealing to Dominguez.

MEDIUM

Mixed media

SIMILAR WORKS

Georges Hugnet, *Untitled Decalcomania and Collage*, c. 1935

Oscar Dominguez *Born* 1906 La Laguna, Spain

Died 1958

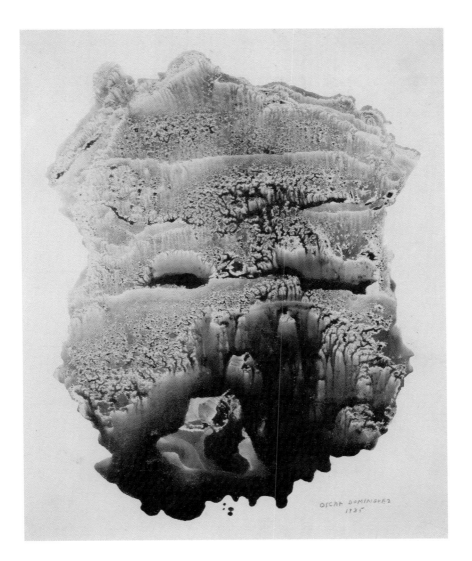

Dominguez, Oscar
Marine Rutting, 1935

Courtesy of Galerie Daniel Malingue, Paris, France/www.bridgeman.co.uk/© ADAGP, Paris and DACS, London

In 1935 Oscar Dominguez curated the International Surrealist Exhibition in Tenerife, at a time when he was a relatively new recruit to André Breton's Surrealist group. His involvement was as enthusiastic as any new recruit and during this year he created a number of paintings as well as Surrealist 'objects' such as *Peregrinations of Georges Hugnet*, a wood and metal collage work that depicts a horse passing through the frame of a bicycle. The work evokes his own childhood memories of cycling around the streets, calling at amusement arcades to replace novelties in slot machines. It is unclear whether *Marine Rutting* was painted before or after *Peregrinations*, but clearly both works are linked, Dominguez often using the same motif in subsequential 'objects' and paintings. *Marine Rutting* suggests a transition between childhood and adulthood as depicted in the two halves of the picture plane, which are separated by the transparent sheet. The horse on the left is redolent of a rocking or fairground horse that is not real, whereas the one on the right is suggestive of a racehorse. The rhomboidal aperture in the transparent screen also symbolizes this transition, being identical in shape to the kite and its association with childhood.

MEDIUM

Oil on canvas

SIMILAR WORKS

René Magritte, *Carte Blanche*, 1965

Oscar Dominguez *Born* 1906 La Laguna, Spain

Died 1958

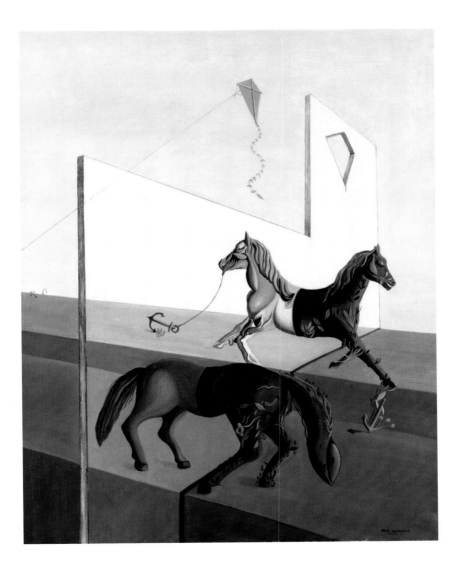

Dominguez, Oscar
L'Ouvre boîte, 1936

Used in this context *boîte* means a tin, as in sardine tin, rather than a box. The circumference of the tin is delineated by the picture frame containing the image and is revealed to the viewer by the large key on the right-hand edge, which opens it. The image depicts a ship whose hull has been opened using a similar device. A hand can be seen pointing towards an overcast sky. The person standing on the quay has also been 'opened' by two keys, his leg resembling an unfolding sheet of metal. Its head has been metamorphosed into a shotgun, which has just released a salvo of pellets. There are aspects of Futurism in the work, the figure resembling Umberto Boccioni's *Unique Forms of Continuity in Space* (1913) and the ship redolent of C. R. W. Nevinson's *The Arrival* (1914).

Is the image suggestive of the Greek legend of Pandora who, having opened the box, revealed all the evils that have beset mankind? As with so many Surrealist images it is an enigma but is possibly a symbolic depiction of Noah and the Ark to an increasingly godless society faced with an impending European war. The hand may be that of God, warning of the impending doom.

MEDIUM

Oil on canvas with tin-opener fixed to original frame

SIMILAR WORKS

C. R. W. Nevinson, *The Arrival*, 1914

Oscar Dominguez *Born* 1906 La Laguna, Spain

Died 1958

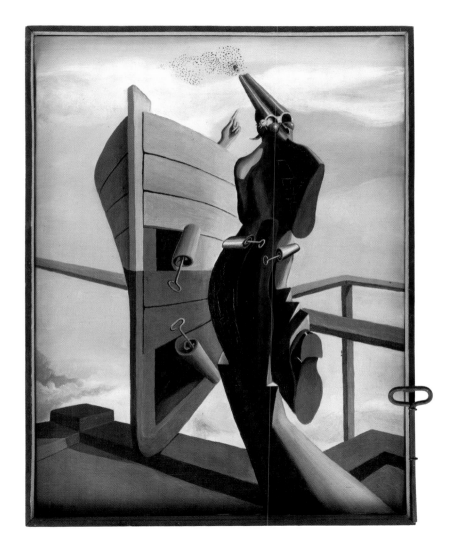

Moore, Henry

A Child Suckling, 1930

Although Henry Moore won a scholarship to the Royal College of Art in 1921, he soon found the Greco-Roman tradition of modelling and casting sculpture too stifling. He was later to refer to removing 'the Greek spectacles from the eyes of the modern sculptor'. Instead Moore sought direct carving from a range of materials influenced by the pre-Columbian art that he had seen in the British Museum. Direct carving also had its antecedents in the work of the then recently deceased sculptor Henri Gaudier-Brzeska (1891–1915) and in the aesthetic theories of John Ruskin (1819–1900), who advocated a 'truth to materials'. Moore's adoption of this maxim allowed him to respect the inherent character of the material, whether it was stone or wood.

A Child Suckling marks the beginning of a period of change in Moore's approach to sculpture, which had begun the year before with his *Reclining Figure* made in Hornton stone. This and subsequent sculptures were influenced by the 'Metamorphosis' works of both Hans Arp and Pablo Picasso, whose work Moore must have seen on his regular trips to Paris and from the reading of Surrealist journals such as *Minotaure*. The mother and child motif continued to be preoccupation in Moore's future work.

MEDIUM

Alabaster

SIMILAR WORKS

Pablo Picasso, *Bather (Metamorphosis I and II)*, 1928

Henry Moore *Born* 1898 Yorkshire, England

Died 1986

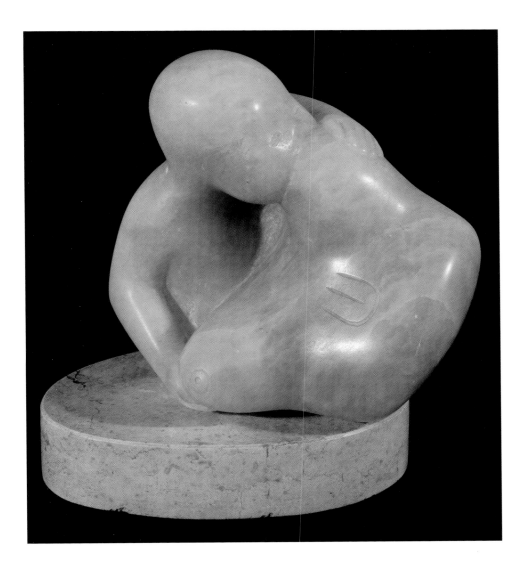

Moore, Henry

Reclining Figure, 1936

Reclining Figure is one of many versions of this title that Henry Moore undertook both in wood and stone. Moore's work, alongside that of Barbara Hepworth (1903–75), is often delineated from more conventional sculpture by the appearance of 'holes'. This development of the modernist aesthetic explored the balance, or tension, between the form and the vacant space it occupied, sometimes known as 'anti-form'. In essence the space passes through the figure, thus relinquishing its defences or its 'closedness'. Moore's first work of the 'pierced form' in 1932 came as a result of a 'found' object, in this case a stone, in which nature's erosion had predetermined where the hole should appear. The essence of 'chance' in the work conformed to Surrealist ideals that Moore had already been considering at that time.

In *Reclining Figure* the 'holes' appear and disappear depending on the focal plane of the viewer. They can help to create a figure that is sexually ambiguous in its pose, drawing the viewer into the 'secret' places of its anatomy and yet denying access because of the infinity of the 'holes'.

MEDIUM

Elmwood

SIMILAR WORKS

Hans Arp, *Two Thoughts on a Navel*, 1930

Henry Moore *Born* 1898 Yorkshire, England

Died 1986

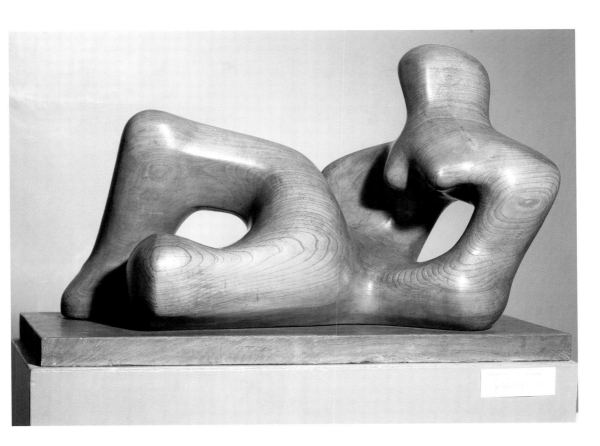

Moore, Henry
Mother and Child, 1938

In a further development of the 'holes' in his sculpture, which he felt were imbued with spirituality, Henry Moore added string to the spaces creating a further ambiguity in the work. Now the 'holes' or spaces could be delimited and at the same time draw the viewer's eye towards their 'innerness'. Thus there is a further tension between the interior and the exterior, the open and the closed, which is alluded to by the use of the tense string.

Moore was interested in natural phenomena such as caves, which he equated to the natural enveloping qualities of a mother's womb. In Surrealist and Freudian terms the desire for the mother's womb is both regressive and highly erotic. In *Mother and Child*, Henry Moore returned once again to a timeless and Classical theme that had occupied his earlier career. By the late 1930s he had adopted a less doctrinaire view about a 'truth to materials', having this work cast in lead. The model for this was probably made in plaster, which would have been carved once hard. By this time Moore was working in Hampstead, London, in the company of many European exiles fleeing Nazi persecution such as the sculptor Naum Gabo (1890–1977).

MEDIUM

Lead and string

SIMILAR WORKS

Barbara Hepworth, *Pelagos*, 1946

Henry Moore *Born* 1898 Yorkshire, England

Died 1986

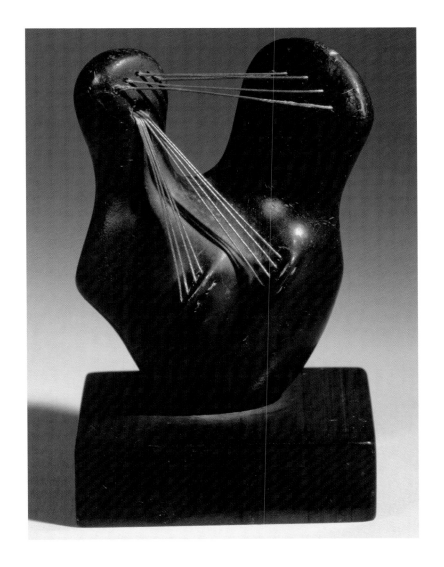

Oppenheim, Meret

Objet (Déjeuner en fourrure)
('Object (Fur Breakfast)'), 1936

Object (Fur Breakfast) was and continues to be an icon of Surrealism, more recently because of its iconic status within the feminist movement. It was originally conceived by Meret Oppenheim (1913–1985), a Swiss artist who had joined the Surrealists shortly after her arrival in Paris. It was to be a participatory work for inclusion in the Surrealist 'objects' exhibition at the Galerie Charles Ratton in 1936. Having purchased a 'ready-made' from the department store Uniprix, Oppenheim then covered it in gazelle fur. The title, given by André Breton, plays on the titles of other iconic modern works by Edouard Manet (1832–83) (*Le Déjeuner sur l'herbe*) and Léger (*Le Grand déjeuner*), in which the female nude takes centre stage. Oppenheim used a Dada methodology to subvert their bourgeois status by using mass-produced ubiquitous objects, thus removing what the writer Walter Benjamin called the 'aura' of the art object.

Object (Fur Breakfast) became iconic at the time of its making, not just through the witty sexual innuendo of punning, but because of its manifest appeal to the Surrealists through the photography of Man Ray. For them the appeal was in the subversion of rational logic in order to provide a platform for the exploration of a deeper logic, that of the unconscious.

CREATED

Paris

MEDIUM

Cup, saucer and spoon covered in gazelle fur

SIMILAR WORKS

Salvador Dali, *Lobster Telephone*, 1936

Meret Oppenheim *Born* 1913 Berlin, Germany

Died 1985

Oppenheim, Meret
Occasional table, 1939

In this work Meret Oppenheim continues with a number of Surrealist preoccupations, the most significant of which is the preconception of specific gender roles and stereotyping in a patriarchal society. At first this object may appear as an opulent or even decadent excess of Art Deco design for the bourgeois market, particularly in its use of gold leaf. Oppenheim is, in line with Dada and Surrealist ideals, commenting on bourgeois excesses, as well as on gender stereotypes. As a (male) viewer one is drawn to the legs, to consider their shape before considering their functionality. There is an obvious parallel here with women being viewed in the same stereotypical manner. The viewer is also being denied access to the rest of the body, emphasized by the flatness and width of the table's top.

Oppenheim was certainly among the youngest of the Surrealist generation of the 1930s and yet seemed to embody Surrealism and its ethos. Celebrated as the 'fairy woman whom all men desire' she was photographed most famously by Man Ray. The photograph depicted her naked standing behind a printing press, one arm covered in black ink. The photograph is highly erotic and yet denies access to her body, through the intervention of the press's wheel and the ink-stained arm.

CREATED

Paris

MEDIUM

Wood with gold leaf and brass

SIMILAR WORKS

Alan Jones, *Table Sculpture*, 1969

Meret Oppenheim *Born* 1913 Berlin, Germany

Died 1985

Dalí, Salvador

The Persistence of Memory, 1931

Before joining the Surrealist group formally in 1929, Salvador Dali imbued his work with a sense of the fantastic and the extraordinary, personified in the work of the Old Masters such as Hieronymus Bosch and in his own time by Giorgio de Chirico. In *The Persistence of Memory*, one of his earlier Surrealist works, Dali was influenced by Bosch's *Garden of Earthly Delights*, which he combined with a Catalan background, a feature of much of his early work. This painting was one of the first Dali executed using his 'paranoid-critical' approach in which he depicts his own psychological conflicts and phobias.

The Persistence of Memory contains a self-portrait over which is draped a 'soft watch'. For Dali, these 'soft watches' represent what he called the 'camembert of time', suggesting that the concept of time had lost all meaning in the unconscious world. The ants crawling over the pocket watch suggest decay, an absurd notion given that the watch is metallic. These 'paranoid-critical' images reflect Dali's reading and absorption of Freud's theories of the unconscious and its access to the latent desires and paranoia of the human mind, such as the unconscious fear of death alluded to in this painting.

MEDIUM

Oil on canvas

SIMILAR WORKS

Yves Tanguy, *The Cupboard of Proteus*, 1931

Salvador Dalí *Born* 1904 Figueres, Spain

Died 1989

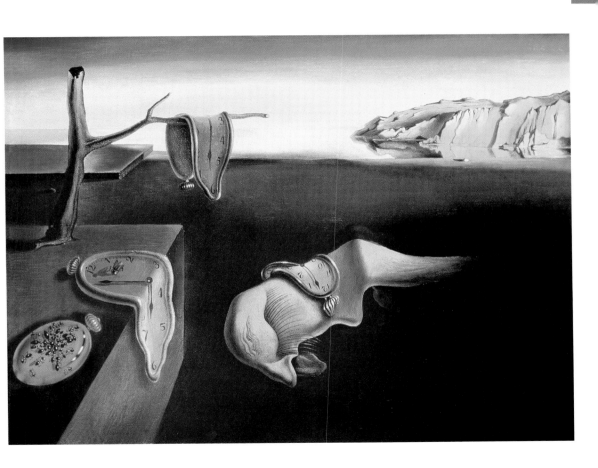

Dalí, Salvador

Banlieue de la Ville Paranoique
('Suburb of the Paranoiac-critical Town'), 1936

Salvador Dalí continued his 'paranoid-critical' approach, in *Suburb of the Paranoiac-critical Town*, which is based on certain motifs in the paintings of Giorgio de Chirico. More importantly they are also based on the paranoia alluded to in de Chrico's work. In an earlier preparatory drawing for this work, Dalí included a young girl skipping, redolent of the girl in de Chirico's *Mystery and Melancholy of a Street* (1914).

Dalí's 'paranoid-critical' method was based on the writings of the psychiatrists Georg Kraepelin and Eugen Bleuler, who earlier in the twentieth century began to formulate theories concerning paranoia and schizophrenia. Dalí's particular interest was their assertion that paranoia 'lends itself to the coherent development of certain errors to which the subject shows a passionate attachment'. In 1932 Freud's own work on paranoia was translated, and in 1933 the psychoanalyst Jacques Lacan published two articles in *Minotaure* on the subject including *Paranoid Forms of Experience*. However, Lacan was also informed by Dalí's own 1930 writing on the subject, *L'Âne Pourri*. For Dalí, his 'paranoid-critical' approach, which was meant to destabilize preconceived notions of reality, enabled him to depict objects and scenarios that could have alternative meanings for the viewer.

MEDIUM

Oil on canvas

SIMILAR WORKS

Giorgio de Chirico, *Piazza d'Italia*, 1916

Salvador Dalí *Born* 1904 Figueres, Spain

Died 1989

Dalí, Salvador

Soft Construction with Boiled Beans (Premonition of Civil War), 1936

Salvador Dali famously remarked that in the painting *Soft Construction with Boiled Beans* he had foretold the outbreak of the Spanish Civil War six months beforehand. In *The Secret Life of Salvador Dali* (1942), an egotistic self-promotional autobiography, Dalí relates the genesis of the work: '(I) showed a vast human body breaking out into monstrous excrescences of arms and legs tearing at one another in a delirium of auto-strangulation. As a background to this frenzied flesh devoured by a narcissistic and biological cataclysm, I painted a geological landscape that had been uselessly revolutionized for thousands of years, congealed in its normal course. The soft structure of that great mass of flesh in civil war I embellished with a few boiled beans, for one could not imagine swallowing all that unconscious meat without the presence (however uninspiring) of some mealy and melancholy vegetable.'

In this work Dali appears to take an apolitical stand, showing the Spanish as both aggressor and victim. However, this and another work *The Enigma of Hitler* (1938), portrayed him as a supporter of Franco and the Fascist cause, anathema to André Breton and the other Surrealists, which led to his removal from the Surrealist circle in 1939.

MEDIUM

Oil on canvas

SIMILAR WORKS

Wilhelm Freddie, *Portable Garbo*, 1941

Salvador Dalí *Born* 1904 Figueres, Spain

Died 1989

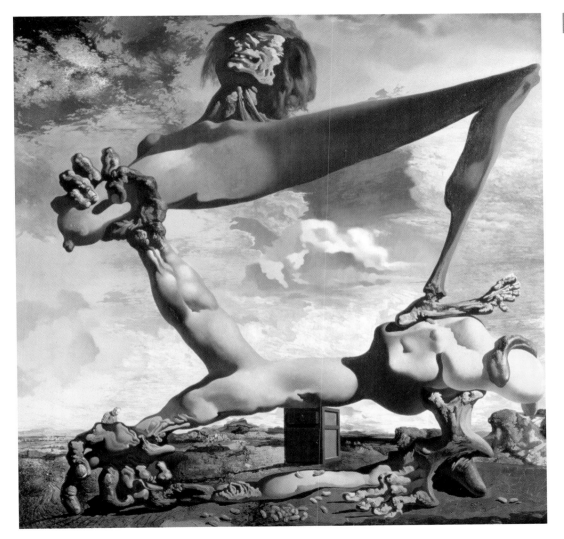

Dalí, Salvador
Le Sommeil ('Sleep'), 1937

In Shakespeare's *Hamlet*, the hero soliloquies: 'To sleep, perchance to dream. Ay, there's the rub; for in that sleep of death what dreams may come.' In *Le Sommeil* Salvador Dali returned to a classic Surrealist motif that was probably inspired by his inclusion in the exhibition of Surreal 'objects' at the Galerie Charles Ratton, in which the public were invited to 'touch their dreams'. Dreams are, of course, the essence of much Freudian theory because of their access into the unconscious, a preoccupational theme for the Surrealists, including Dali.

Freudian theory, however, extends beyond just a consideration of the unconscious. In the 1920s Freud proposed a theory, Thanatos or 'Death Instinct', in which he suggests that all animals, including humans, try to prolong their life by defending all threats of death that are inappropriate to their particular species. In humans this is manifest as aggression if the threat is external and self-destruction when directed at the self. The counterpart to Thanatos is Eros in which an individual life moves towards a 'natural' death. *Le Sommeil* seems to suggest that tension, the head in a catatonic state supported by a series of crutches.

CREATED

Paris

MEDIUM

Oil on canvas

SIMILAR WORKS

Roland Penrose, *Portrait of Valentine*, 1937

Salvador Dali *Born* 1904 Figueres, Spain

Died 1989

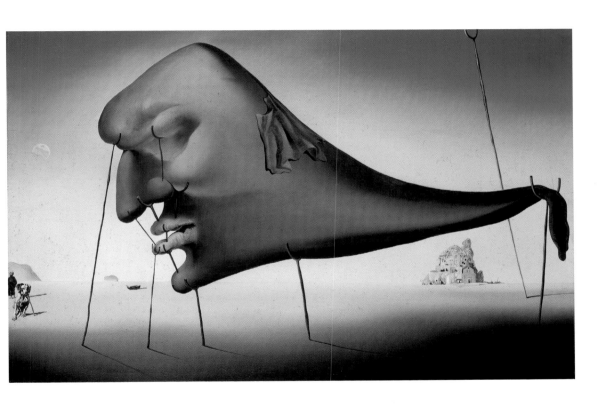

Dalí, Salvador

Lobster Telephone, 1936

These often witty juxtapositions in the Surrealist 'object' belie the seriousness of their purpose. The poet Le Comte de Lautréamont had already greatly influenced the Surrealists by describing the 'chance encounter of a sewing machine and an umbrella on a dissecting table' as an example of the arbitrary notions of chance that would provoke 'the most powerful poetic detonations'. Other Surrealists such as Alberto Giacometti (1901–1966), had produced 'objects' that were surreal, but it was Salvador Dalí who in 1931 seized on the general notion of a 'general catalogue of Surrealist objects'.

The Surrealist 'object', at least in Dalí's hands, had a duality of purpose. In a published article in 1931 he stated that, 'Objects which function symbolically leave no room for formal preoccupations. They depend only on the individual's amorous imagination', suggesting that their production is in advance of an Automatism of unconscious thought. Many of Dalí's 'objects' had sexual connotations, often in the context of fetishism. The 'object' also served to illustrate the pointlessness of the art object as codified by the Dadaists. In the same article Dalí stated, 'Museums will quickly be filled with objects whose uselessness, grandeur and clutter will necessitate the construction, in the desert, of special towers to house them'.

CREATED

Paris

MEDIUM

Telephone and plaster model of a lobster

SIMILAR WORKS

Meret Oppenheim, *My Nurse*, 1936

Salvador Dalí *Born* 1904 Figueres, Spain

Died 1989

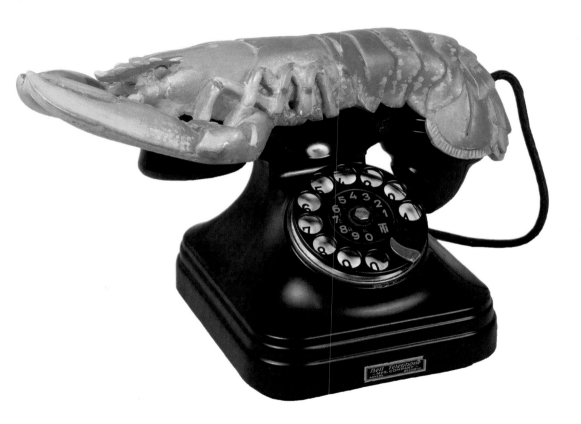

Dalí, Salvador

Retrospective Bust of a Woman, 1933

The reference to Jean-François Millet's (1814–1875) *The Angelus* is a key aspect of *Retrospective Bust of a Woman* by Salvador Dalí. Millet's famous picture is of a poor peasant couple facing each other in a field, lamenting the death of their child. The woman's hands are clasped together and her head is bowed in a prayerful pose. This image that Dalí remembered from his own childhood became an obsessive preoccupation for him in the period 1932 until 1935. Dalí's various interpretations of the motif are essentially sexual suggesting that the woman is akin to the preying mantis, paying pre-coital homage to her mate before eventually devouring him. According to Dalí the man had his hat lowered to conceal an erection. This allusion suggests a key Freudian concept of castration anxiety that Dalí was keen to explore within his 'paranoid-critical' method. In another depiction *The Architectonic 'Angelus' of Millet*, Dalí uses biomorphic forms that depict the probe of the female mantis penetrating the male, its phallic tenure by a female alluding to the ideal androgyny that had possession of both male and female genitalia.

Dalí's obsession is analogous to his reading and interpretations of Freud's *The Interpretation of Dreams*, revealing repressed desires and fantasies.

CREATED

Paris

MEDIUM

China dummy, painted bust with corn cob, cartoon film strip as collar and plastic replica of *The Angelus* with two inkwells and quills

SIMILAR WORKS

Wilhelm Freddie, *Sex-Paralypsappeal*, 1936

Salvador Dalí *Born* 1904 Figueres, Spain

Died 1989

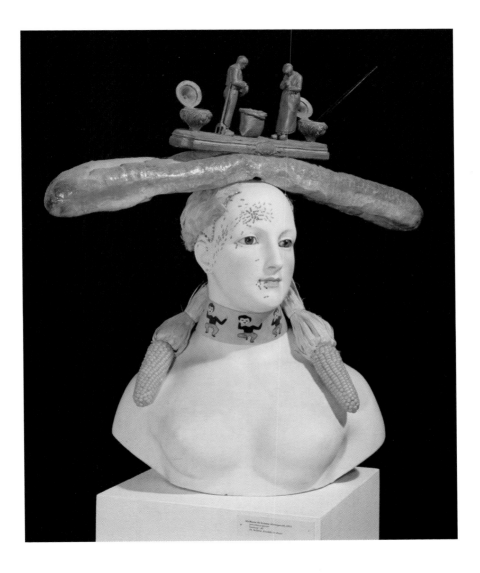

Magritte, René
The Annunciation, 1930

Courtesy of Tate, London/© ADAGP, Paris and DACS, London 2005

An artistic style that was singled out for particular criticism by the Surrealists was Purism, a post-Cubist aesthetic based on the 'machine art' of Le Corbusier (1887–1965) and others during the early 1920s. One such painting was Fernand Léger's *The Baluster* on view at Le Corbusier's Pavilion de l'Esprit Nouveau in 1925, which was criticized like other Purist works for its logical forms.

In his pre-Surrealist career René Magritte showed an empathy with much of the Purist aesthetic, but after seeing Giorgio de Chirico's painting *Song of Love* (1914) he began his interest in Surrealism. He was particularly interested in de Chirico's use of disparate and seemingly unconnected and/or displaced motifs. Partly as a tribute and partly as critique of Purist forms, Magritte selected the motif of the balustrade in many of his early works, such as *The Lost Jockey* (1925) in which the baluster (or bilboquet as Magritte called it) replaced the trunks of the depicted trees. The motif appears again in *The Annunciation* with the balusters replacing the Classical pillars within a traditional Renaissance depiction of the subject, such as Raphael's *Annunciation* of 1503.

MEDIUM

Oil on canvas

SIMILAR WORKS

Giorgio de Chirico, *The Enigma of a Day*, 1914

René Magritte *Born* 1898 Lessines, Belgium

Died 1967

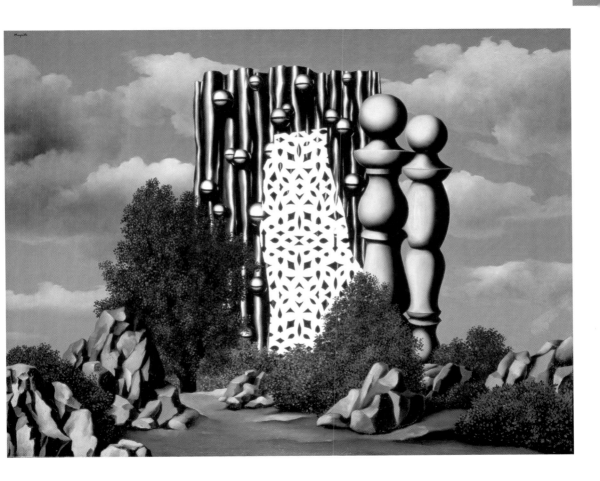

Magritte, René

The Human Condition II, c. 1930

A continual preoccupation for the Surrealists was the metaphysical, or the unpicking of *a priori* assumptions about the illusionary depiction of reality. In so much of his work, René Magritte wittily plays with these perceptions by addressing the problem laterally. In *The Human Condition II*, Magritte exemplifies the contradictions between the three-dimensional space and the limits of a two-dimensional canvas. More importantly the title refers to the relationship that humans have with those contradictions as part of 'the human condition'. As such Magritte continues the process of questioning the assumptions of Renaissance ideas of painting being a 'window on reality', which had already begun to be debunked by Picasso and Braque in their Cubist 'laboratory'. For Picasso 'reality was in the painting', replacing *trompe-l'oeil* for what he called *trompe-l'esprit*.

The Human Condition II was a variant of a painting executed in 1934, in which he began to explore the ideas around the theme of inside and outside. In the first version the painted canvas is placed in front of a glazed window. The second version adds another playful twist to the original, by suggesting that the viewer is already outside, looking through a *trompe-l'oeil* archway.

MEDIUM

Oil on canvas

SIMILAR WORKS

Marie Cernisova Toyen, *Myth of Light*, 1946

René Magritte *Born* 1898 Lessines, Belgium

Died 1967

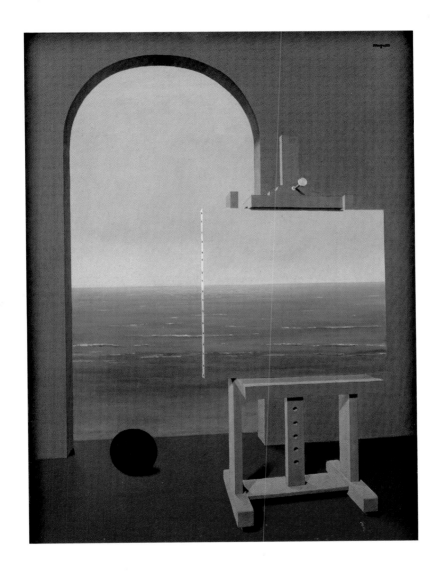

Magritte, René
Golconde, 1953

In a seminal text on modernism, *The Painter of Modern Life* (1863), its author Charles Baudelaire (1821–1867) discusses the *flâneur*, a 'man of the crowd' who can observe and yet remain anonymous with impunity; a text based on the hero of an Edgar Alan Poe tale that was translated by him into French.

René Magritte, who also paid homage to Poe in the painting *Not to be Reproduced* (1937), led a very reclusive life in his small terraced house in Brussels. He rarely travelled after 1930 and lived to all intents and purposes a petit bourgeois lifestyle. He was, however, a 'man of the crowd', regularly taking his dog Loulou for a morning walk and sitting in the Greenwich Café in the afternoons. These activities enabled Magritte to observe the minutiae and the extraordinary aspects of human life, the consequential and the inconsequential, the normal and the abnormal. The bowler-hatted men and drab houses in *Golconde* represent the anonymity of the artist's life, impassive and distant, a 'man of the crowd'. Magritte's collage style of a repeating motif reinforces these notions, but also enters a dialectic in which the absurdity of the men 'raining' makes the viewer question reality within a paradoxical matrix of contradictions.

MEDIUM

Oil on canvas

SIMILAR WORKS

Conroy Maddox, *Passage de l'Opéra*, 1940

René Magritte *Born* 1898 Lessines, Belgium

Died 1967

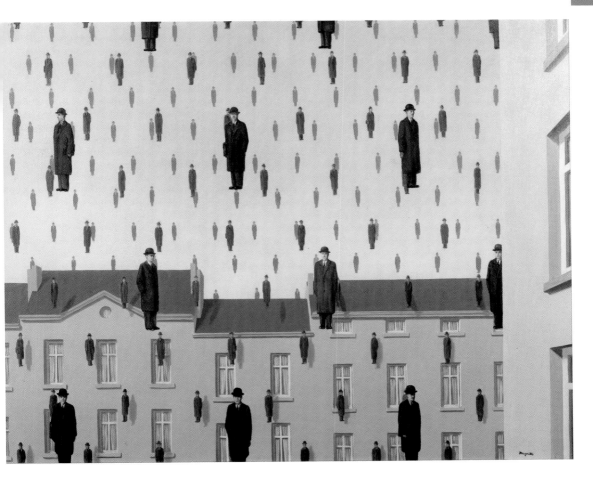

Magritte, René
The Treason of Images, 1955

Linguistics was already a discursive subject by the time René Magritte began his paintings about the paradox of reality as exemplified by words and images. For example, in his *Philosophical Investigations* Ludwig Wittgenstein held that words are tools to be used in a variety of ways dependent on their contextual use and that such use cannot necessarily be reconciled with reality. Magritte was interested not only in paradoxes of illusion and reality, as most Surrealists were, but also the manner in which language could disguise thought. In linguistics, an object can be denoted by the written word, or depicted as a resemblance of that object. However, the reconciliation of the two is dependent on the viewer/reader's own empirical experiences which may not correspond with the artist/writer.

Magritte's *The Treason of Images* presents the viewer with an image of a pipe with the accompanying text stating unequivocally, 'This is not a pipe'. For Magritte an image is not to be confused with a tangible object. An image of a pipe cannot be confused with the tangibility of a pipe's 'pipeness'. Magritte's concerns, like those of Wittgenstein, are the use, or misuse, of logic to break the tyranny of the written word. In essence there is no 'pipeness' in the word pipe or a depiction of a pipe.

MEDIUM

Gouache and watercolour on paper

SIMILAR WORKS

Eduardo Paolozzi, *Real Gold*, 1950

René Magritte *Born* 1898 Lessines, Belgium

Died 1967

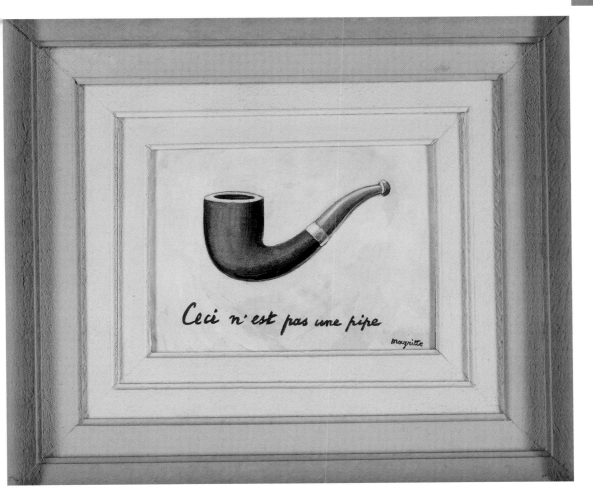

Magritte, René
Le Fils de l'homme, 1964

The bowler-hatted man came to personify René Magritte and his relative anonymity, the figure either depicted with his back to the viewer or his face obscured. In *Le Fils de l'homme* we are confronted by such a figure, his face obscured by an apple. This suggests not only the aspect of anonymity but also Magritte grappling with another modernist motif, the theory of relativity. Sir Isaac Newton's theories about gravity or 'the mechanical world view' were called into question following Einstein's theories about space and time, which were published in 1916 and in which he proposed an 'electromagnetic world view'.

Since Newton's gravitational theories were based on seeing an apple fall to the ground, Magritte positions his apple in suspension and we, the viewer, are unsure whether this is permanent or it is still falling. However, *Le Fils de l'homme* is not just a reflection of scientific progress. Magritte is deliberately subverting any dogmatic view of the physical world by disturbing its empiricist normalcy and questioning the compromise that humans make in reconciling the 'real' world. This plurality of experience, which corresponded with Einstein's Theory of Relativity, abolished the absoluteness of space and time in Newtonian terms, and thus the predictability of life.

MEDIUM

Oil on canvas

SIMILAR WORKS

Oscar Dominguez, *Max en bouteille*, 1939

René Magritte *Born* 1898 Lessines, Belgium

Died 1967

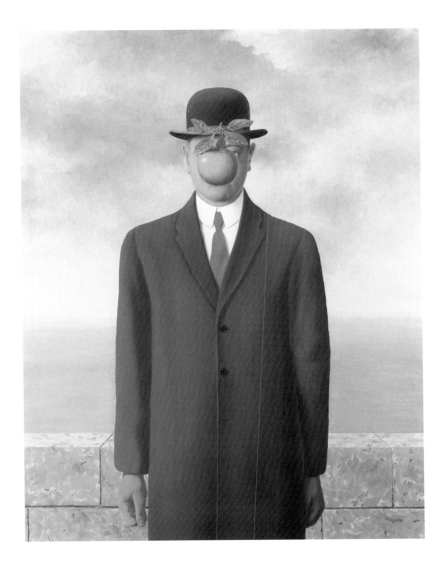

Tanguy, Yves
Je Vous Attends, 1934

Courtesy of Private Collection, Lauros/Giraudon/www.bridgeman.co.uk/© ARS, NY and DACS, London

According to the legend, Yves Tanguy was driven to painting after seeing one of Giorgio de Chirico's paintings in a gallery window. Tanguy had no formal training and was the only major Surrealist to be self-taught. The writer and poet Jacques Prévert (1900–77) introduced him to Surrealism, and it was with him that he shared a house on the rue du Château. Here regular Surrealist meetings took place during which the game of *Cadavre exquis* was played. This early exposure to Automatism was to be a key factor in Tanguy's oeuvre.

By the late 1920s Tanguy abandoned all reference to figuration, preferring the anthropomorphic and biomorphic forms that populate his canvases. He was never able to explain his work or its meanings, since everything was devolved from his own imagination and memory using the technique of Automatism. His earlier canvases are always imbued with a dark and sometimes menacing atmosphere that resembles a lunar or extraterrestrial landscape that stretches to infinity. As André Breton remarked, 'It will be a new horizon, one in front of which the no longer physical landscape will spread out'.

CREATED

Paris

MEDIUM

Oil on canvas

SIMILAR WORKS

Salvador Dali, *Fried Eggs on the Plate, Without the Plate*, 1932

Yves Tanguy *Born* 1900 Paris, France

Died 1955

Tanguy, Yves
Globe de glace, 1934

Yves Tanguy's pictures suggest a pre-human existence when organic forms were being shaped. *Globe de glace* seems to fit that, its title suggesting the aftermath of an ice age. The horizon is non-existent, the terrain and sky appearing to meld into a milky landscape. The viewer is unable to distinguish not only any sense of perspective through the lack of shadow, but also whether the terrain is wet or dry, what is hard and what is soft. There is no sense of mass in the objects, or whether they are living or dead. In many ways this 'landscape' is a reflection of the 'inner landscape' of our minds, defining that moment immediately before we fall asleep. André Breton referred to these 'dreamscapes' as 'not in the abstract, but at the very heart of the concrete'.

Although specifically referring to the work of André Masson, Breton referred to 'the chemistry of the intellect' in his use of Automatism. Tanguy appears to give a highly individualistic plasticity to that same idea, imbuing the work of Masson, Hans Arp and Joan Miró with a sculptural form that makes his work so innovative.

CREATED

Paris

MEDIUM

Oil on canvas

SIMILAR WORKS

Joan Miró, *Person Throwing a Stone at a Bird*, 1926

Yves Tanguy *Born* 1900 Paris, France

Died 1955

Tanguy, Yves

Composition, 1938

An important aspect of Yves Tanguy's oeuvre was that despite the complexities of some of his works he never used preliminary drawings, relying instead on a high degree of Automatism in the early stages of a painting. His paintings with indeterminate titles, such as *Composition*, have often been likened to seascapes or beach scenes. Tanguy, a native of Brittany, spent time at sea in the merchant navy, as his father had done before him. Writing about Tanguy, André Breton drew on this analogy to describe his paintings: 'The sea ebbs far off disclosing as far as the eye can see sands on which crawl, stand erect, arch, sink and sometimes fly, formations of an entirely new character, without any immediate equivalent in nature, and which, it must be pointed out, have not to this day yielded to any valid interpretation!'

At this time Tanguy began to show rocks in the distance of his pictures, similar to those found on the Brittany coast and which provide the viewer with an immutable foothold on empirical experience. However, the artist sets up a tension in his pictures by including aspects of the ephemeral and illogical, biomorphic shapes that appear familiar, but are subject to change if we lose our concentration.

CREATED

Paris

MEDIUM

Oil on canvas

SIMILAR WORKS

Roberto Matta, *Rocks*, 1940

Yves Tanguy *Born* 1900 Paris, France

Died 1955

Tanguy, Yves
Indefined Divisibility, 1942

After settling in the town of Woodbury, Connecticut, in 1942, Yves Tanguy changed his style of painting to reflect a rural life away from the hustle and bustle of the city. This change of environment and sense of space, clearer light and a more peaceful existence facilitated a change in his palette, which was now much brighter, and an increase in size of his biomorphic forms that came to dominate his landscapes. In 1940, shortly after arriving in America, Tanguy visited Nevada where he saw the huge rock formations that probably influenced this increase in scale.

He did not, however, change his 'automatic' style of commencing a painting, although his style was influenced by his relationship with Kay Sage whom he married in 1940. Sage was also a Surrealist painter, her work incorporating architectural motifs that were often lit from the side, casting shadows of their geometric forms on the picture plane. An example is *A Little Later* from 1938. Tanguy and Sage worked very closely together and in his *Indefined Divisibility* it is easy to see her influence. Tanguy had a profound effect on the Abstract Expressionists with his mastery of the tension between the logic of the sensation and the imaginative freedom of thoughts and dreams.

MEDIUM

Oil on canvas

SIMILAR WORKS

Kay Sage, *I Saw Three Cities*, 1944

Yves Tanguy *Born* 1900 Paris, France

Died 1955

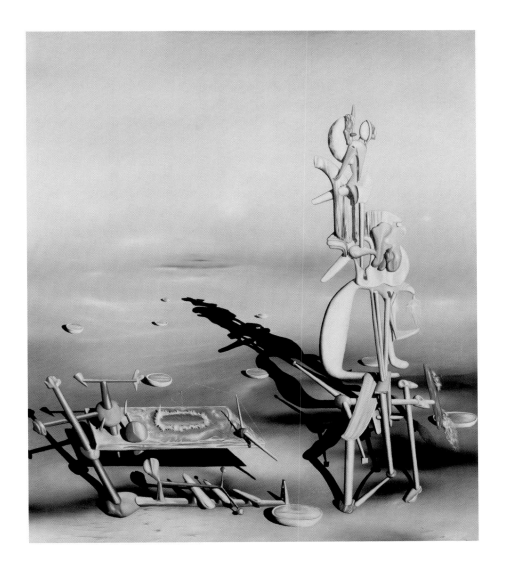

Delvaux, Paul

The Man in the Street, 1940

A relative latecomer to Surrealism, Paul Delvaux did not deviate from his popular motif of women in architectural settings. Most often the women were naked but sometimes they were fully clothed in an old-fashioned pseudo-Edwardian style, suggesting a childhood memory in the artist's mind. Variations on the theme saw these naked women partially transmuted into trees or other vegetation and sometimes the tableau included men. In essence they are highly derivative of the metaphysical paintings of Giorgio de Chirico, whom he admired.

Like René Magritte, Delvaux was Belgian, but unlike his compatriot he was not interested in the shocking and sometimes menacing juxtapositions suggested in his (Magritte's) dream-like visions. Although we are unable to identify specifically the geography in *The Man in the Street*, it is familiar to us, as is the man reading a newspaper walking along indifferent to the world at large. However, he is out of place, since he is not walking along a city street. The women's femininity is familiar to us, but they are not recognizable as individuals and their hair has metamorphosed into ivy that trails to the ground. Their poses are mannered as in Renaissance painting, their distant look suggesting anything but sensuality.

MEDIUM

Oil on canvas

SIMILAR WORKS

Remedios Varo, *Born Again*, 1960.

Paul Delvaux *Born* 1897 Anheit, Belgium

Died 1994

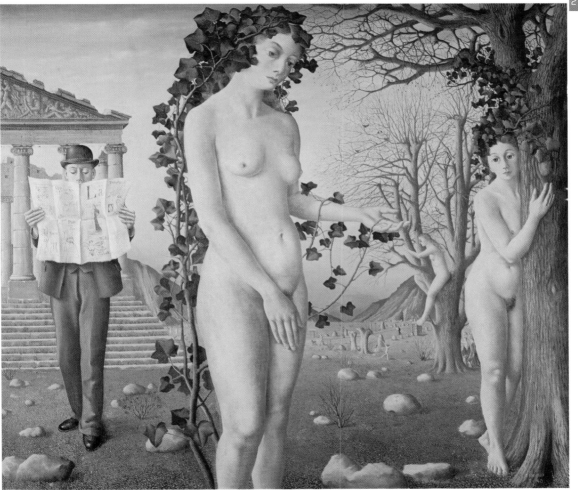

Delvaux, Paul

Venus Asleep, 1944

Painted in Brussels at the time of heavy bombing to the city, Paul Delvaux sought to show the anguish being felt as a contrast to the serenity of the sleeping Venus. Delvaux is not depicting the story of Venus, but merely using her as a representative of love and its life force, the counter to hate and death, which is possibly represented by the skeletal figure. As with many Surrealist figurative paintings there is an ambiguity to the *mise en scène*.

There are signs of panic in the street with people waving their arms pleading for salvation. But whose attention is the naked woman on the right seeking? Is it the fully clothed woman who appears dismissive, a personification of an indifferent bourgeoisie? Or is she asking her to intervene in a sexual encounter between the skeleton and Venus, suggested by their respective poses? Freud wrote about the death instinct, or Thanatos, and the human desire to resist threats to life by unnatural means. In Delvaux's scenario this can be interpreted as the enemy bombing. Freud proposed that the counter to Thanatos was Eros, the Greek god of love, whose sexual life instinct guarantees biological survival. Could the skeleton be Thanatos?

CREATED

Brussels

MEDIUM

Oil on canvas

SIMILAR WORKS

Giorgio de Chirico, *Ariadne*, 1913

Paul Delvaux *Born* 1897 Anheit, Belgium

Died 1994

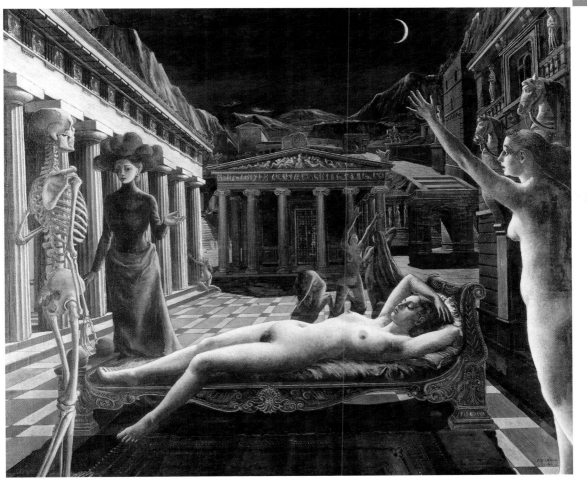

Delvaux, Paul
All the Lights, 1962

In the mid nineteenth century, the poet and writer Charles Baudelaire had described women as, 'a divinity, a star that presides over all the conceptions of the male brain ... a kind of idol, empty headed perhaps, but dazzling, an idol that holds men's destinies and wills in thrall to her glances'. This view of women held sway until well into the twentieth century, when the Surrealists attempted to unpick this stereotype of woman objectified.

In *All the Lights* Paul Delvaux attempts this unpicking using an innocent pubescent girl who is dressed as if attending her first communion, the stereotypical *femme-enfant*. The girl is placed under a spotlight, a motif repeated in the background, for the artist and the viewer to examine. The viewer is denied any sense of objectification, due to the girl's dress, demeanour and lack of sexual innuendo. There is nothing sexually explicit or implicit in Delvaux's picture, his scene imbued with a sense of mourning for a lost or former existence, perhaps a childhood. The dark sky suggests another side to the scenario, the sense of childhood fear and anxieties that may be subsequently repressed, only to surface later as neuroses in adulthood.

MEDIUM

Watercolour, pen and ink on paper

SIMILAR WORKS

René Magritte, *Empire of Lights*, 1954

Paul Delvaux *Born* 1897 Anheit, Belgium

Died 1994

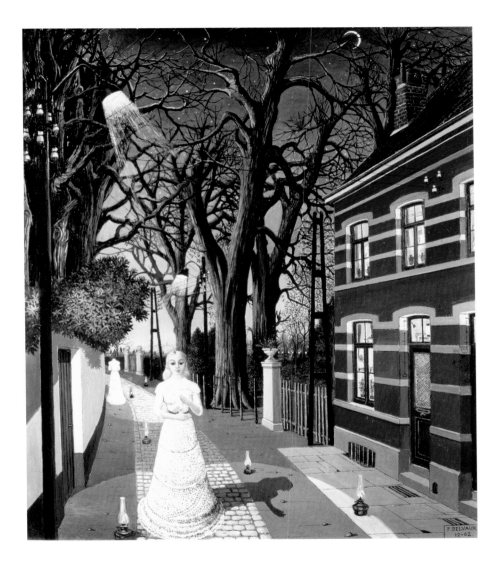

Delvaux, Paul
Les Adieux, 1964

A major theme of Surrealist activity was desire, often depicting women as its object. Its male practitioners believed that women were closer to the irrationality of dreams and the latent portent of their significance within the unconscious. They also believed that women held the key to understanding male desire within that unconscious. In his novel *Nadja*, André Breton related his account of a fleeting but intense relationship he had with the heroine. In the book Breton wore his heart on his sleeve, trying to understand the complexities of his often contradictory feelings for her. *Les Adieux* seems to be a response to that same quest. The males are anonymous, also a recurrent motif of Magritte's, so that our attention is given to the woman bidding her farewells. Her pose is mannered, an impassive and innocent look that conveys no sensuality. We are unable to contemplate her status, her look completely devoid of anecdote or emotion, resembling that of a mannequin.

The candle is something of an enigma, possibly signifying the fleetingness of life. Are her farewells permanent? Is she saying farewell to the men whose destiny is known only to her? The answer to the riddle is available only to people who understand the language of the unconscious.

MEDIUM

Oil on cardboard

SIMILAR WORKS

René Magritte, *The Ready-made Bouquet*, 1957

Paul Delvaux *Born* 1897 Anheit, Belgium

Died 1994

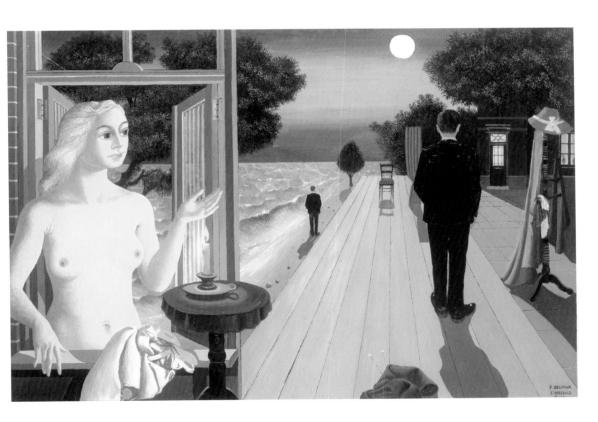

Toyen (Marie Cerminova)

The Dangerous Hour, 1942

In 1923 Marie Cerminova joined *Devetsil*, an avant-garde group in Prague whose leading lights included Franz Kafka (1883–1924). She had already changed her bourgeois name into the proto-feminist, genderless Toyen. In 1928 Toyen illustrated a new edition of the Marquis de Sade's *Justine*, perhaps the most servile and abused of all his female protagonists. Thus began her journey into Surrealism, becoming a founder member of the Czech Surrealist group and organizing their first exhibition in 1935. Following the Nazi occupation of Czechoslovakia, Toyen's work fell into the category of 'degenerate' art, which was banned under the regime. Although she remained in Czechoslovakia, Toyen worked in secret while in hiding, her paintings unknown to the outside world until after the Second World War.

In *The Dangerous Hour*, Toyen depicts the Nazi eagle of the Third Reich. The tips of its wings have been transformed into human hands, resting on broken glass embedded in the fence on which the eagle is perched. This symbiosis suggests that the hands belong to a Nazi. The absence of blood on the impaled hands, suggests contempt for the Czech resistance or any other barrier to Nazi supremacy. The title suggests that this is possibly a decisive time in the occupation.

CREATED

Former Czechoslovakia

MEDIUM

Oil on canvas

SIMILAR WORKS

René Magritte, *The Companions of Fear*, 1942

Toyen (Marie Cerminova) *Born* 1902 Prague, former Czechoslovakia

Died 1980

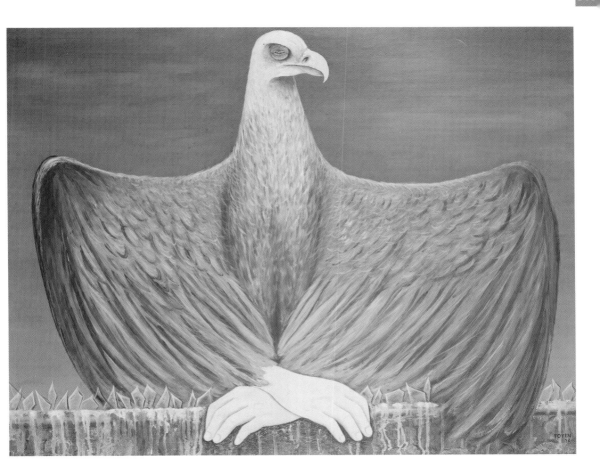

Toyen (Marie Cerminova)
At the Chateau Lacoste, 1946

By the time Toyen returned to a Sadeian theme at the end of the Second World War, the death of her soul mate and fellow avant-gardist Jindrich Styrsky (1899–1942) and the oppression of Nazi occupation had given her more than enough material with which to expound her ideas about psychic liberation. Styrsky, also a Surrealist, had produced a number of photographs of the Chateau Lacoste, the castle that belonged to the Marquis de Sade. Toyen's painting depicts the crumbling walls of a chateau that are reminiscent of Styrsky's photographs. She depicts a fox devouring its prey, for no other purpose than self gratification. The prey looks real enough, but the fox appears as a drawing that has come to life, its only contact with the bird is the leg, which seems to have crushed it.

During the war years, Toyen reflected much of the sadism inherent in the Marquis de Sade's writings. Either side of that she was also interested in the expression of sexual curiosity, adopting Sade's philosophical eroticism in many of her works. Her depictions are always suggestive rather than explicit in comparison to other Surrealists pursuing the same enquiry such as Salvador Dali and Hans Bellmer (1902–1975).

CREATED

Former Czechoslovakia

MEDIUM

Oil on canvas

SIMILAR WORKS

Victor Brauner, *The Wolf Table*, 1947

Toyen (Marie Cerminova) *Born* 1902 Prague, former Czechoslovakia

Died 1980

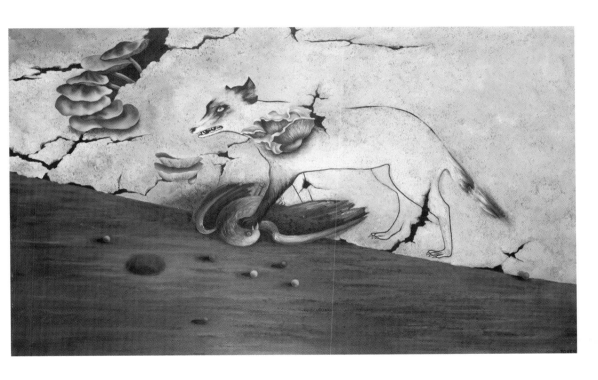

Surrealism

Places

Nash, Paul

Harbour and Room, 1932–36

Courtesy of Tate, London/© Estate of Paul Nash 2005

In the late 1920s Paul Nash made a number of trips to various parts of France and Italy. The trips, with his wife, had a twofold purpose: the improvement of Nash's health following a gas attack in the trenches and to visit the European avant-garde. Nash became a writer on art as well as an artist, contributing a number of articles on European modern art to *The Listener* from 1931. His interest in the development of modern art in England led him to co-found a new group of artists in 1933 called Unit One, a cohesive artistic 'brotherhood' that included Abstractionists such as Ben Nicholson (1894–1982), and future Surrealists such as Edward Wadsworth (1889–1949) and Henry Moore (1898–1986). Like the latter two, Nash had been producing works that bordered on Surrealism and Abstraction at a critical period in the development of Modernism in England: it was not until 1936 and the First International Surrealist Exhibition in London that Surrealism actually gained a foothold.

Harbour and Room was included in this exhibition, its four-year execution a reflection of that period of development in the Surrealist aesthetic in England. Its inspiration came from staying in a hotel room in the south of France and the strange reflections of the harbour, viewed through the window, in the room's mirrors.

CREATED

England

MEDIUM

Oil on canvas

SIMILAR WORKS

René Magritte, *The Door to Freedom*, 1933

Paul Nash *Born* 1889 London, England

Died 1946

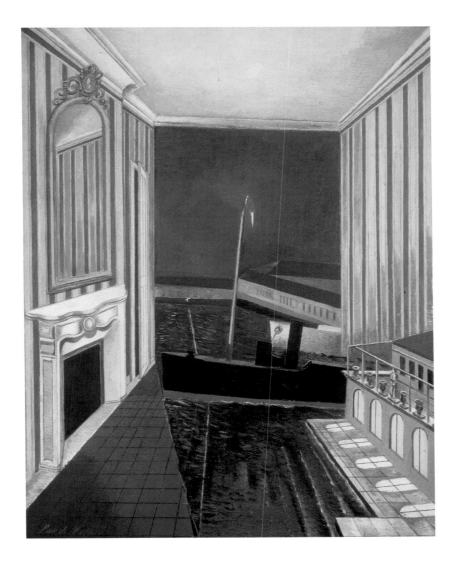

Nash, Paul

Tiger, Tiger, c. 1938

'Tiger, tiger, burning bright/In the forests of the night,/What immortal hand or eye/Could frame thy fearful symmetry?' In one of Nash's rare sorties into collage, the artist shows the inspiration of the European Surrealists such as Max Ernst (1891–1976), whose work he saw and admired in the London exhibition in 1936. However, Nash makes it particularly English, using the words of William Blake's (1757–1827) poem and a setting of a ruined castle, in a strange juxtaposition with an Asian tiger. The incongruity of the scene is emphasized by the colour of the tiger set against the monochrome background, which was probably photographed by Nash, a keen photographer.

In 1936 Nash moved from Swanage, which he described as 'seaside Surrealism' to Hampstead in north London, where he began his Surrealist adventure. His *Landscape from a Dream* (1936–38) shows his debt to Ernst in the strange depictions of birds and trees that Nash had written about earlier in the decade. In the four years preceding the Second World War, many European artists and writers fled to Hampstead, including members of the Bauhaus, Naum Gabo (1890–1977) and even Sigmund Freud (1856–1939). Hampstead became a hotbed of avant-garde activity for English artists living there, including Barbara Hepworth (1903–75), Henry Moore and of course Paul Nash.

CREATED

London

MEDIUM

Collage

SIMILAR WORKS

Paul Eluard, *To Each his Own Anger*, 1938

Paul Nash *Born* 1889 London, England

Died 1946

Trevelyan, Julian
Basewall, 1933

Britain's politicians had taken a very apathetic and non-interventionist view concerning the rise of Fascism in Europe. With the exception of Winston Churchill who spoke of, 'Dictators (who) ride to and fro upon tigers which they dare not dismount. And the tigers are getting hungry', other politicians such as the then prime minister Neville Chamberlain said: 'How horrible, fantastic, incredible it is that we should be digging trenches and trying on gas masks here because of a quarrel in a far away country between people of whom we know nothing.'

As in Europe, the English Surrealists became involved in left-wing politics, criticizing the government for its inaction. In a famous stunt that had Dadaist overtones, some of the Surrealists grouped together at the May Day parade in 1938 at Hyde Park and played Spanish Republican songs in a hired van. Their most outrageous stunt was the making of four masks of Neville Chamberlain, which were worn by Surrealist artists, including Julian Trevelyan, who marched through Hyde Park making the Nazi salute. Many of these artists with political convictions to the left belonged to Artists International, a group set up in 1933 by Clifford Rowe, a young designer who had recently spent time in Moscow.

CREATED

Paris

MEDIUM

Oil on canvas

SIMILAR WORKS

Pablo Picasso, *Reclining Nude*, 1932

Julian Trevelyan *Born* 1910 Dorking , England

Died 1988

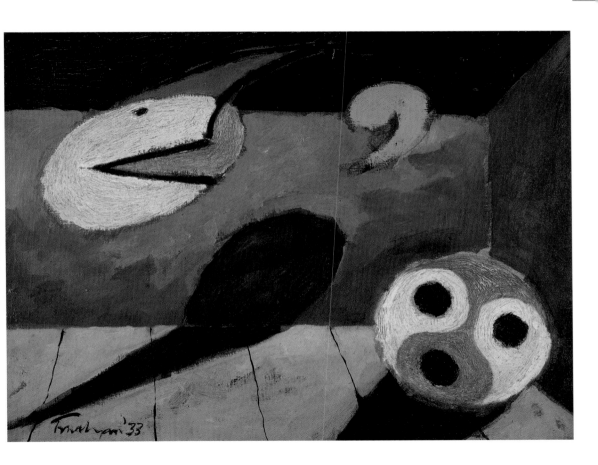

Trevelyan, Julian

To Break a Butterfly Upon a Wheel, c. 1936–37

Courtesy of Private Collection/www.bridgeman.co.uk/© Estate of Julian Trevelyan 2005

Julian Trevelyan spent his formative artistic years in Paris, returning to England in 1934. Like most artists living at the epicentre of modernism for any length of time, it would be impossible not to be inspired by the wealth and diversity of talent in the city. Paris, as the capital of modern art, had attracted visitors from all over Europe, many of them becoming permanent émigrés such as Picasso, Hans Arp (1887–1966) and Joan Miró (1893–1983). Yet it was the visitors who returned home to imbue their own culture with the essence of Parisian modernism who were so instrumental in the devolvement of its aesthetic and ethos.

In *To Break a Butterfly Upon a Wheel* Trevelyan is clearly influenced by the work of Miró, and certain aspects of Paul Klee's (1879–1940) work. Trevelyan adopted many of Miró's early motifs of fine lines, geometric shapes and vaporous backgrounds as in *Catalan Landscape (The Hunter)* (1923–24). In Trevelyan's painting, however, he is not motivated by Miró's 'automatic' technique, but rather the anecdotes of a remembered childhood through dreams, abstracted, like Miró, into its key component parts. As Trevelyan wrote in 1930, 'to dream is to create'.

CREATED

London

MEDIUM

Oil and pencil on board

SIMILAR WORKS

Joan Miró, *Catalan Landscape (The Hunter)*, 1923–24

Julian Trevelyan *Born* 1910 Dorking , England

Died 1988

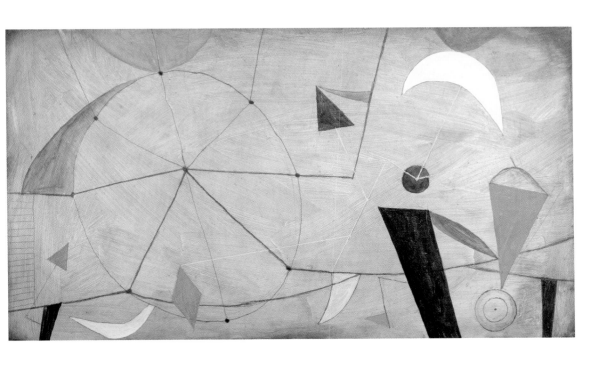

Banting, John

The Abandonment of Madame Triple-Nipples, 1939

A key aspect of John Banting's oeuvre was his continual satire of both form and formality. His depictions of women were somewhat misogynistic, the applied titles removing any sense of their own femininity and merely objectified them by men. Sometimes the titles would be based on items they were wearing, such as *Lady Diamond Lit*, or in the case of *Madame Triple-Nipples* drawing attention to an anatomical abnormality that had sexual overtones. However, these are not mere misogyny. In many ways Banting's drawings of this period are similar to the bourgeois stereotypes in the Berlin of George Grosz (1893–1959) and Otto Dix (1891–1969), in which they emphasized the absurdities of the bourgeoisie through caricature, highlighting those aspects of gluttony and overindulgence, juxtaposing them with impoverished characters. Banting's critique was of a false femininity, one that complied with upper-middle-class standards within the artificiality of high society, his use of emaciated forms a comment on man's inevitable self-destruction.

In another work, *Mutual Congratulations* (1936), Banting painted two skeletal forms, whose physical traits and aloofness represented the middle-class male and female. They appear to be conversing, but their ossified forms and lack of anecdote make their conversation meaningless, reflecting the puerility of their discourse.

CREATED

England

MEDIUM

Pencil on paper

SIMILAR WORKS

Max Ernst, *The Woman with a Hundred Heads Opens her August Sleeve*, 1929

John Banting *Born* 1902 England

Died 1972

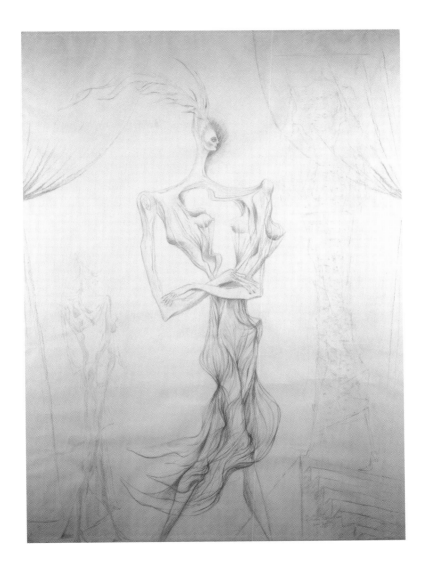

Banting, John
Goat Man and Guitar

A sociological activity occurred in England at the same time as Surrealism gained a foothold. The Mass Observation Unit was set up in 1936 in order to examine leisure and contemporary culture as part of a social anthropology of Britain. Apart from observing everyday people in their work and domestic environments and at leisure, artists were invited to record their activities for posterity. The town chosen for the 'observation' was Bolton in Lancashire, selected for its typicality of mixed classes and in particular the workers within its cotton mills. The inquisitive nature of its questionnaires involving bathroom behaviour, taboos and phobias would have provided many of the Surrealist artists with suitable material for their paintings. Despite the inclusion of men such as the poet David Gascoyne and the filmmaker Humphrey Jennings in the Unit who were sympathetic to Surrealism's aims, both politically and aesthetically, they were unable to hold sway with the more ethnologically minded and apolitical founder Tom Harrisson.

A number of artists, particularly the Surrealists, became politically active after this, doubling the recruiting efforts of the Artists International to paint banners in support of the Republican cause in Spain. John Banting was one of their number visiting Spain with Nancy Cunard while the war was on.

CREATED

England

MEDIUM

Oil on board

SIMILAR WORKS

Pablo Picasso, *Still Life with Guitar*, 1942

John Banting *Born* 1902 England

Died 1972

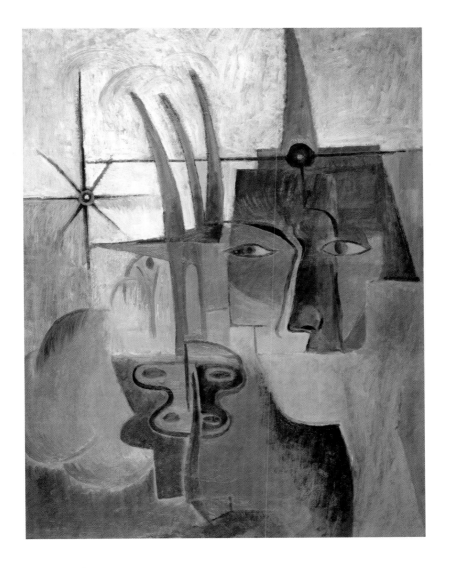

Colquhoun, Ithell
Rivières Tièdes ('Tepid Waters'), 1939

Writing in 1940, Ithell Colquhoun related the experience of women: 'One day in the translucent water I felt strange and found that my body was exuding a dark glue, not quite a blood. I knew what had happened. Certain wise savages still put their women in a hut of reeds away from the village ... the tribe thus gives each woman a few days each month of rest and solitude, for contact with the night side of her own nature. What must be done, though it makes civilization turn over. It is harmful to attempt a normal appearance – business, housework, the catching of trains – when normality is absent, and its place is taken by intensified sensibility to hidden springs.'

Colquhoun and other women Surrealists sought to use imagery to highlight women's experience as it differed from men's, often emphasizing the biological as well as the spiritual differences. In *Tepid Waters* Colquhoun used the isolated Italianate church as a metaphor for the 'hut of reeds', a sanctuary for the woman to make contact 'with the night side of her own nature'. In line with Colquhoun's own interest in the occult, the church appears hermetically sealed, a bar to the male species.

MEDIUM

Oil on panel

SIMILAR WORKS

Remedios Varo, *Harmony*, 1956

Ithell Colquhoun *Born* 1906 Assam, India

Died 1988

Colquhoun, Ithell
The Pine Family, 1941

Ithell Colquhoun's membership of the English Surrealist group, which she joined in 1939, coincided with a visit she made to André Breton (1896–1966) in Paris. Like many women Surrealists, particularly the English, she was unimpressed by his 'adoration of women' based on love. Her membership of the English group was short-lived due to her continuing interest in the occult, which led to her exclusion the following year. In subsequent years she painted a number of works that were sexually orientated, either explicitly or implicitly, subverting or inverting many of the ideas of (male-dominated) Surrealism. Colquhoun's ideas reveal a distancing of women Surrealists from (male) Surrealist ideas about desire, since there was little support from their male counterparts for a genuinely liberated understanding of female sexuality.

The Pine Family is a parody of the male obsession of the myth of perfect love, the androgyny. In this work Colquhoun depicts three 'torsos', part human, part tree, which resemble freshly cut logs. The label on the middle 'torso' reveals that it is a 'circumcised Hermaphrodite'; the one nearest to us says 'celle qui boite' ('One who limps'), a parody of the theme of Gradiva personified by Salvador Dalí (1904–89) and André Breton as, 'the one who advances'.

CREATED

England

MEDIUM

Oil on canvas

SIMILAR WORKS

André Masson, *Gradiva*, 1939

Ithell Colquhoun *Born* 1906 Assam, India

Died 1988

Pailthorpe, Grace
The Spotted Ousel, 1942

There can be few if any Surrealist artists better equipped to understand psychoanalytical theory and its relevance to art than Grace Pailthorpe. Having studied medicine and worked as a surgeon during the First World War, Pailthorpe subsequently took up the study of psychology and Freudian psychoanalysis. Her studies in criminal psychology enabled her to found the first institute to specialize in the treatment of delinquency in 1928. Many of her ideas for treatment were radical, but Sigmund Freud and Carl Jung (1875–1961) supported her work. The treatment that Pailthorpe advocated was a combination of therapy and freedom, since one without the other was detrimental to human status. In 1935 she met Reuben Mednikoff (1906–76), an artist who had become interested in psychoanalysis as a way of solving his own personal problems.

Their subsequent relationship was made in heaven. Mednikoff taught Pailthorpe to paint and express her ideas creatively, while he provided an ideal 'patient' for her research. Although they were later married there was a considerable age difference, which meant that in some ways it was more of a mother-child relationship. Nevertheless their extraordinary partnership enabled both artists to create many innovative and exciting works of Surrealism.

CREATED

London

MEDIUM

Oil on cardboard

SIMILAR WORKS

Reuben Mednikoff, *The Little Man*, 1944

Grace Pailthorpe *Born* 1883 Surrey, England

Died 1971

Pailthorpe, Grace

Surrealist Fantasy, 1938

The 'mother–child' relationship that Grace Pailthorpe had with her partner Reuben Mednikoff appears to have dominated much of her work as the leitmotif. In *The Spotted Ousel* it was manifest in the adult mother feeding her chick. In her painting *Surrealist Fantasy* it is subtler. The left-hand top corner depicts a pregnant woman. The top of centre reveals a breast, encircled by an umbilical cord that gently winds its way down. To its left is the suggestion of a hand, its five fingers touching and caressing. The background is organic plasma filled with Eros's life force.

There is, however, a deeper meaning to Pailthorpe's work than Symbolism. In an article written in 1938 she stated her case for painting as the raw material for psychological enquiry. Pailthorpe rejected the art of, for example, Salvador Dali, as linked to the Western traditions of art and therefore not free of conscious inhibition. Instead she proposed her own work and that of Mednikoff as reliable because of the authenticity of their 'research' sessions. She advocated an art of the future that 'will arrive when completely freed fantasy evolves from uninhibited minds'. Inevitably, however, like Dali, Pailthorpe sought to externalize the unconscious and reintegrate it visually with the conscious.

CREATED

London

MEDIUM

Oil on board

SIMILAR WORKS

Rita Kernn-Larsen, *Festen*, 1937

Grace Pailthorpe *Born* 1883 Surrey, England

Died 1971

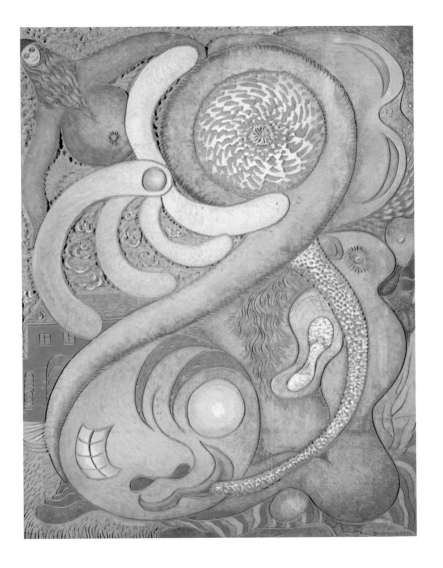

Maddox, Conroy

The Combat, 1941

Although English Surrealists were already aware of 'automatic' techniques of painting, it was the visit of Gordon Onslow-Ford (1912–2003) to André Breton in 1938, and his subsequent friendships with the leading lights of the group in Paris, including Roberto Matta (1911–2002), that brought many of the ideas of Automatism to England. Conroy Maddox, through various trips to Paris at the same time, also developed a friendship with Matta, whose ethereal landscapes and explorations of the unconscious were to have such a profound effect on the English artist's own 'anthropomorphological landscapes' such as *The Combat*. Perspective detail, although not entirely absent, is sacrificed so that our attention is not given to the depth of field but to the creatures that inhabit the space. These creatures are biological and organic 'forms' rather than discernable species, akin to those of Matta and Yves Tanguy (1906–58).

Maddox called his own form of Automatism '*écrémage*', a derivative of Oscar Dominguez's (1900–55) *Decalcomania*, in which he used the more intense pigments of gouache paint to create brighter and more colourful 'forms' than those of his Parisian counterparts. However, like many of his Surrealist colleagues on both sides of the Channel, Maddox's work is based on collage, denying the existence of pictorial frontiers.

CREATED

Birmingham, England

MEDIUM

Gouache on paper

SIMILAR WORKS

Yves Tanguy, *Eve of Slowness*, 1937

Conroy Maddox *Born* 1912 Ledbury, England

Died 2005

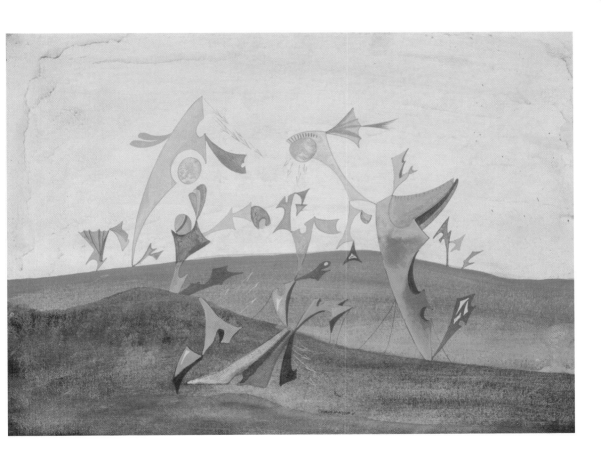

Maddox, Conroy

Untitled, 1950

Collage continued to be a critically inspirational force for Conroy Maddox throughout his long career; always adhering to the spirit of Surrealism long after the others had left the party. As he pointed out, collage is the separation of the image 'from its original function, withdrawn from its utilitarian use' and then having 'power to operate in the field of possibilities directed only by the needs and necessities of the artist'. It is clear from some of the motifs that Maddox used that his collages were influenced by Max Ernst, if not in technique then certainly in the nightmarish scenarios that he depicted, such as *A Week of Happiness* from 1934. The man with the lion's head used by Ernst in that work appears in one of Maddox's later paintings *Passage de l'Opera* (1970–71).

In 1944 Scotland Yard seized Maddox's paintings and collages, believing them to be encrypted messages to the enemy. They had already raided the premises of the anarchistic Freedom Press, whose Surrealist publication *Free Unions Libres* was also accused of printing encoded messages. Despite protestations from many leading lights such as T. S. Eliot, E. M. Forster and Herbert Read, the papers and Maddox's works remained confiscated until the end of the Second World War.

CREATED

Birmingham, England

MEDIUM

Collage

SIMILAR WORKS

'Scottie' Wilson, *Greedies II*, 1950

Conroy Maddox *Born* 1912 Ledbury, England

Died 2005

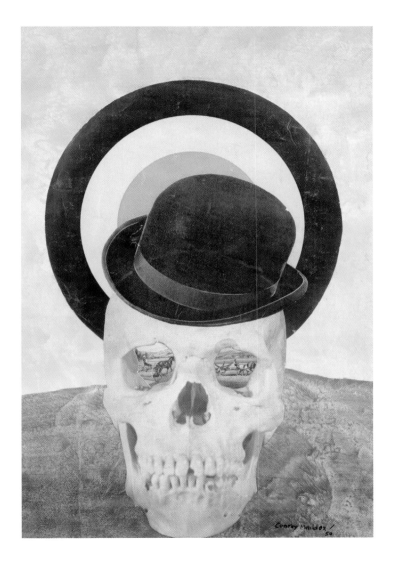

Morris, Desmond
Rank and File, 1949

Courtesy of Christie's Images Ltd/© Desmond Morris 2005

English Surrealist activities resumed immediately after the Second World War and regular weekly meetings of the officially renamed 'Surrealist Group in England' were convened at the Barcelona restaurant in London. However, the London Gallery, a centre for Surrealist exhibitions and activities under the patronage of E. L. T. Mesens, the Belgian Surrealist poet, had been damaged in the Blitz; it was not opened again until late 1946, with the financial help of Roland Penrose (1900–84). There was a general sense of artistic apathy with the London-based Surrealist group around Penrose, who seemed in this immediate postwar period to be more interested in politics than art.

In Birmingham, however, the Surrealist group around Conroy Maddox was more dynamic. Their group included the young Desmond Morris, an undergraduate studying zoology at Birmingham University, with a passion for painting. Morris's observations of zoological and microscopic life forms were a sound preparation for his depictions of biomorphic but non-discernable shapes. His witty collage-based *Rank and File* is suggestive of these biomorphic forms placed on microscope slides, which are then laid out next to each other on the laboratory bench.

CREATED

England

MEDIUM

Pen, black ink and watercolour

SIMILAR WORKS

F. E. McWilliam, *Head in Extended Order*, 1948

Desmond Morris *Born* 1928 nr. Swindon, England

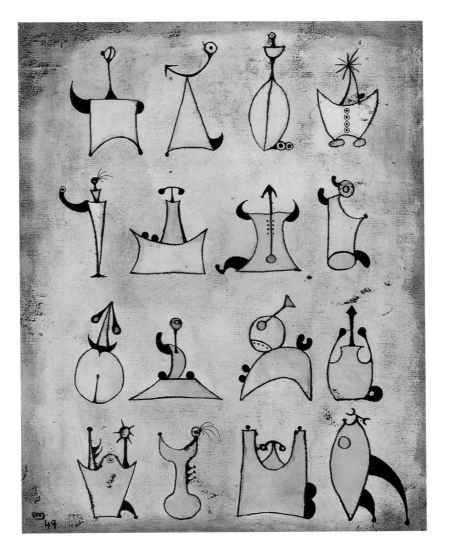

Morris, Desmond
Dyadic Encounter, 1972

In the *Catalogue Raisonné* of Desmond Morris's paintings, its author Silvano Levy separates the artist's oeuvre into four creative periods, 1969 to 1988 being designated the 'Naked Ape Period'. It was in 1967 that Morris published his controversial book *The Naked Ape*, which was serialized in one of the leading daily newspapers making it perhaps the most widely read book of its day. Morris provided scientific evidence based on his own observations and research about a number of sexual behavioural traits in humans that were still considered taboo subjects. He suggested, for example, that the rounded shape of female human breasts was primarily a sexual signalling device that differentiated itself from the 'milk machines' of other mammals. Morris also provided an insight into sexual behaviour and non-verbal communications such as body language.

Many of the behavioural patterns and causative factors contained in Morris's book are of particular interest to Surrealists. As a Surrealist himself, Morris was ideally placed to explore his themes and ideas in paint. *Dyadic Encounter* is one such exploration, a social intercourse between two people. The figure on the left is male, suggested by the limp phallus, which appears to be remonstrating with the mammary laden female on the right.

CREATED

England

MEDIUM

Oil on canvas

SIMILAR WORKS

Jorge Camacho, *Dance of Death*, 1976

Desmond Morris *Born* 1928 nr. Swindon, England

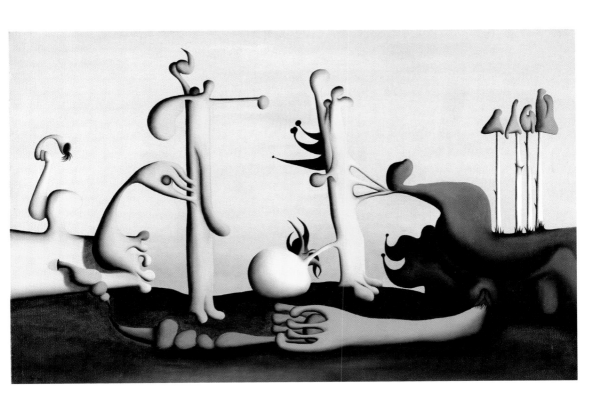

Mednikoff, Reuben

King of the Castle, 1938

Courtesy of Private Collection/www.bridgeman.co.uk/© Estate of Reuben Mednikoff 2005

Reuben Mednikoff trained as an artist at St Martins's School of Arts before embarking on a career in advertising illustration in the early 1930s. His chance meeting with the doctor and psychoanalyst Grace Pailthorpe changed his career radically and together they embarked on a very scientific approach to Surrealist painting through the exploration of the unconscious. In April 1935 Mednikoff left his secure job in advertising and spent time with Pailthorpe in Devon and Cornwall, his 'automatic' drawings serving as a catalyst for her analysis of him. She subsequently wrote, 'I felt that there must be somewhere a quicker way to the deep layers of the unconscious than by the long drawn out couch method, and I had a feeling that it was through art.'

This analysis of his unconscious enabled Mednikoff to explore repressed thoughts about his own childhood and his difficult relationships with his father and older sister. Pailthorpe, a much older woman, enabled him to recreate his childhood using psychoanalytic theory and acting as a surrogate sister. Thus many of the tensions, phobias and neuroses that had laid dormant and repressed were released. *King of the Castle* explores the difficulties within the mother-child relationship, the tension between protectiveness and the need to facilitate the child's independence of its mother. His use of vivid colours highlights that tension.

CREATED

England

MEDIUM

Oil on panel

SIMILAR WORKS

Victor Brauner, *Totem of Wounded Subjectivity*, 1948

Reuben Mednikoff *Born* 1906 England

Died 1976

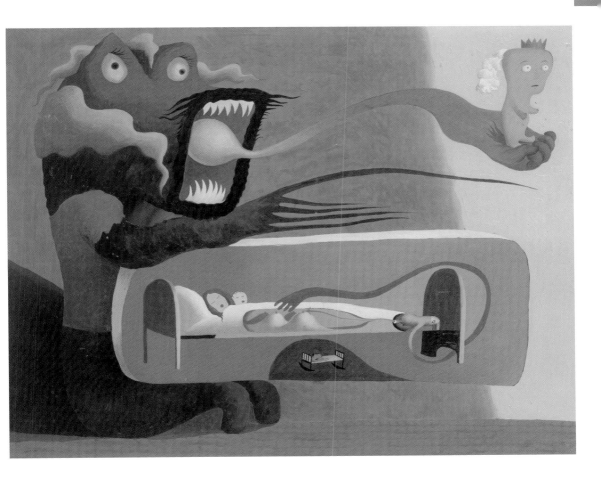

Mednikoff, Reuben
Blow

During the psychoanalytical sessions that Reuben Mednikoff underwent, Grace Pailthorpe encouraged him to confess to his deeds and misdeeds and his thoughts, good and bad, that would incur punishments or rewards. His obsessions and neuroses, repressed since childhood, were so extensively examined and psychoanalysed that he became almost totally dependent on and eager to please her: 'I have always been anxious to prove to Dr P and to find opportunities of proving to myself that I was as capable as she – capable of giving to the world, by reason of my intelligence, a creation that would be admired. It would also seem that my wish to paint beautiful works is based upon a similar unconscious idea.'

Both Mednikoff and Pailthorpe submitted work to the International Surrealist Exhibition in London in 1936, which are among the most evocative works of Surrealism based on psychoanalytic theory ever produced. Mednikoff often portrayed fantastic polymorphic creatures indulged in seemingly violent or aggressive acts. However, in *Blow* one can see the influence of Pailthorpe. *Blow* still retains elements of Mednikoff's violence, such as the teeth, but it includes the bird motif and the foetal qualities of Pailthorpe's oeuvre.

CREATED

England

MEDIUM

Oil on board

SIMILAR WORKS

Grace Pailthorpe, *The Blazing Infant*, 1940

Reuben Mednikoff *Born* 1906 England

Died 1976

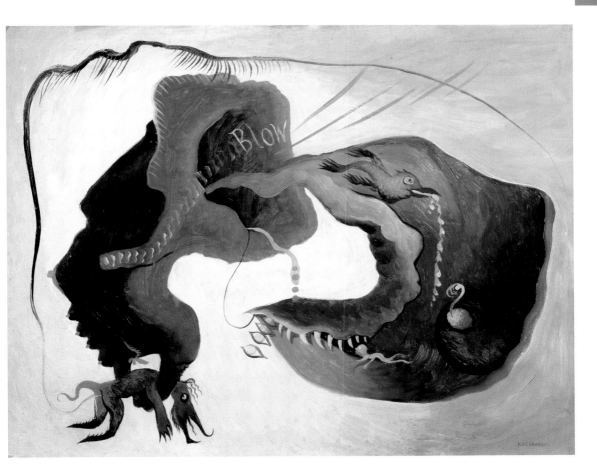

Penrose, Roland

The Conquest of the Air, 1938

Courtesy of Southampton City Art Gallery, Hampshire, UK/www.bridgeman.co.uk/© Estate of Roland Penrose 2005

Roland Penrose was arguably the most important and influential figure in the dissemination of the Surrealist aesthetic in England and he continued to be its principal architect both as a painter and writer, as well as a collector. Penrose spent his formative years in Paris from 1922, becoming part of the avant-garde circles around André Breton and Pablo Picasso. In the early 1930s he became a collector and brought many paintings and sculptures, mainly by Giorgio de Chirico (1888–1978), with him when he returned to England in 1935. In 1938 he purchased Paul Eluard's (1895–1952) collection of over 150 Surrealist works, including Max Ernst's *Celebes* (1921), which became the core collection of the London Gallery.

In 1938 Penrose organized the exhibition of Picasso's *Guernica* (1937) to the British public in London. The effect of that appalling destruction was well known in Britain and is possibly alluded to in Penrose's *The Conquest of the Air*. The masked man is both anonymous and indifferent to the viewer. His open head reveals an eagle, the symbol of the Third Reich, ready to fly once the man has made the conscious decision to release it. The background suggests the open sea. Could it be the English Channel?

CREATED

England

MEDIUM

Oil on canvas

SIMILAR WORKS

John Melville, *Concavity of Afternoons*, 1939

Roland Penrose *Born* 1900 London, England

Died 1984

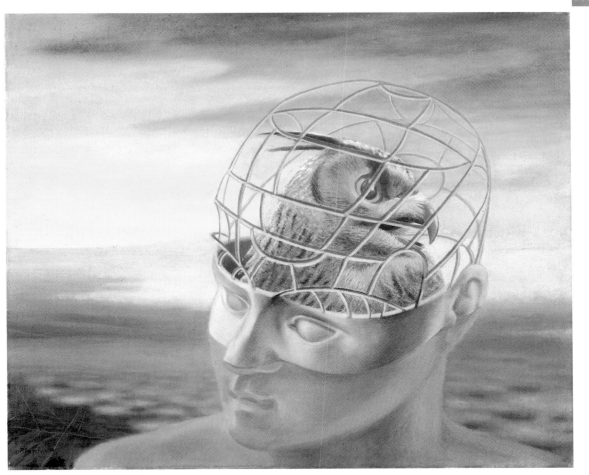

Penrose, Roland

Portrait, 1939

The influence of the Paris group of Surrealists on Roland Penrose cannot be overstated. Apart from the contact he had with them personally, the collection of Surrealist works that he purchased from Paul Eluard contained ten works by Pablo Picasso, eight works by René Magritte (1898–1967), three by Salvador Dali, eight by Joan Miró and no less than 40 by Max Ernst. In many ways Ernst represents the greatest influence on Penrose, who in 1938 began a series of collages using colour postcards that Magritte described as 'beyond the limits Ernst might have attained'. Although *Portrait* is an oil painting, it is clearly based on Dada collage that borrows heavily from Ernst and Francis Picabia (1879–1953). The motif at the top of the picture is similar to that used by Ernst in *Men Shall Know Nothing of It* from 1923. The 'automatic' writing is similar to that used by many of the Surrealists for example in Picabia's *The Cacodylic Eye* (1921). *Portrait* was submitted to the Royal Academy for inclusion in the United Artists exhibition in 1939, but was refused on grounds of obscenity as Penrose had included the word 'sex' in his absurd and nonsensical poem.

CREATED

England

MEDIUM

Oil on canvas

SIMILAR WORKS

Eileen Agar, *Fish Circus*, 1939

Roland Penrose *Born* 1900 London, England

Died 1984

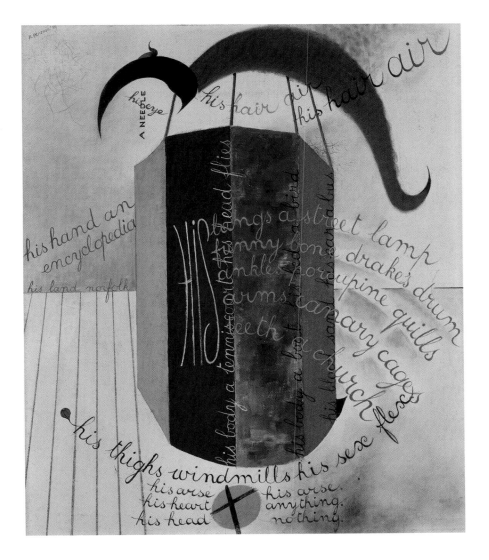

Penrose, Roland
Octavia, 1939

In his pre-war paintings Roland Penrose was not averse to provoking controversy in his painting, writing or political activities. His experiments with collage enabled him to develop a series of paintings along the theme of displacement, opening up some pictorial spaces while closing others. In *Octavia* Penrose used many Surrealist preoccupations such as desire, fetishism and sadomasochism. The figure appears androgynous, the arms and hands not conforming to gender conventions. A number of Freudian ideas concerning sexual desire and neuroses, suggested for example by the phallic spikes, are expressed in the picture and yet Penrose refuses to allow the viewer to indulge in these fantasies by placing a heavy black line across the picture plane that disturbs the imagination.

The sexual ambiguity of his paintings was also echoed in Penrose's writing. In 1939 he published 'The Road is Wider than Long', a Surrealist poem that was suggestive of his passion and desire for Lee Miller, a photographer who was later to become his wife. The poem was also a spiritual journey, devoid of a specific time and space, which is narrated through its text and the accompanying, often witty, photographs by Miller.

CREATED

England

MEDIUM

Oil on canvas

SIMILAR WORKS

Max Ernst, *The Tottering Woman*, 1923

Roland Penrose *Born* 1900 London, England

Died 1984

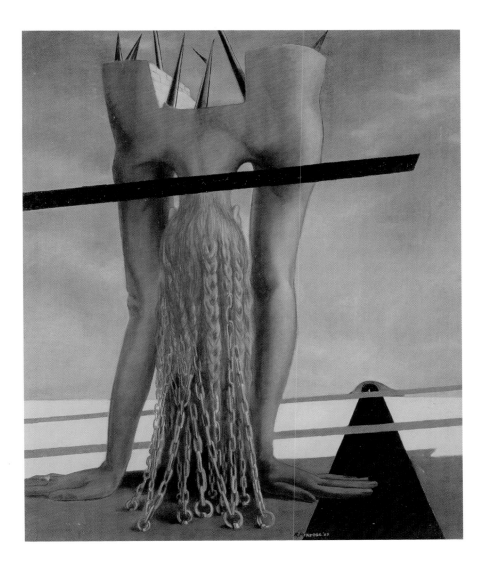

Wadsworth, Edward
Bronze Ballet, 1940

In the early days of Surrealism in Britain, there were two distinct groups of artists that were originally attracted to the work of Giorgio de Chirico, one that adopted a more Romantic view of Surrealism, or Magic Realism, and the other adopting the full Surrealist ideals. Paul Nash and John Banting belonged very much to the latter whereas artists such as Edward Wadsworth had a more Romantic approach to their work that was more apolitical.

Wadsworth was originally one of the Vorticists, who along with C. R. W. Nevinson (1889–1946) and others were influenced by the Futurists' machine aesthetics. Wadsworth, from northern England's industrial heartland, continued his interest in machinery even in his later landscapes, which were invariably of industry or objects of industrialization set within it. *Bronze Ballet* is a harbour scene whose tranquillity, epitomized by the sailing boat, has been broken by the arrival on the quayside of large propellers, to be used for merchant shipping or the Royal Navy as it prepares for war. The painting reflects a period at the end of the so-called 'phoney war' as Britain prepared for the Nazi onslaught.

CREATED

England

MEDIUM

Tempera on canvas mounted on wood panel

PERIOD/MOVEMENT

Magic Realism

SIMILAR WORKS

Paul Nash, *Totes Meer* ('Dead Sea'), 1940–41

Edward Wadsworth *Born* 1889 Yorkshire, England

Died 1949

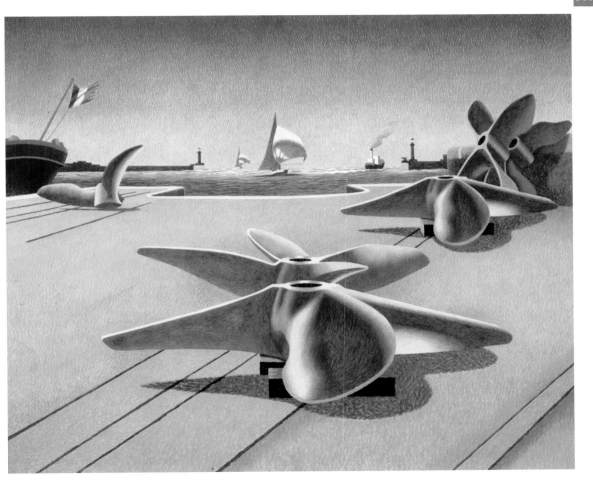

Wadsworth, Edward

Sea Verge, 1943

Sea Verge encapsulates all the enigma of Giorgio de Chirico's *Pittura Metafisica* and places it very definitely in an English landscape. Like his contemporary Paul Nash, Edward Wadsworth's landscapes are devoid of people but imbued with a sense of them having just left, which creates a haunting emptiness. The landscape is a shoreline on which a kind of gibbet has been erected. The ropes suspend coats that are without their wearers, leaving the viewer to ponder the enigma.

The depiction of the landscape within the avant-garde is almost entirely a peculiarly British phenomenon. Before, during and after the Second World War, many of its adherents painted landscapes that were broadly within a Surrealist aesthetic, but did not necessarily support its ideals. Both Nash and Edward Wadsworth were founder members of Unit One, a cohesive group of avant-garde artists working in the 1930s that also included another landscape painter, Tristram Hillier (1905–83). The landscapes of all three are similarly haunting. In Hillier's *Surrealist Landscape*, for example, he plays with a flat, infinite, horizon-less landscape that is reminiscent of Tanguy's. Recognizable but meaningless objects that have no relevance to each other dominate the landscape.

CREATED

England

MEDIUM

Tempera on board

SIMILAR WORKS

Toni del Renzio, *Le Rendez-vous des Moeurs*, 1941

Edward Wadsworth *Born* 1889 Yorkshire, England

Died 1949

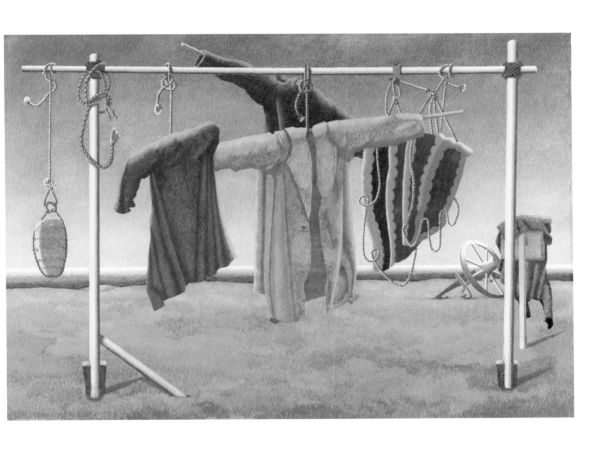

Carrington, Leonora

The Temptation of St Anthony, 1947

Leonora Carrington was a rebel and was expelled from her convent school in acts of rebellion against the Catholic Church and her family, whose excessive piety she loathed. Carrington also despised the capitalist ideals of her father, a wealthy textile manufacturer in Lancashire.

In *The Temptation of St Anthony* Carrington brings these two things together. When he was 20 years old, St Anthony's father died leaving him a large sum of money. After subsequently reading Matthew's Gospel in which the reader is encouraged to sell one's possessions, in exchange for treasures in heaven, St Anthony disposed of his inheritance and embraced asceticism, becoming a hermit. In the desert he was subjected to temptation by demons in much the same way as Jesus had been. Having resisted these temptations, St Anthony went on to found a monastery based on his own ascetic life. Carrington's interpretation is iconoclastic, defying the conventions of Renaissance paintings that depict St Anthony resplendent in a red cloak. Although St Anthony is given a physical presence in Carrington's painting, he appears as an emaciated hermit, the resplendent red cloak given instead to his tormentor.

CREATED

Mexico

MEDIUM

Oil on canvas

SIMILAR WORKS

Remedios Varo, *Ascension to Mount Analogue*, 1960

Leonora Carrington *Born* 1917 Lancashire, England

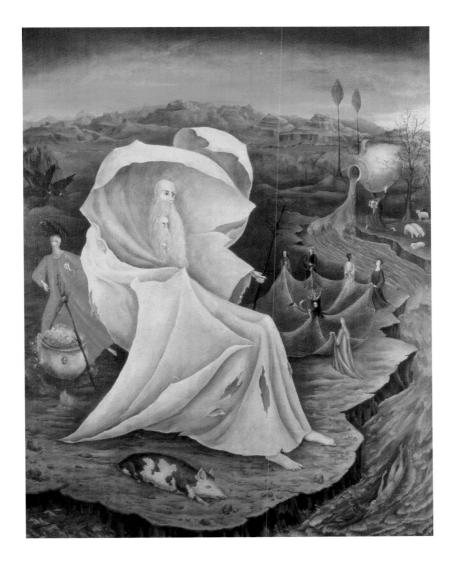

Carrington, Leonora

Again the Gemini are in the Orchard, 1947

Courtesy of Christie's Images Ltd/© ARS, NY and DACS, London 2005

A central theme for many of the women Surrealists was alchemy and their possession of its secret powers, which for them was linked to the mysterious cycles of nature. André Breton had already put forward the proposal that women possessed these Hermetic powers and suggested that men could unlock these secrets by means of love. Some women Surrealists sought their own empowerment of this resource for picture making, believing that the origins of their own creativity were rooted in Hermetic tradition.

In 1942, after a short stay in New York, Carrington moved to Mexico, sharing her enthusiasm for alchemy with another woman Surrealist, Remedios Varo (1908–63), also a European exile. Although their depictions were somewhat different, they shared a common exploration in paint and poetry, of life's mysteries and its resolution using alchemy. In her one-act play, *Une Chemise de Nuit de Flanelle*, written in 1945, Carrington developed characters that would later populate her paintings. One character, Prisne, populates the worlds of the living and the dead, a theme that is used in *Again the Gemini are in the Orchard*, the twins representing that same duality. The painting's allusion to fertility, through the allegory of the garden, suggests that this duality is part of the life cycle of humanity.

CREATED

Mexico

MEDIUM

Oil on board

SIMILAR WORKS

Remedios Varo, *Solar Music*, 1955

Leonora Carrington *Born* 1917 Lancashire, England

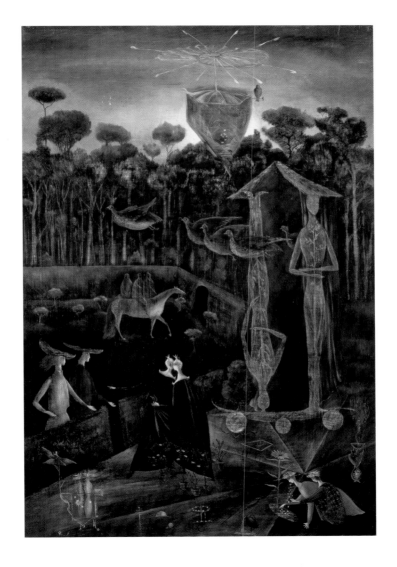

Carrington, Leonora

Baby Giant, 1947

Courtesy of Christie's Images Ltd/© ARS, NY and DACS London 2005

There are two constant motifs in Leonora Carrington's work after 1945, the partridge or other bird, and the egg. The partridge makes a number of appearances in Carrington's work, most famously in *Portrait of the Late Mrs Partridge* from 1947, in which a woman is seen walking with a partridge that is not to scale and appears incongruous. In one hand, the woman carries an egg, while the other gently rests on the back of the overgrown partridge. The incongruity of scale also appears in *Baby Giant*. This time the central figure is surrounded by 'normal' scale birds, resembling geese, flying around her and from inside her cape. However, she is standing within two Lilliputian worlds. The first is a hunting scene at the bottom of the picture, redolent of a Hieronymus Bosch painting; the other is a seascape in which appear Viking ships, whales and various sea creatures. The central figure has a mane of wheat that replaces her hair and is carrying an egg very carefully with both hands. These symbols of the generative and regenerative powers of nature, as exemplified by the egg, are key motifs in the work of many of the Surrealist women artists. For Carrington in particular, the egg also represented the alchemist's oven.

CREATED

Mexico

MEDIUM

Oil on board

SIMILAR WORKS

Leonor Fini, *Sphinx Regina*, 1946

Leonora Carrington *Born* 1917 Lancashire, England

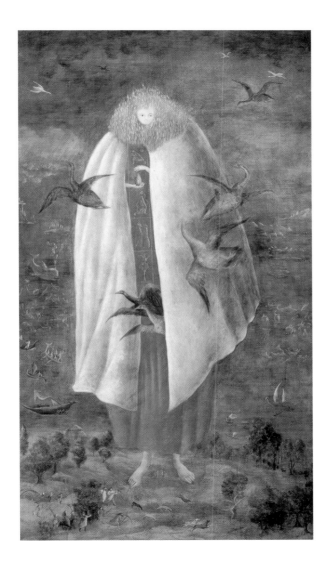

Agar, Eileen

Lewis Carroll with Alice, 1960–62

Although this is an oil painting, *Lewis Carroll with Alice* is clearly based on collage, using a wide range of shapes and colours to build up the mosaic-like image, possibly inspired by Nusch Eluard's use of the medium in the mid 1930s to express the correlation of women to nature. This work includes reference to the English landscape and its connotations of nature, a key motif in the work of Eileen Agar, following a brief but inspirational love affair with Paul Nash, while she lived close to him and his wife in Dorset.

The motif of 'Alice' can of course be seen within the context of the *femme-enfant*, but in English Surrealism, Lewis Carroll's 'Alice' already retained a special place within the British Romantic tradition. The critic Herbert Read, who fell at the first hurdle in trying to explain Surrealism, or as he called it 'Super-realism', to the British public, continually saw the aesthetic within the Romantic tradition. Read, a modernist who critically supported, amongst others, Nash and Henry Moore, had more of an affinity with Abstraction, which probably explains Agar's use of geometric shapes in what is essentially a Surrealist work.

CREATED

England

MEDIUM

Oil on canvas

SIMILAR WORKS

Rita Kernn-Larsen, *Self Portrait*, 1937

Eileen Agar *Born* 1899 Buenos Aires, Argentina

Died 1991

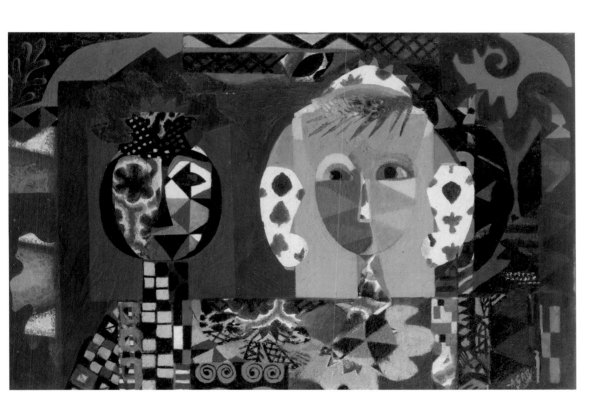

Agar, Eileen

Angel of Anarchy, 1936–40

Courtesy of Tate, London/© Estate of Eileen Agar 2005

Angel of Anarchy is probably Eileen Agar's most famous work, its title a derivative of Herbert Read's contemporary work, *Poetry and Anarchism*. Read's work was idealist, although not linked to Marxism in its espousal of a Utopian ideal for 'the abolition of poverty and the consequent establishment of a classless society that will not be established without a struggle'. This idealism was analogous to current events in England such as the Jarrow marches and the general feeling, as exemplified by Neville Chamberlain's visit to Munich, that pacifism and appeasement would be preferable to conflict. Agar's own anarchistic tendencies were also sympathetic to these ideals and in particular her concern for the Republican cause in Spain.

The original *Angel* was in fact a modelled bust of her husband that she subsequently applied paint and paper doilies to, making it resemble a totemic head. The original was lost, but a photograph of it appeared on the cover of the catalogue for the Surrealist Objects and Poems exhibition at the London Gallery in 1936, at which it was shown. When Agar came to make the second one, she completely covered the head in textiles and fur so that the face became anonymous, a visual metaphor perhaps for the anonymity of the 'unknown soldiers' preparing once again for war.

CREATED

England; Original 1936, this is a replica dated 1940.

MEDIUM

Textiles over plaster and mixed media

SIMILAR WORKS

Ithell Colquhoun, *Bride of the Pavement*, 1942

Eileen Agar *Born* 1899 Buenos Aires, Argentina

Died 1991

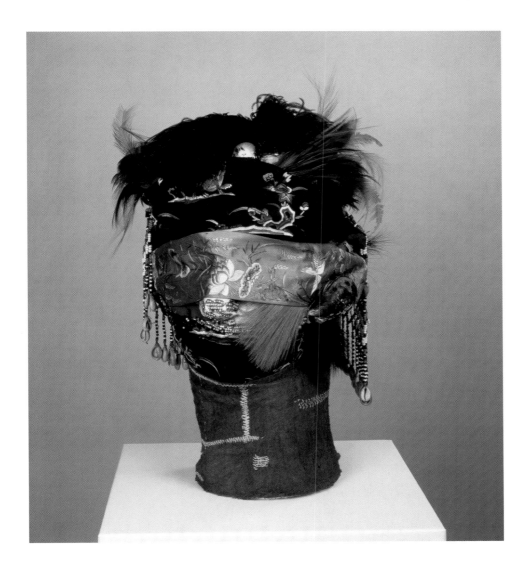

Agar, Eileen
The Object Lesson, 1940

During the late 1930s, Eileen Agar and her husband Joseph Bard spent the summers in the company of many of the Parisian avant-garde including Picasso and Dora Maar, Paul and Nusch Eluard and Roland Penrose. Later she wrote: 'It is inevitable to confuse the delights of being young, with the place and the time one was young in; the south of France in the summer, Surrealism on the horizon, Stravinsky in the air and Freud under the bed. The world was small then, the freedom of the intellectuals and the pleasure-loving twenties and early thirties were the privilege of those few with avant-garde ideas. In spite of the Teutonic fury, we could still bathe, bask in the sun, eat and have a merry heart.'

Agar, who remained in London throughout the war, produced no work of any substance until after 1946. In what must be one of her last pieces before this lull, *The Object Lesson* was a witty use of an artist's mannequin holding a champagne cork, a remnant of the recent hedonistic age that Agar had been a part of.

CREATED

England

MEDIUM

Gouache and collage on soft board

SIMILAR WORKS

Edith Rimmington, *Eight Interpreters of the Dream*, 1940

Eileen Agar *Born* 1899 Buenos Aires, Argentina

Died 1991

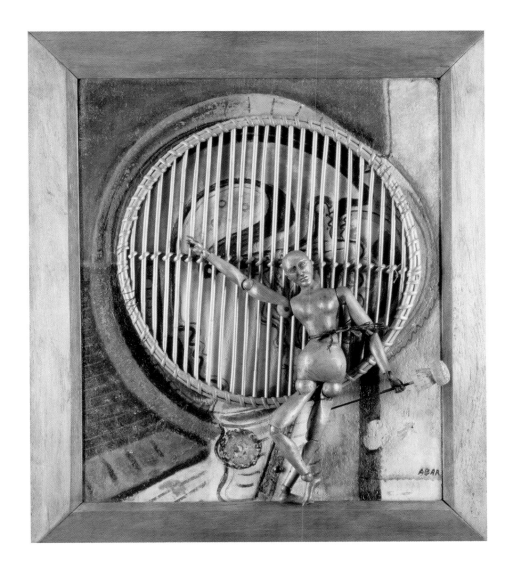

Paalen, Wolfgang

Composition, 1934

Wolfgang Paalen's *Composition* is essentially a Surrealist work, but one that still shows the influence of the *Abstraction-Création* group whose fold he joined in 1934. At this time Paalen, a self-taught Austrian painter, was exhibiting with the Surrealists at the Salon des Surindédependents while also experimenting with abstract, geometric and biomorphic shapes. Another member of *Abstraction-Création* was Hans Arp who, like Paalen, also trod the fine line between the Purist 'architectonic' aesthetic of an art based on logic and the biomorphic abstraction of Surrealism. *Composition* is similar in style to the work of Jean Hélion (1904–87); also a fellow member of *Abstraction-Création*, whose *Equilibrium* of 1933–34 bears a resemblance. In 1932 Hélion tried to formulate abstraction as follows: 'Non-figuration, that is to say cultivation of pure plasticity, to the exclusion of any explanatory, anecdotal, literary or naturalistic element – abstraction because certain artists have arrived at the conception of non-figuration through progressive abstraction from the forms of nature; creation because artists have achieved non-figuration directly through a conception of purely geometric order.'

Of course, this formulaic approach to painting is not within the ideals of Surrealism and after 1935 Paalen became absorbed completely in the Surrealist aesthetic.

CREATED

Paris

MEDIUM

Oil and black pen on canvas mounted on cork board

SIMILAR WORKS

Jean Hélion, *Equilibrium*, 1933–34

Wolfgang Paalen *Born* 1905 Vienna, Austria

Died 1959

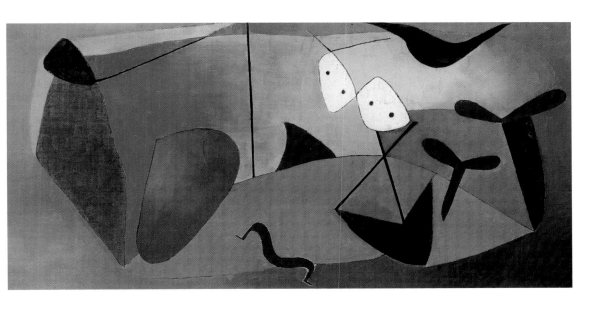

Paalen, Wolfgang
Untitled, 1937

Having committed himself to Surrealism, Wolfgand Paalen began experimenting with *fumage*, an 'automatic' form of painting using the smoke from a lighted candle to make the random marks on the canvas. The naive figures depicted in *Untitled* have been started using this process, to which Paalen has added paint marks for the necessary detail. The technique was praised by André Breton, referring to his paintings as being 'pregnant with poetic meaning'.

At this time Breton had recently opened his Paris gallery called Gradiva, Paalen and others lending a hand in its decoration. The name Gradiva was based on Wilhelm Jensen's book of the same name, which tells the story of a young archaeologist who has a delusional fantasy about a girl represented in a Roman relief. Believing that the girl was buried during a volcanic eruption, he sets off to try and locate her, only to find a former childhood sweetheart who bears a striking resemblance to the girl he was seeking. He subsequently discovers that the delusion he has been suffering from is actually a repressed desire for his former childhood sweetheart. The story was subsequently analysed by Sigmund Freud and depicted very graphically by André Masson (1896–1987), making it a significant Surrealist motif.

CREATED

Paris

MEDIUM

Mixed media on canvas

SIMILAR WORKS

Victor Brauner, *Petite Morphologie*, 1938

Wolfgang Paalen *Born* 1905 Vienna, Austria

Died 1959

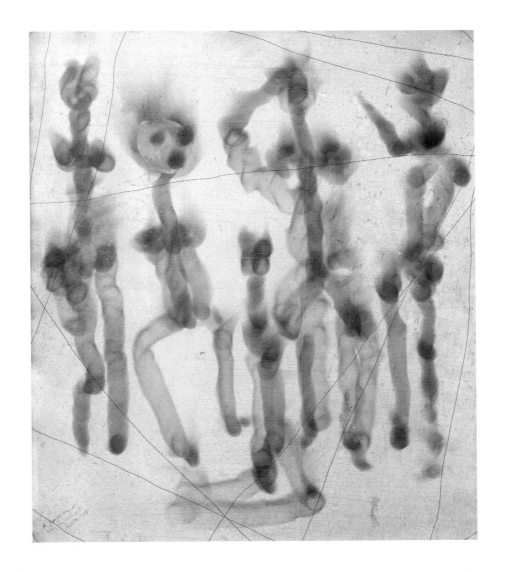

Oelze, Richard

Judith

As with many so-called 'degenerate' artists living in Nazi Germany after 1933, Richard Oelze was fearful for his life. His pictures of this period are dominated by dreams and premonitions of an increasingly morbid nature, reflecting his and other non-Nazi Germans' fears for the future. Before the ascendancy of the regime, Oelze had studied at the Bauhaus and then been forced to watch its demise, another victim of Nazi oppression against 'degenerate' art.

Within the *Apocrypha*, a later fifth-century addition to the Bible, is the story of Judith, a pious and beautiful widow who rebukes her people, the Israelites, for losing faith with God while they are under siege from the Assyrians and their leader Holofernes. *Judith*, who promises to deliver them from their aggressors provided they keep the faith, then tricks Holofernes, beheads him while he is asleep and returns with his head on a plate. The Israelites, motivated by this action, then attack the Assyrians causing them to flee. Judith reflects Oelze's current concerns, namely a deliverance from Nazi oppression. Oelze adds a sense of irony to the drawing by using Judith as his motif, since in Hebrew the name means 'Jewess', a comment on the particularly brutal treatment of the Jews (Israelites) by the Nazis at the time.

MEDIUM

Pencil on paper

SIMILAR WORKS

Edith Rimmington, *Washed in Lethe*, 1938

Richard Oelze *Born* 1900 Magdeburg, Germany

Died 1980

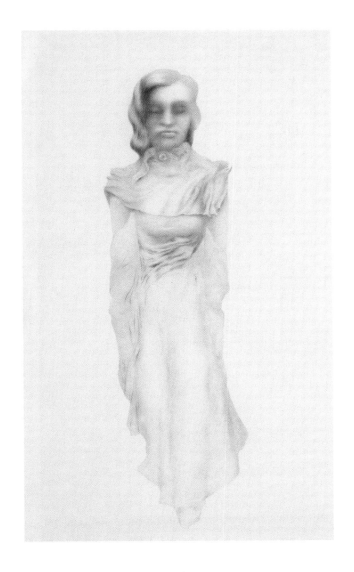

Oelze, Richard

Oracle, 1955

After serving in the German military and his subsequent imprisonment, Richard Oelze continued his artistic career in the 1950s, having studied many of the Old Masters including Rembrandt (1606–69). He became interested in the chiaroscuro effects of light and dark. Having eschewed spatial recession as epitomized in his earlier work, Oelze emphasized the spatial element of his pictures by contrasting light and dark radically. An example can be seen in *Oracle*, an early painting of this period in which the light blazes through into an otherwise dingy scene, silhouetting the strange biomorphic forms of his characters.

An oracle is generally regarded as the delivery of a message, through a human being, by a deity or supernatural being. It can also signify the place where the message was delivered. Sometimes the message is a prophesy and is often delivered through action or event rather than orally. The most famous oracle was at Delphi, where Apollo had slain a monster serpent that had occupied the local temple. Thereafter people came to the temple to listen to his words through the Delphic priests. Apollo was among other things the god of prophesies. It is possible that Oelze has depicted himself as the oracle, through his painting, prophesying the inherent problems of the then recently displaced Palestinians.

CREATED

Germany

MEDIUM

Oil on canvas

SIMILAR WORKS

Yves Tanguy, *The Mirage of Time*, 1954

Richard Oelze *Born* 1900 Magdeburg, Germany

Died 1980

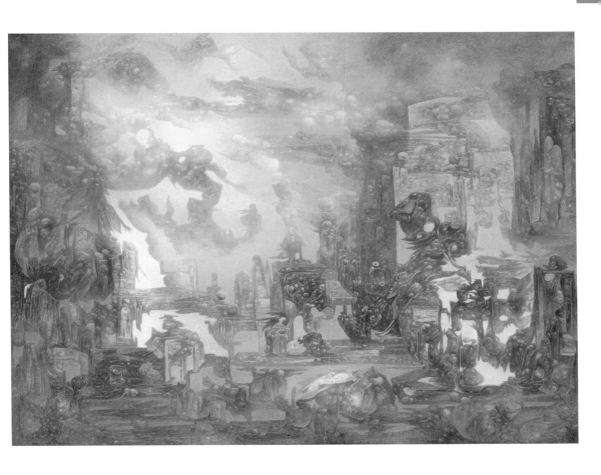

Bellmer, Hans

La Poupée, Second Partie ('The Doll, Part II'), 1936

André Breton was visually excited by the potential of Hans Bellmer's 'Doll', when a series of photographs were sent to him in Paris in 1934. Bellmer produced these photographs as a collection with an introductory intricate prose poem that he called '*Die Puppe*' ('The Doll'). Breton immediately understood Bellmer's agenda; the exploration of the seemingly innocent childhood games that develop as sexual fantasies and desires in adulthood. It was also seen as a revolt against tyranny, both political (Bellmer was German) and parental, in dealing with sexually taboo subjects such as repressed desires. Breton and Paul Eluard were so excited by the potential of its use as a Surrealist object that a copy of the text was translated into French (*La Poupée*) the following year. In this year, following a brief visit to Paris, Bellmer continued his explorations by creating a number of *poupées* in which he made wooden dolls with ball joints. These creations were hybrids, often using two lower halves of dolls joined together to produce a figure with two pelvises and four legs, but no arms. These 'creations', which may well have been undertaken by any boy as a prank, were seen by Bellmer as repressed erotic desires in adulthood that began in boyhood.

CREATED

Germany

MEDIUM

Hand-tinted photograph

SIMILAR WORKS

Oscar Dominguez, *Electrosexual Sewing Machine*, 1934

Hans Bellmer *Born* 1902 Kattowicz, Germany

Died 1975

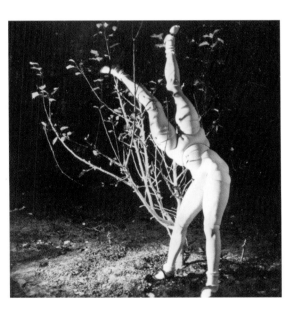
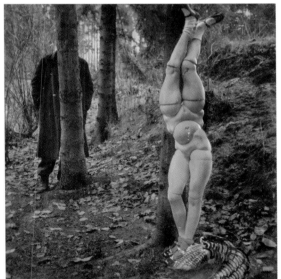

Bellmer, Hans

Children, The Spring Games, c. 1936–37

In some ways *Children, The Spring Games* is based on the drawings of Marcel Duchamp's (1887–1968) *Large Glass* (1915–23), which had explored the frustrated machinations of a bachelor for the right to copulate with his 'bride', using machinery-like objects metaphorically.

After his initial experiments with *La Poupée*, Hans Bellmer explored the visual possibilities of his work. His early work gave way to a more sado-masochistic and violent eroticism that explored the tension between the female as 'castrated' and the female as fetish, by breaking down the complete woman (doll) into its component parts, many of which, in themselves and when juxtaposed with other parts, became phallic. By its very nature the work is of course not resolvable, but his attempts in this direction make it all the more volatile and violent, emphasizing the tension. Bellmer was also seeking, in his use of the doll, to explore the relationship between the pre-Oedipal and Oedipal moments in childhood and how those anxieties were manifest in adulthood. Often the 'doll' had a child's pudenda, but the torso had fully developed breasts, or would adopt a suggestive pose, or both. Other 'dolls' would be juxtaposed with furniture that adopted pre- or post-coital poses.

CREATED

Germany

MEDIUM

Pencil and watercolour on mounted card

SIMILAR WORKS

Toyen, *Relâche*, 1943

Hans Bellmer *Born* 1902 Kattowicz, Germany

Died 1975

Bourgeois, Louise

Quarantinia 1, 1947–53, cast 1984

Louise Bourgeois's introduction to Surrealism was unusual and fortuitous. Born in Paris, Bourgeois lived above André Breton's Gradiva gallery, where she would have seen the work of all the Surrealists. After her art-school training, Bourgeois was introduced to Fernand Léger (1881–1955) who persuaded her to sculpt rather than paint. However, it was the meeting with the American art historian Robert Goldwater that was to transform her life. In the year that she married him, 1938, Goldwater published his ground-breaking work *Primitivism in Modern Art* and the couple moved to New York in advance of the threatened Nazi occupation. There she made use of the contacts that Goldwater had, bringing her into contact with the exiled Surrealists.

These inspirations did not materialize in Bourgeois's work until the 1950s when she developed a series of highly eroticized biomorphic forms that were, generally speaking, phallic. Yet her work was outside the mainstream of European Surrealism because of her distaste for Breton's dogmatic approach, although her work found favour with the exiled Marcel Duchamp. *Quarantinia 1* appears to be a step towards that eroticism, in its totemic and phallic allusions. It is interesting to note that the sculpture was not cast until 1984, indicating that she still considered it experimental.

CREATED

USA

MEDIUM

Bronze

SIMILAR WORKS

Max Ernst, *The King Playing with the Queen*, 1944

Louise Bourgeois *Born* 1911 Paris, France

Hugo, Valentine

Book cover for *Contes Bizarres* by Achim d'Arnim, 1933

Before Valentine Hugo's involvement with the Surrealists, she collaborated on a number of works with her husband Jean Hugo, the great-grandson of the writer Victor Hugo, on stage designs for Jean Cocteau's ballet *Mariès de la Tour Eiffel*. Cocteau regarded her as, 'the only woman whose kindness and beauty had made me regret my homosexuality'. The break-up of their marriage coincided with Valentine meeting André Breton, with whom she subsequently had an intense intimate relationship. During the next few years her paintings become imbued with a sense of the alchemic, the book cover for *Contes Bizarres* by Achim d'Arnim, being a perfect example. In this work Hugo portrays herself and Breton as the protagonists. Breton, resplendent as the archangel with his sword of fire, lunges towards the passive recumbent Hugo. Like so many of the Surrealists, male and female, she was captivated by a charm that bordered on arrogance.

Although Hugo was a part of the inner sanctum of Surrealism, her work never deviated from the Hermetic tradition, which had more in common with the Symbolism of Gustav Moreau (1826–98) than the Surrealist aesthetic of say, Leonora Carrington.

CREATED

Paris

MEDIUM

Printed colour lithograph

SIMILAR WORKS

Leonora Carrington, *Portrait of Max Ernst*, 1939

Valentine Hugo *Born* 1887 Boulogne-sur-Mer, France

Died 1968

Trouille, Clovis

My Tomb, c. 1947

Clovis Trouille was one of the second generation Surrealists that emerged after 1930, even though he was actually older than Max Ernst and others from the Dadaist era. He did not work in central Paris but in the area known as Buttes-Chaumont, a quiet suburb of the city where he worked almost in seclusion. However, his images belie this sedate working practice. Until 1930 he was employed painting the faces on mannequins for use in department stores. During the 1930s the mannequin played a key role for many of the Surrealists as they explored the whole notion of desire. In 1938 the Exposition Internationale du Surréalisme contained many exhibits of male and female mannequins, such as the male-mannequin taxi driver of Salvador Dali's *Rainy Taxi* (1938), and the collaborative work that showed a group of 15 'mannequin-prostitutes', the most outrageous of which was the *Mannequin with a Birdcage* (1938) by André Masson.

After the Second World War, Trouille continued the theme of the mannequin in a series of paintings depicting lewd and disturbing pictures of anonymous women in erotic poses. *My Tomb* is a self-indulgent flight of fancy that uses a collage-based style to depict an orgy of sex and depravity in which the artist plays the central character as voyeur.

MEDIUM

Oil on canvas

SIMILAR WORKS

Roberto Matta, *The 120 Days of Sodom*, 1944

Clovis Trouille *Born* 1889 La Fère, France

Died 1970

Labisse, Félix

Arthus les Sables, 1947

Courtesy of Christie's Images Ltd/© ADAGP, Paris and DACS, London 2005

Although Félix Labisse did not belong officially to the Surrealist group around André Breton, he was a Parisian-based artist who flirted with its aesthetic. However, he was, like many of these peripheral artists, faithful to the image rather than the imagination. Originally a pupil of the Symbolist painter James Ensor, Labisse began designing theatre sets before being encouraged to paint by his Surrealist friend Robert Desnos (1900–45). Labisse remained in Paris during the Nazi occupation, but also often stayed in Belgium with friends for months at a time.

During the war he began painting a series of works that depicted metamorphoses of different animals and mixing them with human forms such as *Snatched Portrait*, which depicts a woman with the head of a preying mantis. In 1948 he produced a collection of work with an explanatory text called *Histoire naturelle*. It contained a number of fictive characters, hybrids of various animals that he gave names to such as 'Wyvern-Guénégote' and 'Arthus des Sables'. This hybrid character seems to have the body of a silver-birch tree on to which has been grafted the fractured head of a cat; set against a background fusion of the landscapes of Yves Tanguy and Salvador Dali.

CREATED

Paris

MEDIUM

Oil on canvas laid down on panel

SIMILAR WORKS

Wifredo Lam, *The Jungle*, 1943

Félix Labisse *Born* 1905 France

Died 1982

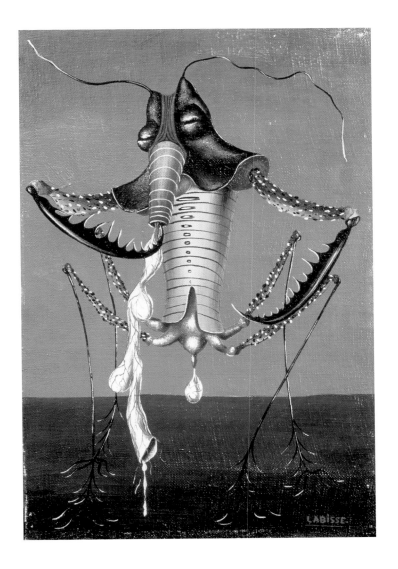

Labisse, Félix

Libidoscaphes dans la Baie de Rio, 1962

During the early 1960s, Félix Labisse developed a series of paintings that he called 'Libidoscaphes'. These sexually ambiguous painted shapes bear a striking resemblance to Hans Bellmer's *La Poupée*, but are supposed to represent a libidinal meteor that has fallen from the sky. The gender of this flesh-coloured organic figure is indistinct and appears to be ageless, creating a recognizable human form that is ambiguous.

According to Sigmund Freud, who published his *Three Essays on the Theory of Sexuality* in 1905, the newborn child has an unstructured libido, which he called 'polymorphously perverse'. Because it is unstructured, the child's libido is stimulated by any part of its body, needing further stimuli of experience to determine its erotogenic zones. The child's first and primary satisfaction is feeding from its mother's breast, the so-called 'oral' stage. The second 'anal' stage is one in which the child can exercise voluntary control of its bowel; 'holding on' or 'letting go' both being pleasurable experiences, as choices. This stage is, however, conditioned by social mores. The final stage is the 'phallic' one in which both genders experience the pleasure principle of genital stimulation at an early age. Because this is also conditioned by social mores, differences of sexual anatomy become more apparent, with their inherent anxieties and neuroses leading to confusion.

CREATED

Paris

MEDIUM

Oil on canvas

SIMILAR WORKS

Brassai, *Nude*, 1931–32

Félix Labisse *Born* 1905 France

Died 1982

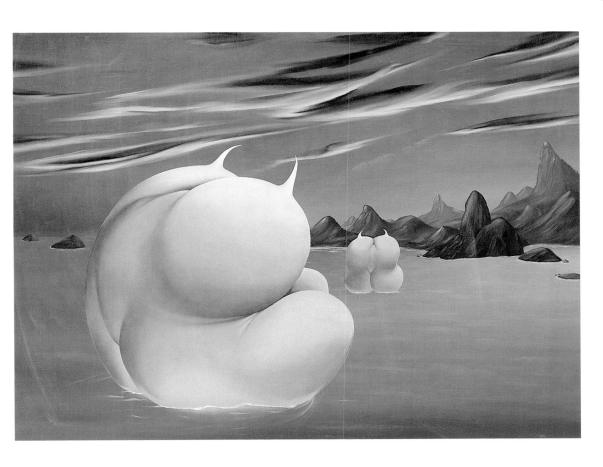

Roy, Pierre
Still Life with Shells, c. 1930

Pierre Roy was probably the oldest of the recognized Surrealist painters, even working on designs for the Exposition Universelle held in Paris in 1900. Like so many of the Surrealists, Roy was greatly influenced by the *Pittura Metafisica* paintings of Giorgio de Chirico. In his early Surrealist work, as *Still Life with Shells* shows, Roy was also influenced by René Magritte's examples of the incongruity of recognizable objects within an unfamiliar or haunting space. In *Still Life with Shells* the sea in the background looks unrealistic, as though the artist has deliberately painted a poor *trompe l'oeil* effect to confuse the viewer, who is left wondering if that was intentional or not. The obvious token of the sea, the anchor and shells, leave the viewer in no doubt about what the artist is supposed to be alluding to, but is left wondering why, and to what end. The partially drawn curtain tells the viewer that it is a window and yet the shutter on the left of the picture, whose presence is emphasized by the roundel design, is too large for the aperture's width. These enigmas are typical of Surrealist artists who, like Roy, were influenced by metaphysical painting.

CREATED

Paris

MEDIUM

Oil on canvas

SIMILAR WORKS

René Magritte, *The Human Condition*, 1933

Pierre Roy *Born* 1880 France

Died 1950

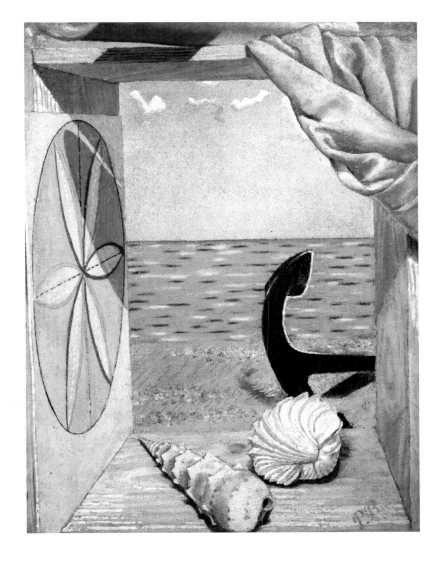

Roy, Pierre
The Port Road, 1943

Courtesy of Musée des Beaux-Arts, Nantes, France/www.bridgeman.co.uk/© ADAGP, Paris and DACS, London 2005

Although Pierre Roy was an early exhibitor and adherent of Surrealist ideals, he appears to have been marginalized within both groups of artists, those around André Breton and around Georges Bataille (1897–1962). Roy was not included in Breton's comprehensive review of Surrealist painters, *Le Surréalisme et la peinture* ('Surrealism and Painting', 1928), and was excluded from all other subsequent texts. This may be because Roy was a follower and devotee of Giorgio de Chirico, whom Breton had ostracized for turning away from metaphysical painting towards Neo-classicism, which Breton abhorred. Consequently Roy appears to have continued with stage designing and executing what are essentially metaphysical paintings.

Like many *Pittura Metafísica* works, *The Port Road* is something of an enigma that needs unravelling. In 1939 Roy made a trip to Hawaii and in consequence his paintings thereafter are more colourful and exotic. It is entirely possible that *The Port Road* was set in Pearl Harbor, the Hawaiian port that was strategically bombed by the Japanese in 1941. The picture shows a woman sitting alone in a room, suggesting that the men have gone to war. Through the window is a mountain range, suggestive of those that form a backdrop at Pearl Harbor. In the foreground are two more clues, the ship's propeller and the number 21, the number of battleships and other naval vessels that were either sunk or damaged irreparably in the attack.

MEDIUM

Oil on canvas

SIMILAR WORKS

René Magritte, *The Domain of Arnheim*, 1949

Pierre Roy *Born* 1880 France

Died 1950

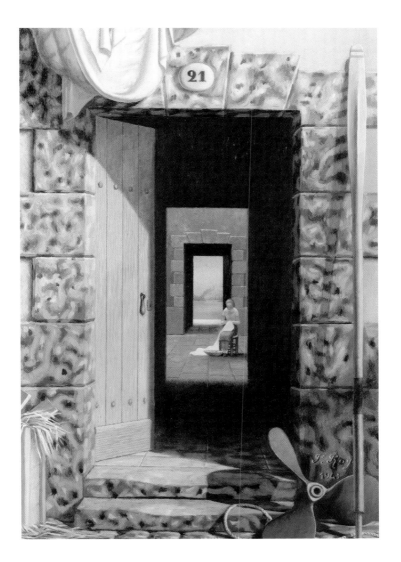

Prévert, Jacques

By the Sea

Jacques Prévert is better known for his poetry and film screenplays, than his art works, although as with many multi-talented artists one usually informs or nourishes the other. His collected poems issued under the name Paroles in 1946 quickly made him one of the most celebrated French poets of the twentieth century. His screenplays were often satirical and mocking of institutional social mores, but his poetry was subtler in its attack on those same institutions, preferring to use language itself rather than the blunter instruments of his Dada contemporaries. Like them however, his criticism was of the Great War and particularly of the bourgeoisie for their machinations.

In one of Prévert's most celebrated works Barbara, the poet uses a repetitive lyricism suggestive of the monotony of bourgeois values. But rather than criticizing those bourgeois values in terms of class distinctions as his Dada contemporaries did, Prévert tells the story of the war's devastating effect on a young woman whose lover has been killed. Prévert's repetitive lyricism evokes the suggestion of the futility of war.

> And the one who held you in his arms
>
> Lovingly
>
> Is he dead missing or living still
>
> Oh Barbara'

MEDIUM

Collage

SIMILAR WORKS

Remedios Varo, *The Spirits of the Mountains*, 1938

Jacques Prévert *Born* 1900 Paris, France

Died 1977

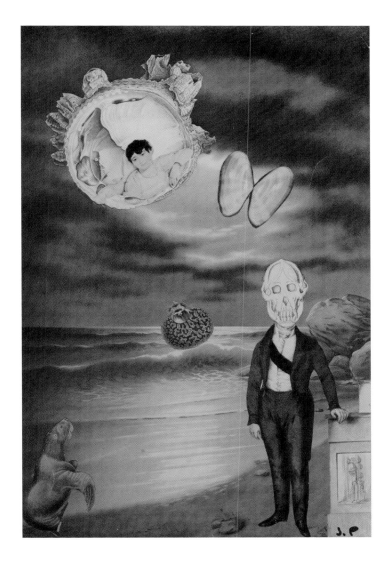

Prévert, Jacques

Man with the Head of a Deer

Jacques Prévert produced a number of screenplays for one of France's great film directors, Marcel Carné, and between them they developed a style of cinematography known as Poetic Realism. Often gritty in their storyline and their settings, these films nevertheless were a lyrical portrayal of everyday life, based on the earlier films of Fritz Lang and the realism of Josef von Sternberg's *Kammerspielfilm*. One of the earliest films of this genre was *Quai des brumes*, a slow, brooding film that was held by some to be responsible for the eventual capitulation of the Vichy government to the Nazis, because of its apparent apathy. Poetic Realist films are pervaded by a sense of fatalism.

Probably the most famous of the collaborations in this genre was the film *Les enfants du paradis* made between 1942 and 1944 during the Nazi occupation. It was made covertly, because of its subversive nature, but with the determination that it would be shown publicly in a free France. The story, although set in the early nineteenth century, is an allegory relevant to contemporary occupied France. Its central character is a beautiful actress Garance, who is resisting the pursuit of four courtiers who in their different ways are each trying to possess her.

MEDIUM

Collage

SIMILAR WORKS

Valentine Hugo, *Le Harfang des Neiges*, 1932

Jacques Prévert *Born* 1900 Paris, France

Died 1977

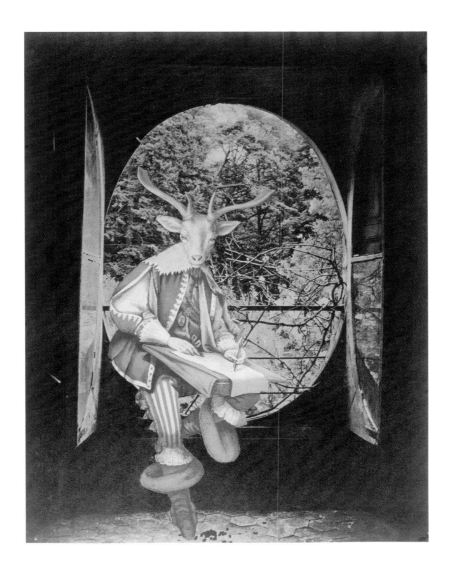

Prévert, Jacques

The Aeroplane, 1957

In 1924 the Nobel laureate writer Anatole France died. Considered by many to be one of the greatest Classically based writers ever, he was not equally revered by André Breton, who considered his work vulgar in its use of language. Although France shared many political ideals with the Surrealists, they considered that his empathy was one of pure self-interest. Breton, with contributions from some of the other Surrealist writers, wrote his own satirical eulogy entitled *'Un Cadavre'* ('The Corpse'), stating 'Let us not forgive him' in a parody of the endless eulogies being heaped on the late writer.

By the late 1920s there was dissention within the ranks of the Surrealists, with a new group around Georges Bataille, which included Robert Desnos and Jacques Prévert, offering an alternative literary set that was less dogmatic in its approach. By this time Breton had become something of a control freak within the original group and the dissenters published their own response to Breton's earlier *'Un Cadavre'*. Using the same title, the group published a critique of Breton in early 1930 in which they accused him of turning Surrealism into a religion, of which he was the self-styled 'Pope'.

CREATED

France

MEDIUM

Collage

SIMILAR WORKS

René Magritte, *Time Transfixed*, 1939

Jacques Prévert *Born* 1900 Paris, France

Died 1977

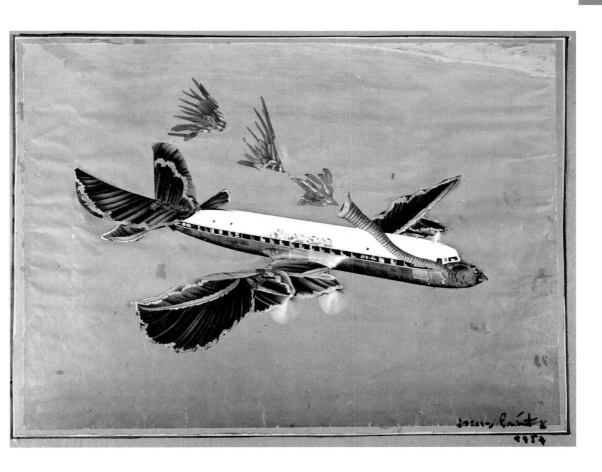

Desnos, Robert

The Death of André Breton, 1922

By 1922 Dada had almost burnt itself out as an artistic movement due to the lack of new material. The previous year the so-called 'Salon Dada' was a shambles with André Breton and Marcel Duchamp, two of its main protagonists, refusing to take part in Tristan Tzara's exhibition. Breton was vindicated in his action. Having decided to attend the exhibition anyway, he found a number of handwritten inscriptions on the wall including the famous 'Dada is the biggest confidence trick of the century'. Whether this statement is true or not, Breton no longer felt that Dada could represent the more serious political aspirations of, what was still then, a literary movement. Breton subsequently moved into a new apartment in the rue Fontaine in 1922, where he continued his 'automatic' writing techniques that he had been developing with Phillipe Soupault since 1920.

Robert Desnos was one of the first writers within Breton's group to express literary ideas in paint using the same techniques. Many of Desnos' works were drawings that became the illustrations for Louis Aragon's first little book that can broadly speaking be called Surrealist, *Une Vague du rêves* (1924). *The Death of André Breton* marks the transition, a celebration of the international success of Dada and the advent of Surrealism.

CREATED

Paris

MEDIUM

Oil on canvas

SIMILAR WORKS

Francis Picabia, *Dada Portrait*, 1920

Robert Desnos *Born* 1900 Paris, France

Died 1945

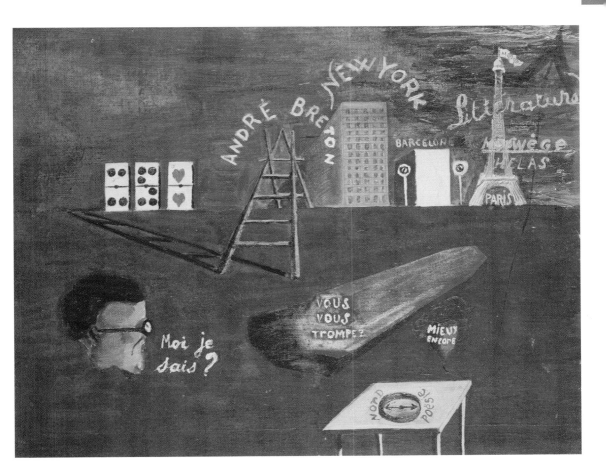

Desnos, Robert

The Fish Jumping out of the Inkwell, 1939

Courtesy of Bibliotheque Litteraire Jacques Doucet, Paris, France, Archives Charmet/www.bridgeman.co.uk/© ADAGP, Paris and DACS, London 2005

Robert Desnos continued to be a loyal supporter of André Breton during the 1920s although his dictatorial leadership came to be regarded as oppressive. As Desnos later remarked, 'To be a friend of Breton is one of the moral horrors of the times; many who have fallen into an irremediable decline give no further excuse than the fact that they were, for only a day, his friend'.

In 1924 the first dedicated Surrealist journal *La Révolution surréaliste* began publication. The first issue contained the infamous photograph of the anarchist Germaine Berton surrounded by other photographs of members of the Paris avant-garde including Pablo Picasso, Breton and Desnos, as well as influential figures such as the writer Antonin Artaud and the psychoanalyst Sigmund Freud. Berton had become infamous as the killer of the right-wing politician Marius Plateau. A number of other key avant-gardists had also chosen to depict her martyr status, including the painter Robert Delauney. The photomontage by Man Ray (1890–1976) of Berton and the avant-garde showed the political significance of the Surrealists as a part of the vanguard and clearly marked out their political affinities. However, Breton's affinities were to waver in the next decade, which would not find favour with a number of the early Surrealists, including Desnos.

CREATED

Paris

MEDIUM

Watercolour

SIMILAR WORKS

René Magritte, *The Therapist*, 1937

Robert Desnos *Born* 1900 Paris, France

Died 1945

Buñuel, Luis & Dalí, Salvador
Still from *Un Chien andalou*, 1928–29

This self-consciously avant-garde film was directed by Luis Buñuel and written mostly by Salvador Dalí. Both men were of Catalan origin and the film is imbued with a sense of the Spanish macabre. Using the film technique of montage that had been so influential in the earlier films of Sergei Eisenstein, Buñuel manipulated a series of short clips to create a reality that was illogical. Not only were the sequences themselves enigmatic, the use of montage made them disparate and completely illogical. For example, a camera shot of a hairy armpit then switches to one of a sea urchin. Above all, the film was designed to shock bourgeois sensibilities. In one sequence ants are seen crawling out of an open hand, reflecting Dalí's obsession with decay. In another scene two pianos are seen being dragged across a room, laden with a priest and a dead donkey, suggestive of an aversion to Catholicism and Biblical anecdote, as many Surrealist works were.

The scene shown is perhaps the most shocking of all for the audience, in which a cut-throat razor is seen being dragged across the surface of an eye. The mixed reaction to this film did not prevent Buñuel and Dalí from making another Surrealist film, however. *L'Âge d'or* caused a riot after its screening in Paris in 1930 and was banned in France for many years.

CREATED

Paris

MEDIUM

Film still

SIMILAR WORKS

Walter Ruttmann, *Symphony of a Great City*, 1927

Luis Buñuel *Born* 1900 Calanda, Spain

Died 1983

Salvador Dalí *Born* 1904 Figueres, Spain

Died 1989

Escher, M. C.

Ascending and Descending, 1960

Although M. C. Escher did not belong to any Surrealist group, his work shares its aesthetic language if not an idealist or motivational one. His work before about 1937 is based on observations of reality, depicted as a kind of super-reality in the exaggerated use of line to emphasize a key aspect of the motif. For example in *St Peter's Rome* (1935) the view is from inside the dome of the church. By exaggerating the angle of the view towards the ground, one that could not possibly have been taken from reality, the viewer is presented with a vertiginous headlong plummet to the marble floor.

His work post 1937 is from a period when he was forced to flee to Switzerland, avoiding the imminent build-up of Fascist troops in Italy, where he had been living until then and which had been such an inspiration for his 'architectural' drawings. After this time Escher had to rely more on memory and imagination and so began to create more playful forms of spatial exploration. These **were based** on his observations of the regular divisions of the plane at the Alhambra, which prompted an investigation of the mathematical principles behind it.

CREATED

Netherlands

MEDIUM

Lithograph

SIMILAR WORKS

François Morellet, *Sphère-Trame*, 1962

Maurits Cornelis Escher *Born* 1898 Leeuwarden, Netherlands

Died 1972

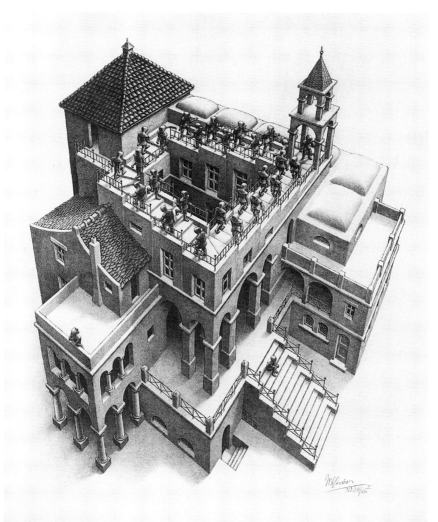

Escher, M. C.
Circle Limit III, 1959

M. C. Escher was not only interested in architectural form. With works such as *On the Fifth day of Creation* from 1926, nature as the motif was an integral part of his oeuvre. In this work he depicts a cross-section of a landscape revealing a number of species of birds, some flying while others are perched on the shore and a swan is afloat. Below the surface of the water are a number of fish species and marine life. The caption in the painting refers to the creation story in Genesis, a theme that he used several times, drawing an analogy with his own creative process.

Escher's development of the natural motif led to a process of abstraction in which the shapes and patterns became as important as the motif itself. *Circle Limit III* is from a series of works along the same theme that use stylized natural forms of fish, birds and insects. The starting point for Escher and for the Surrealists was the exploration of ideas within a scientific rationale. Where Escher's work parts company with the Surrealists was that the latter was politically motivated, whereas the former was only interested in its formalist qualities.

CREATED

Netherlands

MEDIUM

Woodcut with four colours

SIMILAR WORKS

Victor Vasarély, *Tlinco*, 1956

Maurits Cornelis Escher *Born* 1898 Leeuwarden, Netherlands

Died 1972

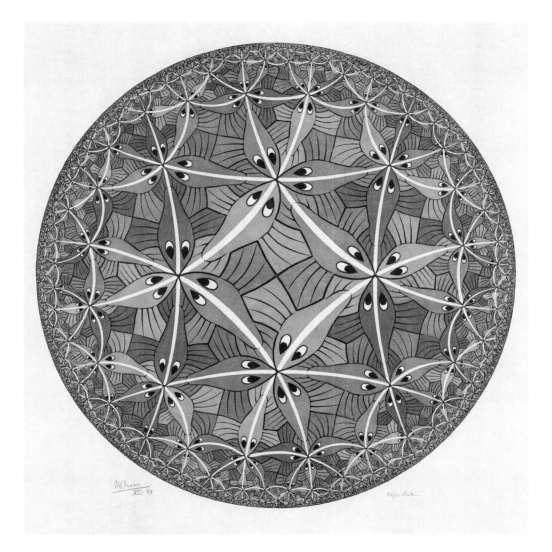

Gorky, Arshile
The City, c. 1935

In terms of Surrealism, Arshile Gorky's work can be divided between pre- and post-1936, when he first read the art dealer Julien Levy's book on Surrealism, in New York. Until then Gorky's work shows an affinity with the work of Picasso in its paint handling, but in his mural commission for Newark Airport, completed in 1936, he was already beginning to show the biomorphic forms that were to inform his later work. According to the patron for *The City*, the work was influenced by a photograph taken from the roof of a building in New York that Gorky had seen and which 'had interesting abstract forms', suggesting at this time the artist's only concern was the potential of its formal qualities.

Julien Levy became a key figure in the dissemination of Surrealist ideals and polemics when many of the European artists fled to America in the late 1930s. Until then American modern art was, broadly speaking, divided between the aesthetics of Abstraction and Social Realism. Levy posited himself between them, stating in his book, ' In the history of art, Surrealism is a revolution, firstly against the bondage of realism, secondly against the snob monopoly of abstract painting'.

CREATED

New York

MEDIUM

Oil on canvas

SIMILAR WORKS

Pablo Picasso, *Bullfight*, 1934

Arshile Gorky *Born* 1904 Khorkum, Armenia

Died 1948

Gorky, Arshile

Composition, c. 1946

The fact that Arshile Gorky did not use an anecdotal title for this work suggests that the motif ceased to be relevant to his work at this time. This work shows how far he has shifted away from the Cubism of Picasso to a painting style that was inspired by his meeting with Yves Tanguy, André Masson and in particular Roberto Matta. What he gained from Matta was the sense of a constantly shifting space that seemed untameable. By 1942 Gorky had assimilated much of Matta's influential style. *Composition* is a typical work of this period in which rough patches of paint, some of which are applied thinly and run, are interspersed with delicate lines. Gorky's work always seems 'automatic', but is in fact very considered and deliberated over. It owed much to the psychoanalytical theories of Carl Jung who had distanced himself from his former mentor Freud in order to develop theories that were less centred on libidinal interpretations. In its place Jung proposed a psychoanalytical approach that attempted to develop a spiritual and personal completeness by understanding emotional disturbances. The linking of emotional and mental trauma to spirituality is a key aspect of Gorky's work, becoming a foundation for the later generation of Abstract Expressionists.

CREATED

New York

MEDIUM

Oil on canvas

SIMILAR WORKS

Roberto Matta, *Locus Solus*, 1942

Arshile Gorky *Born* 1904 Khorkum, Armenia

Died 1948

O'Keeffe, Georgia

Ram's Head, White Hollyhock-Hills, 1935

Another artist who did not belong to the Surrealist group, even when it was in exile in America was the American artist Georgia O'Keeffe. After working as a commercial artist and art teacher, she moved to New York in 1918 to become a full-time painter with the encouragement and financial help of the photographer Alfred Stieglitz. From him she learned to isolate certain elements from his photographic process, such as cropped images and the use of the telephoto lens. O'Keeffe is probably best known for her flower pictures in close-up and the first of these images came from this experimental period in 1924. From this period on, she developed a synthesis of photography and a symbolic use of a motif, which may or may not be abstracted. From 1929 O'Keeffe spent the summers in New Mexico where the dry bones of animal carcases fascinated her, being bleached by the intense light of the sun on the arid desert plains. Influenced by the technical possibilities of photography, her paintings of this period juxtapose the precisely painted flowers and animal bones that were referenced in close-up detail, with the imprecise barren landscape of the Mexican desert. *Ram's Head, White Hollyhock-Hills* is a perfect example of this style.

CREATED

New Mexico

MEDIUM

Oil on canvas

SIMILAR WORKS

Paul Nash, *Landscape of the Megaliths*, 1937

Georgia O'Keeffe *Born* 1887 Wisconsin, USA

Died 1986

O'Keeffe, Georgia

Red Hills with White Shell, 1938

The summer visits of Georgia O'Keeffe to New Mexico from 1929 were not with her husband Alfred Stieglitz. They were as a guest of the wealthy socialite Mabel Dodge Luhan who also invited, amongst others, the writer D. H. Lawrence and the photographer Ansel Adams. Luhan and her husband owned Ghost Ranch and it was from there that O'Keeffe made her sorties into the desert with Adams and Mabel's husband.

What attracted O'Keeffe to New Mexico as a leitmotif was the combination of the intense light, strong colours and the vastness of the landscape. She realized the limitations of black and white photography, not just because of the inability to convey colour, but also because the intense light created deep and heavy shadows that diminished the clarity of the landscape forms. *Red Hills with White Shell* shows O'Keeffe's awareness of Wassily Kandinsky's (1866–1944) use of the circle and triangle, as 'something more than geometry'. It is based on the hills and canyons around Ghost Ranch, which continued to be an important source of inspiration. In 1940 she succeeded in buying the property for her own use and she eventually purchased a disused Catholic mission further south of Ghost Ranch, where she settled permanently in 1949, after Stieglitz's death.

MEDIUM

Oil on canvas

SIMILAR WORKS

Eileen Agar, *Rocks, Ploumanach, Brittany*, 1936

Georgia O'Keeffe *Born* 1887 Wisconsin, USA

Died 1986

Calder, Alexander

Untitled, 1947

It is not hard to see the influence of Joan Miró in this work , in its composition and use of colour and shape. Although American born, Alexander Calder began visiting Paris from 1926 on, where he met Miró and Paul Klee. Having met Piet Mondrian (1872–1944) in a subsequent sojourn, he was invited to join *Abstraction-Création* alongside Naum Gabo and Hans Arp. It was from these meetings and influence that he exhibited his first 'construction'. Although he remained committed to Abstract art, his work is imbued with many of the qualities of a Surrealist aesthetic. Calder replaced his purely Constructivist ideas with more biomorphic forms, his shapes being informed by dream-like forms accessed in the unconscious, rather like Miró's. However, Calder's images are also imbued with humour, an aspect often lacking in Miró's paintings and more often found in Klee's work. The smiling moon in *Untitled* is borrowed from a similar motif used by Klee, for example in *Clown* (1929) and *Senecio* (1922).

Because Calder knew many of the European Surrealists at first hand, his home in Roxbury, Connecticut, was a natural magnet for the émigrés when they arrived in the late 1930s and early 1940s, becoming something of an outpost for the movement.

CREATED

Probably USA

MEDIUM

Oil on canvas

SIMILAR WORKS

Joan Miró, *Constellation*, 1941

Alexander Calder *Born* 1898 Pennsylvania, USA

Died 1976

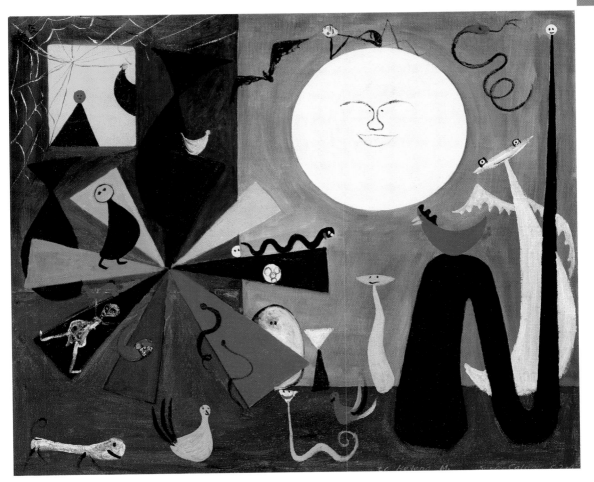

Calder, Alexander

Untitled, 1954

Having gained a diploma in mechanical engineering in 1919, Alexander Calder continued his education in fine art by enrolling at the Art Students League in New York until 1924. While he was training as an artist he visited Barnum's Circus most evenings where he would sit and draw circus life. His dual talents were fused in an ambitious project to create a miniature circus in which the acrobats and other performers were equipped with movable parts. It was during his visits to Paris from 1926 that he gave private performances of his miniature circus, from which he derived his 'mobiles'. These 'mobiles' were an animated caricature of the circus in abstract form.

As a Surrealist 'object' they function as all 'objects' of this type do, by teasing the viewer and challenging his or her perceptions of the work. With a mobile the 'work' is created and recreated with each slight movement of the air, Calder going to great lengths to ensure lightness of the 'object' and therefore more freedom of movement. The mobile also defines and redefines the space that the 'object' occupies, the space becoming an integral part of the work itself.

CREATED

Paris

MEDIUM

Mobile, mixed media

SIMILAR WORKS

Julio le Parc, *Continual Mobile, Continual Light*, 1963

Alexander Calder *Born* 1898 Pennsylvania, USA

Died 1976

Author Biographies

Michael Robinson (Author)

Michael Robinson is a freelance lecturer and writer on British art and design history. Originally an art dealer with his own provincial gallery in Sussex, he entered academic life by way of a career change, having gained a first class honours and Masters degree at Kingston University. He is currently working on his doctorate, a study of early modernist period British dealers. He continues to lecture on British and French art of the Modern period.

Donna Roberts (Foreword)

Dr Donna Roberts is a freelance writer specialising in Surrealist art. After gaining a PhD at the University of Essex, she became a Senior Research Officer at the AHRB Research Centre for Studies of Surrealism and its Legacies. Recent publications include 50 short texts for *Themes and Movements: Surrealism* (Phaidon Press, 2004) and contributions to a catalogue of the Tate's collection of Dada and Surrealist works. Current projects include an anthology of texts from Surrealist periodicals, also for Tate Publishing, and an anthology of translations of Czech Surrealist texts.

Picture Credits: Prelims and Introductory Matter

Further Reading

Ades, D., *Dada and Surrealism*, Thames and Hudson, 1974

Alexandrian, S., *Surrealist Art*, Thames and Hudson, 2001

Berthoud, R., *The Life of Henry Moore*, Giles de la Mare Publishers, 2003

Breton, A., (translated by Simon Watson Taylor), *Surrealism and Painting*, MFA Publications, 2002

Calvocoressi, R., *Magritte*, Phaidon Press, 1984

Camfield, W. A., *Max Ernst – Dada and the Dawn of Surrealism*, Prestel Varlag, 1993

Causey, A., *Paul Nash*, Clarendon Press, 1980

Caws, M. A. (ed.), *Surrealism*, Phaidon Press, 2004

Chadwick, W., *Women Artists and the Surrealist Movement*, Thames and Hudson, 1991

Curtis, P., *Sculpture 1900-1945*, Oxford University Press, 1999

Fer, B. et al, *Realism, Rationalism, Surrealism, Art Between the Wars*, Yale University Press, 1993

Gablik, S., *Magritte*, Thames and Hudson, 1985

Gale, M., *Dada and Surrealism*, Phaidon Press, 1997

Hughes, R., *The Shock of the New*, Thames and Hudson, 1991

Lanchner, C., *Joan Miró*, Museum of Modern Art, 1993

Last, R. W., *Hans Arp – The Poet of Dadaism*, Wolff, 1969

Levy, J., *Surrealism*, Arno, 1968

Mink, J., *Duchamp*, Benedikt Taschen, 1995

Morse, A. R., *Dali – A Study of his Life and Work*, Rainbird, 1958

Mundy, J., *Surrealism – Desire Unbound*, Tate Publishing, 2001

Passeron, R., *Surrealism*, Editions Pierre Terrail, 2001

Remy, M., *Surrealism in Britain*, Ashgate Publishing, 1999

Richardson, J., *A Life of Picasso*, Pimlico, 1992

Waldberg, P., *Surrealism*, Thames and Hudson, 1997

Warncke, C-P., *Pablo Picasso 1881-1972*, Benedikt Taschen, 1997

Index by Work

General Index